Landscape as Photograph

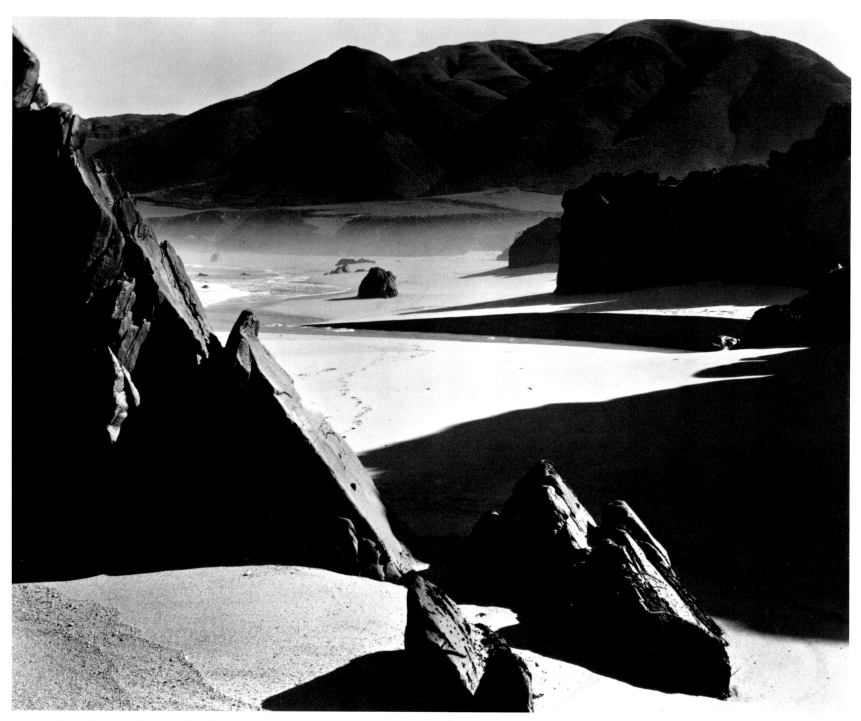

Brett Weston, *Garapata Beach*, 1954.

Landscape as Photograph

Estelle Jussim · Elizabeth Lindquist-Cock

Yale University Press New Haven and London

Published with the assistance of the F. B. Adams, Jr.,
Publication Fund.

Designed by James J. Johnson and set in Walbaum Roman.
Printed in the United States of America by Rembrandt
Press Inc., Milford, Connecticut.

Library of Congress catalogue card number: 84–40671
International standard book numbers: 0–300–03221–8 *(cloth)*
 0–300–03941–7 *(pbk.)*

10 9 8 7 6 5 4 3 2

Contents

Illustrations

COLORPLATES *following page 100*

Acknowledgments

This book would have been impossible to produce without the kind assistance of many individuals and the cooperation of many institutions. Our greatest measure of gratitude goes to the photographers who gave us permission to reproduce their works. Deepest appreciation for his many courtesies goes to James Enyeart, director of the Center for Creative Photography, University of Arizona, Tucson, as well as to Terence Pitts, curator, Lawrence Fong, registrar, and the darkroom staff at the Center. We also especially thank Andrew Eskind, director of interdepartmental services, Joan Pedzich, director of photographic archives, Barbara Galasso, darkroom assistant, and Linda E. McCausland, supervisor of reproduction services at the International Museum of Photography at George Eastman House. At the Visual Studies Workshop, Rochester, N.Y., we thank Lynn Underhill, Helen Bruner, and Robert Bretz. Without the extensive and varied collections of these institutions, research would have become overwhelmingly difficult.

We want to express our sincere gratitude for the encouragement offered by Nathan Lyons, director of the Visual Studies Workshop, Carl Chiarenza, professor of art history at Boston University, and Heinz Henisch, editor, *History of Photography*, and professor at Pennsylvania State University. Professor Peter Bunnell of Princeton University facilitated access to the Minor White Archives. Georgia O'Keeffe graciously granted permission to reproduce a print by Alfred Stieglitz.

Photographers too numerous to mention, whose works unfortunately could not be included for reasons of publishing economics, were more than generous with their time, suggestions, and enthusiasm. We cannot thank them enough.

For readers curious about such details, the research for the book was shared between us. Each of us wrote a version of each chapter and

xii argued these intensively. For the sake of a unified style, Jussim then produced the final manuscript. During all these exchanges, Judy Metro, our editor at Yale University Press, kept us firmly on course. We enjoyed and appreciated her good sense and lively wit. Barbara Folsom, manuscript editor at Yale, sympathetically and intelligently polished the rough spots.

ACKNOWLEDGMENTS

E.J. • E.L.-C.

Introduction

Among his opening observations in *Landscape into Art*, Sir Kenneth Clark noted that humanity is surrounded by a nonhuman world of trees, flowers, grasses, rivers, hills, clouds—all incorporated into the idea of "nature." He remarked that whatever is called nature is a human conception, not a totally independent reality. Not that he was debating the reality of the phenomenological world; he was simply recognizing that nature is a reification embodying changing attitudes and definitions.

There are at least two major discursive formations regarding the natural world. There is "Nature," which stands for a primordial force, a generative, creative energy: God as First Mover. Then there is "nature" denoting daisies, rocks, marshes, waterfalls, mountains, rainstorms: all specific phenomena including the flora and fauna of the world. Each concept interconnects with other fundamental philosophies which, taken together, constitute the reigning ideologies of an era. These ideologies compete for validation.

This book originated in conversations continuing over several years between two historians of photography who became deeply interested in observable changes in American attitudes toward both "Nature" and "nature," particularly as these attitudes influence the production of landscape photographs. The center of our concerns were the ideologies which implicitly or explicitly shape the aesthetic, moral, and political outcomes of the practice of landscape photography. Finding no available explication of these interlocking issues, we decided to collaborate on an investigation of various subsets of landscape photography. We had no intention of producing a chronology, or even of establishing constraints on what might be interpreted as "landscape," nor did we have any desire to discuss only "master" photographers or, indeed, *all* landscape photographers. This book is neither a history nor a biographical survey, although we did discover that certain issues have dominated the critical discourse during specific eras. We also believe that issues in

criticism can be illuminated or illustrated by a considered but nonrestrictive selection of photographs.

It should be stressed that we have made no effort to place a value judgment on either photographers or their images. The reader will undoubtedly note the absence of examples of the work of many remarkable photographers of landscape. For our purposes, the photographs reproduced here represent a possible focus for critical discourse, but they should not be considered as normative icons to be imitated. Our illustrations were not intended in any way to assign a fixed and exclusive category to this or that ideology or practice. It is the way critics and commentators talk about landscape photography that is of particular interest. To keep the book centered, we confined our selection of images, with two exceptions, to photographs of landscapes within the boundaries of the United States.

Landscape has become something of a buzz word in recent criticism, and we hasten to explain that our use of it may be considered somewhat idiosyncratic. For us, it is primarily a kind of shorthand; like *Nature/nature*, *landscape* is a multidimensional term. As a term in common usage, however, and widely understood today to convey the notion of the natural world dominated by nonhuman phenomena though by no means empty of the human, we find it offers considerable convenience. *Landscape* is by no means synonymous with *nature*, but it does include nature and offers a wide latitude of description and definition. Landscape photographs include stereographs, calendars, postcards, and all other formats where nature by itself, or in combination with human artifacts and the human presence, was used as the basis for picture-making.

Landscape is a construct. Like nature, what we call landscape is "defined by our vision and interpreted by our minds."[1] Landscape encompasses both scenery and environment but is equivalent to neither. As D. W. Meinig put it, "Environment sustains us as creatures; landscape displays us as cultures."[2] It is our contention that landscape construed as the phenomenological world does not exist; landscape can only be symbolic. In this, we are sustained by most critics, who assert the symbolism of landscape, both as a *construct* of the "real" world and as an *artifact* communicating ideologies about it. As both construct and artifact, landscapes are so saturated with assigned meanings that it is probably impossible to exhaust them.

Of all the recent criticism surrounding the use of the term *landscape* as applied to photography, perhaps none has been more vigorous than that by Rosalind Krauss. Taking issue with both art history and art criticism for making aesthetic objects out of pictures originally taken in the context of expeditionary photography, Krauss argues that Timothy O'Sullivan, for example, was a producer of "views," not "landscapes." Accordingly, O'Sullivan never intended to provide aesthetic pleasure but, rather, simply supplied information to the United States government about the potential for mineral and other types of exploitation in the as yet unknown American West. Furthermore, Krauss claims, O'Sullivan was known primarily through his stereographs, not through his large plate prints, which saw limited publication in the form of government reports.

No one can argue with Rosalind Krauss for rejecting the excesses lavished upon photography by some members of an art historical establishment which only in the last decade decided to take photography seriously, and which, by so doing, overwhelmed the "discursive spaces"[3] of expeditionary photography with aesthetic interpretation. But the fact that Timothy O'Sullivan produced stereographs for public consumption, and large plates for government reports which were seen by relatively few persons, does not invalidate the possibility that he executed both for-

mats with certain canons of aesthetics in mind. We demonstrate that possibility—in fact, that probability—in the early chapters of this book.

We find the anti-art, anti-aesthetic arguments about landscape photography an overreaction to the belated, market-stimulated art establishment's purveying of aesthetic criteria. Our argument is that the aesthetic may enter into image-making where it is least expected. What surprised us during the research and writing of this text were the similarities in conceptualization shared by painting and photography, and the metaphysical ideologies which inform both mediums. Both painting and photography produced what were called "views," and for us the term *landscape* is a convenient rubric which subsumes the term *views*. It seems almost self-evident that a view can be as aesthetic as a landscape, and that a landscape must be considered in the widest possible context. Since we do not have unlimited space for our own text, we focused upon specific topics without any intention of demanding their exclusivity as categories of discourse.

In his essay "The Beholding Eye,"[+] D. W. Meinig offers the following ways of discussing landscapes: as nature, habitat, artifact, system, problem, wealth, ideology, history, place, and aesthetic. As we were primarily interested in the relationships among discourses about nature, art, and ideology, we found that we had to devise our own rubrics. The reader will therefore find chapters on landscape as genre, as God, as fact, as poetry and symbol, as pure form, as popular culture, as concept, and, finally, as propaganda. These are not mutually exclusive terms, and we trust that the reader will discover that what at first may seem an arbitrary method of organizing a complex nexus of issues is in actuality intended to provide a flexible and nonrestrictive variety of methods offering possibilities for further discussion.

We have tried here to develop some useful approaches to the ways in which landscape photographs may be, and are, talked about. We are conscious of the fact that to attempt to describe a photograph is, as Roland Barthes remarked, to change structures, to signify in one code—language—what another code—photography—has relayed. Nevertheless, we believe that criticism of photographs cannot be limited to merely pointing and grunting, nor can the rich contexts of photographs be enjoyed by reproducing images without a substantial text. It is not only possible to verbalize about photographs but important to do so, for they are mighty indicators of cultural assumptions. While meaning cannot always be definitely ascribed, meaning can be adduced, deduced, and produced. The photograph as a presence to be contemplated in pleasurable silence will survive even the most rigorous examination.

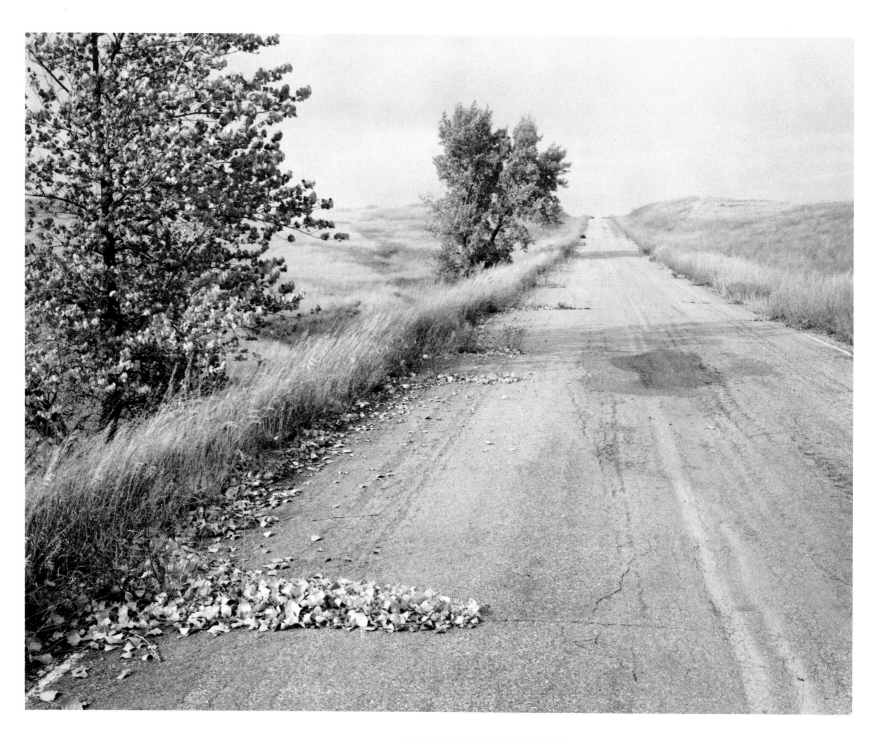

1. Robert Adams, *Nebraska State Highway 2, Box Butte County, Nebraska,* 1980.

1 Landscape as Artistic Genre

*Let the civilized world go to the devil! Long live
nature, forests, and ancient poetry!*
—Théodore Rousseau

When the French painter Paul Delaroche first
glimpsed the newly invented daguerreotype, he
is reported to have exclaimed, in an understand-
able mixture of horror and admiration, "From
now on, painting is dead!" In fact, painting did
not die; it has enjoyed a most combative and lively
relationship with photography, each form of those
visual arts competing, imitating, adopting the
strategies of the other. French portrait artists
promptly copied the smooth chiaroscuro of the
daguerreotype, while the calotypists went out into
the landscape and imitated there what the Bar-
bizon painters were making of nature. English
portraitists emulated Rayburn and Rembrandt in
their paper photographs, and their landscapists
rushed off in search of views that would have
satisfied any eighteenth-century Italian maker of

veduti di Roma. The interplay continued through
pictorialism, precisionism, and photorealism—
painting scorning photography even as it incor-
porated its modalities, from snapshot to motion
studies, while photography emphatically denied
its sisterhood with the older art in an effort to
establish a unique identity.

Delaroche's exclamation revealed far more
than shock at a mechanical recording of nature.
Whether he knew it or not, he was equating that
mechanical recording with the contemporary goal
of much of painting in 1839: to be representa-
tionally illusionistic and dazzlingly detailed. It
seems amazing today that there were such im-
passioned arguments over whether photography
could be art when the goals of painting and "sun-
drawing" were not dissimilar. It was surely no
coincidence that a mechanical method of re-
cording the phenomenological world was in-
vented just as the artistic ideology of realism was
taking hold of the European imagination.

1

Not that realism succeeded in ejecting allegory, bathos, and moralizing neoclassicism from their academy strongholds. Side by side with the superannuated history painting, with its panoply of fake mythology and hyperbolic heroism, realism established the commonplace, the contemporaneous, the democratically real, and the scientific examination of natural phenomena. The camera, to no one's surprise, was the instrument par excellence for an epoch in which the artist Courbet could insist: "Painting is an essentially *concrete* art and can only consist of the presentation of *real and existing things.*"[1] That dogma could have emanated as easily from any of the early practitioners of landscape photography, and, taken at its face value, appears to be one of those unassailable definitions of the work of the camera. After all, what else could a machine do but render the concrete object? What could a machine do other than depict the real and existing?

What is curious is that photography was being denied a status among the fine arts even as critics could insist, like Champfleury, that "the artist's duty is to represent only what he had seen or experienced, without any alteration and without any conventional response or aesthetic affectation."[2] Take Sainte-Beuve's clamor for the truth and nothing but the truth, place it beside Alfred Stieglitz's much-repeated personal ideology of photography—that the search for truth was his obsession—and, on the surface at least, it is difficult to discover a difference between the *stated* goals of realism in painting and those of the purists of photography.

Realism and "truth" notwithstanding, landscape photography did not emerge in an ideological vacuum completely devoid of aesthetic ambition. On the contrary, the very invention of paper photography had been the result of a frustrating encounter between a picturesque Italian landscape and an exceedingly untalented English gentleman who was stubbornly attempting

to draw the charming scene presented by some trees and a lake. William Henry Fox Talbot was failing to capture this scene even with the aid of an artist's *camera obscura*, long known to painters, and the *camera lucida*, a relatively recent invention. Given his admitted lack of talent, what impelled an English gentleman—on his honeymoon, no less—to carry with him the implements of drawing and sketching? From the perspective of history, the fact that he was on a mountain overlooking a beautiful lake and was determined to record the scene is in itself remarkable. Six centuries earlier, in another well-known episode, Petrarch had climbed Mount Ventoux in Provence and was enjoying the mountain air and the enthralling spectacle when he was suddenly conscience-smitten by a page in Saint Augustine that warned him he was endangering his soul. The sensual pleasures of the environment were to be regarded as a perilous temptation, a distraction from eternal salvation. Petrarch fled; Fox Talbot merely regretted his incompetence in the attempt to record nature's delights.

As Sir Kenneth Clark noted in his introduction to *Landscape into Art*, "People who have given the matter no thought are apt to assume that the appreciation of natural beauty and the painting of landscape is [*sic*] a normal and enduring part of our spiritual activity."[3] In the secular world of the early nineteenth century, the pursuit of landscape for its own sake was not only tolerated but encouraged as a suitable aesthetic experience. Fox Talbot was therefore not indulging a human instinct but an acquired behavior. He was enacting a custom whereby educated persons of both sexes in the 1830s displayed their admiration for Nature in a way that simultaneously exhibited the social and cultural pretensions of their class. Furthermore, his response to a scene in Nature was shaped by the aesthetic ideologies of the early Victorians, including literary notions of the sublime and the

picturesque and the influence of German Neo-platonism. Although landscape painting had been a relative newcomer to the visual genres, gaining ascendency with Claude Lorrain and Salvatore Rosa, there was an already conventionalized approach to landscape which had its origins in Dutch painting of the seventeenth century.

It was perhaps easier to understand the relationship among nature, painting, and landscape photography when the camera was recording the cultivated topography of Europe. But when photography came to America and ventured away from New England's Europeanized culture into the deserts of the West, the application of a readily recognizable artistic ideology was more difficult. A typical argument centers on pictures like Timothy O'Sullivan's *Soda Lake, Carson Desert* (1867). As we can see from plate 20 (pp. 42–43), the camera had been pointed at what seems like nothing more than a desolate wilderness of little aesthetic interest. As John Szarkowski remarked in his *The Photographer and the American Landscape* (1963), "It is difficult to imagine a painter of the period being satisfied with a picture quite so starkly simple in concept and image."[4] Barbara Novak, on the other hand, from her vantage point as art historian, included O'Sullivan in her writings on nature and culture because images like *Soda Lake* represented to her the exact correspondence between landscape photography and luminist painting.

How is it possible for one photograph or one photographer to elicit such radically different perceptions? Szarkowski had always regarded O'Sullivan as a genius of "a purely intuitive order . . . a simple record-maker."[5] That was because O'Sullivan had been employed on various government geological surveys, and the assumption was made that what he was seeking was a rigid, scientifically accurate transcription of nature and nothing more. But with the discovery that O'Sullivan had often deliberately tilted his camera,

Szarkowski bleakly recanted. In his recent *American Landscapes* (1981), Szarkowski describes O'Sullivan's deliberate selection of compositional elements as "an act of almost willful aggression toward the principles of record-making, and . . . difficult to explain except on the grounds that O'Sullivan found the picture more satisfactory that way."[6]

What are these presumed principles of record-making, and why should tilting a camera nine degrees from the vertical be considered an act of aggression toward them? Is it possible that an art historian takes compositional strategies for granted while a photography critic does not? Szarkowski acknowledges the "remarkable originality and formal beauty"[7] of much of O'Sullivan's work. In what ways can it be said that photographic originality and formal beauty differ from those same qualities in painting? Indeed, if a photograph is expected to display maximum isomorphism with the natural scene it represents, how is it possible to speak of originality and formal beauty *of the photograph?* Would it not become necessary to address only the originality and formal beauty of the scene represented?

In his *Camera Lucida* (1981), Roland Barthes stated categorically that "whatever it grants to vision and whatever its manner, a photograph is always invisible: it is not it that we see . . . the referent adheres."[8] That is to say, Barthes believes photography is a window on reality, as if the flat piece of paper and the chemicals on it did not exist: we look only at the subject. In Barthes's piquant phrase, photographs belong to "that class of laminated objects whose two leaves cannot be separated without destroying them both: the windowpane and the landscape."[9] If the above comments are correct, how should we approach the whole genre of trompe l'oeil painting, where, as in William Harnett's still-life magic, we believe we are actually looking at fruits, fowl, muskets, letters tacked to a real wall, or how regard

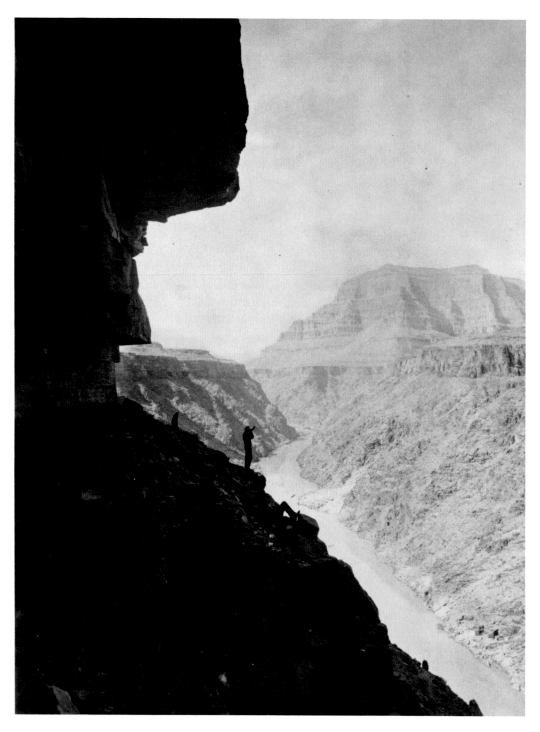

2. William Henry Jackson, *Grand Cañon of the Colorado, No. 1069*, after 1880.

Hans Holbein's *The French Ambassadors,* where the most minute details of two human beings and their environment are presented with formidable representational illusionism?

Inevitably, the argument runs that photography cannot be compared with painting because the camera is pointed at nature at a specific moment in time, capturing just that moment on a specific piece of film, and then must go on to the next moment and the next piece of film. It is therefore to be regarded as the perfect presenter of that moment, of each moment, whereas the painter can roam at will in time and imagination. What, then, are we to think of Alvin Langdon Coburn's excitement about shooting the Grand Canyon with a specially made long-angle lens? It permitted him to compress the complexities of space and structure into a decorative pattern that stressed ideal forms rather than evanescent phenomena.

Comparing one of William Henry Jackson's dramatic views of the Grand Canyon (plate 2) with Michael A. Smith's version of a similar aspect (plate 3), or Coburn's view with Anne Brigman's (plates 4, 5), we can begin to question Barthes's insistence that "a photograph is always invisible; it is not it that we see . . . the referent adheres." In each of the aforementioned images, it seems obvious that the pictures themselves are the result of a complex of technological factors comingled with intellectual aspirations, narrative propensities, aesthetic expertise, and symbolism. If it were only something called "content" that concerned us, we should never be able to distinguish between two photographs of a specific subject. Nor would we be able to admit that photography is *by no means* a universal language, available to all times and places without the troublesome interferences of ethnocentric and tempocentric biases. As Walt Whitman put it, "Nature consists not only in itself objectively, but at least just as much as its subjective reflection from the

person, spirit, age, looking at it, in the midst of it, and absorbing it: [it] faithfully sends back the characteristic beliefs of the time or individual. . . ."[10]

It has taken several generations of critics to recognize and acknowledge that Timothy O'Sullivan, to use him once again as the prototypical nineteenth-century American landscape photographer, may have been as much influenced by his era's aesthetic ideals as, say, Samuel Bourne was in his unmistakably picturesque photographs of British India taken at about the same time. We have yet to extricate the threads of the documentary, or "record-taking" tradition, from the pictorial, and these issues will be addressed in following chapters.

It was not only the aesthetic tradition of landscape painting which influenced American landscape photographers, but scientific and philosophical ideologies as well. Photography was set the task of "proving" or "disproving" theories of evolution and catastrophe as evidenced in geological manifestations. Darwin and Comte: these were fact-gatherers for whom photography would labor. Ruskin's moral naturalism demanded a kind of reverence for modest vistas of trees, lakes, bushes, country paths, and village greens, all part of the intimate scenes of mid-nineteenth-century life in the American Northeast, where landscape photography first served the national pride. Contemporaries immersed in the poetic disposition so prevalent at the time defended the humbler virtues in landscape: "The grandeur of mountain-tops, of wild cascades, and avalanche-piled ravines, is not unknown to American poetry; but the portrayal of simpler surroundings of everyday life has formed the true attachment between singer and listener."[11] For some, at least, it was far better, even more moral, to admire the homely everyday beauties of New England than "to dream of far-off magnificences of Nature."[12]

Unquestionably, for one New Englander who

was to influence his generation profoundly, contact with Nature, or a life in rural America, had implicit moral significance. Ralph Waldo Emerson saw pragmatic, gross "Understanding" as the product of city industries and the demands of the machine; the higher "Reason," visionary and mythopoeic, "requires wild or rural scenes for its proper nurture."[13] As Leo Marx noted, Emerson was not merely a Transcendentalist, but an American standing at the crossroads of machine civilization and the receding, primeval—therefore godly—forest. In Emerson's words: "The land is the appointed remedy for whatever is false and fantastic in our culture. The continent we inhabit is to be physic and food for our mind, as well as our body. The land, with its tranquilizing, sanative influences, is to repair the errors of a scholastic and traditional education, and bring us into just relations with men and things."[14]

Probably only a Bostonian writing in the safety of a well-established city culture could refer in this way to the land as "tranquilizing." Certainly the pioneers who, rightly or wrongly, were warring with native Americans for the privilege of inhabiting the continent would not have called the land tranquilizing. It was the park, the garden, and the village common which offered this paradisical view. If Emerson could have traveled with O'Sullivan across the Fortieth Parallel into the desolate wilderness where no bird sang and no deer sprang daintily through verdant woods, he might have changed his mind. The truth is that the American land encompassed everything from prairie to plantation, from cataclysmic declivities to sheltered ponds, from alkaline desert to towering redwoods. Even in the decade when photography was being developed as a medium—the 1830s—Oliver Wendell Holmes, a fellow Bostonian, could make this rejoinder to Emerson:

For all the declamation about the sources of inspiration to be found in the grandeur of nature in our Western [i.e., American] world, and the influences to be exerted by our free institutions, they have hitherto impressed a tendency to the useful, rather than the beautiful, upon the national mind. The mountains and the cataracts, which were to have made poets and painters, have been mined for anthracite and dammed for water power.[15]

The painter Thomas Cole, returning from a visit to Europe, remarked that what America lacked in tradition-wreathed monuments, it made up for in wildness. Wildness was its glory. Emerson was probably not acquainted with true wildness; his Nature could be beheld in a single acre of the local woods or farmland. While landscape photographers would pay homage to the singular beauties which even one acre can encompass, the typical American notion of landscape was on the grand scale, not in acres to be measured, but in hundreds of square miles. Expansiveness, melodrama, and above all the sensation of open space, the idea of a physical frontier that knew no bounds, were the expectations not only of the landscape painters like Frederic Church, Albert Bierstadt, and Thomas Moran, but of photographers like Carleton Watkins, Eadweard Muybridge, and their ideological descendants, like Ansel Adams.

When landscape photographers had such a plethora of motifs from which to choose among the natural wonders of America, what made them decide to choose one over another? Was there, already in the mid-nineteenth century, so soon after the invention of photography, a hierarchy of aesthetic values that dominated their choices? Did the pressure for information "back East" push them to seek only the new, the undiscovered, the dramatically monumental? Contemporaneous with the first decade of photography, there existed in America a group of painters known as the Hudson River School, of which Thomas Cole was a leader. Asher B. Durand painted *Kindred Spirits* in 1849, his famous portrait of Thomas

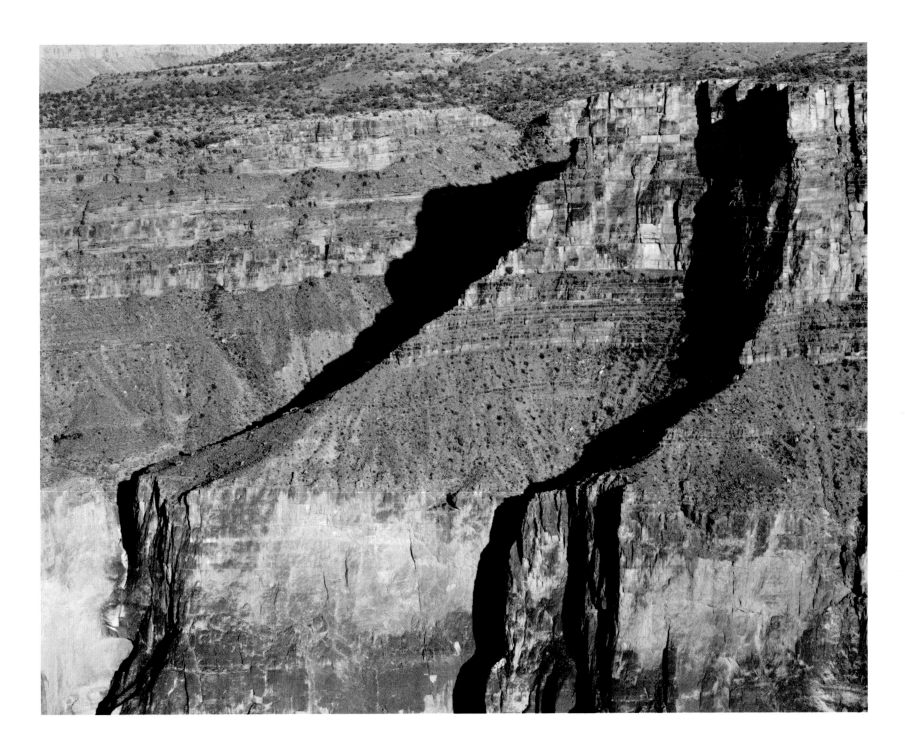

3. Michael A. Smith, *Toroweap Overlook, Grand Canyon*, 1978.

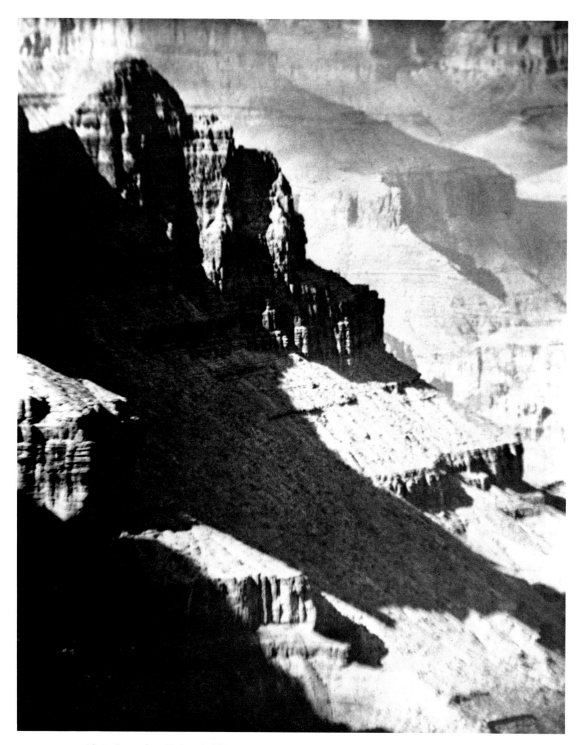

4. Alvin Langdon Coburn, *The Temple of Ohm, Grand Canyon*, 1911.

5. Anne Brigman,
Sanctuary [Grand Canyon], 1921.

Cole and the poet William Cullen Bryant overlooking a cleft in the Catskill Mountains, while below them gushed a picturesque waterfall and above them beatled a not unfriendly crag. It was a gentle scene with the two friends neatly attired in city clothes. No backpacks, no straining ropes, no panting mule-trains, nothing of urgency, hazard, life-threatening exigency, marred the peaceful mood of *Kindred Spirits*. It is hard to imagine a 1980s photographer with any artistic aspirations posing two people in this manner; it would have to be a scene out of *National Geographic*, pleasing, informative, colorful. But when we place *Kindred Spirits* next to Albert Bierstadt's painting of *The Rocky Mountains*, with its melodrama of soaring peaks, wild Indians, infinite spaces, tumbled and decayed trees, and general mood of potential turbulence, the sense of Nature shifts from placid enjoyment and reverential worship to heart-racing thrill. Compare one of Timothy O'Sullivan's photographs from the Fortieth Parallel—say, the one of jagged cubes rearing up in the desert (plate 6)—next to, say Paul Caponigro's mystical scenes of the Connecticut woods celebrating a gentle brook (plate 7), and we know that Ralph Waldo Emerson was geocentrically blind.

> In the woods is perpetual youth. Within these plantations of God, a decorum and sanctity reign, a perennial festival is dressed, and the guest sees not how he should tire of them in a thousand years. In the woods, we return to reason and faith. There I feel that nothing can befall me in life— no disgrace, no calamity (leaving me my eyes), which nature cannot repair.[16]

It is not that Emerson was wrong. He simply did not admit to a landscape beyond his precious woods; nor did he recognize the immense variety encompassed in the word *land*. Obviously, the word *nature*, too, means a complex of phenomena far different to the prairie farmer racing for safety against an oncoming tornado, or to mountain folk hewing their way through stubborn rock to eke out a living, than it does to the Santa Barbara beach buff or to disadvantaged urban children.

But it is not merely preconceptions about the meanings of land and nature, but preconceptions about what is appropriate to photograph that influences criticism of the genre. Communications difficulties encumber even the task of finding a simple definition for the term *landscape*. What, exactly, is a landscape? Is it a picture of wildness, or wilderness? Is it an image of a certain dimension or color? Can it contain humans, animals, houses, ships? Must a landscape always speak of beauty? Of solitude? Of rapture? Of poetic excess? Of homely everyday things? Can a landscape be symbolic? If so, of what? Even the word *land* itself seems to have altered over the centuries: "Long ago the word *land* meant something more distinct than firmament. It meant an open expanse surrounded by forest and covered with grass, what Europeans call a *glade* but what Americans call a *clearing*."[17] *Land* was not equivalent to *nature*. Land had to be made, cleared out by hard labor in forests and brush. *Landscape* was originally a Dutch word meaning a portion of nature which could be contained in a single view for the purposes of making a picture, and it included all the animals, houses, and inhabitants therein. Since the Barbizon and Impressionist painters, however, landscape in art has tended to include farmland, cultivated land, woods, glades, the seashore, and mountains, with the human element definitely subordinated to the vegetation or crags, expressing the idea that "nature" is distinct from the human or animal. This was partly the result of the encroachment on nature by an ever-increasing population, to escape which painters like Théodore Rousseau had fled to the Barbizon woods in the first place. This separation of nature from humanity is causing some alarm,

for its consequences have been unexpected. As the photographer Robert Adams observes:

More people currently know the appearance of the Yosemite Valley and Grand Canyon from looking at photographic books than from looking at the places themselves; conservation publishing has defined for most of us the outstanding features of the American wilderness. Unfortunately, by what was perhaps an inevitable extension, the same spectacular pictures have also been widely accepted as a definition of nature, and the implication has been circulated that what is not wild is not natural.[18]

Robert Adams is as concerned about this problem of segregating nature into wilderness areas as Ansel Adams is about preserving them. Not that Robert Adams wants to desegregate them; he wants to reassert "the affection for life that is the only sure motive for continuing the struggle towards a decent environment."[19] He wants photography to "reconcile us to half wilderness"[20]—in others words, to the mixture of natural forms with civilization; for how many of us can live our entire lives in the purity of an Ansel Adams park scene?

While Robert Adams sees a danger in turning away from people toward a sterile admiration of empty "nature," other photographers, observing the summer hordes trampling down the last vestiges of virgin wilderness in the national parks, view the world as an overcrowded pesthole bent on self-destruction. John Pfahl shows us an Econocan (a portable urinal) usefully but unexpectedly spoiling a vista in the Canyon de Chelly. Lee Friedlander, after amusing us with his shrewd pictures of public monuments, turns to a tangled and overrun site reminiscent of the briars that surround Sleeping Beauty in the fairy tale (plate 8). There seems to be an uneasy truce between photography that embraces what is left of wildness and natural beauty, and photography that

flagellates us with images of destruction. It may be that Lewis Baltz's hellish vision of Park City (plate 9) will prove to be the quintessential statement of what happens to the earth after the bulldozers pass through.

Whether we try to define landscape, as Robert Adams does (plate 1, *Nebraska State Highway 2*) in terms of its human implications, or as Kenneth Clark did, in more generally aesthetic and conceptual terms, we encounter issues of stylistic analysis. Photographers notoriously dislike their pictures to be analyzed according to traditional compositional elements such as line, shape, light and dark, color, unity, balance, proportion, rhythm. If the landscape photograph is supposed to be a seamless gestalt, a unique object completely separate from any history of the visual arts, then it would seem impossible to make connections with labels from painting, poetry, and literature; we hope to prove otherwise.

There has always been a strong tendency in art historical analysis to ascribe a style to a region as well as to a time: the Pont-Avon group, the Fontainebleau school, the Barbizons, the New York Abstract Expressionists, the San Francisco decorative Realists, or the Chicago Bauhaus. Certainly, we can talk about the Western panoramists or acknowledge the Yale University dogma of street photography; nobody can deny the impact of Moholy-Nagy, Harry Callahan, and Aaron Siskind on the Chicago photography scene. While these stylistic contexts are sometimes useful for discussion, they may be too limiting. Landscape photography, like all aspects of communication, requires placement within the larger contexts which include politics, economics, religion; obviously, our attitudes toward nature and images thereof may be significantly shaped by whether we are male or female, rich or poor, fundamentalist or Buddhist. The recent example of the Secretary of the Interior, James Watt, revealed how directly messianic Christianity can

6. Timothy O'Sullivan, *"Karnak," Montezuma Range, Nevada*, 1868.

7. Paul Caponigro, *Redding, Connecticut, Woods Series,* 1968.

8. Lee Friedlander, *Pomona, New York*, 1975.

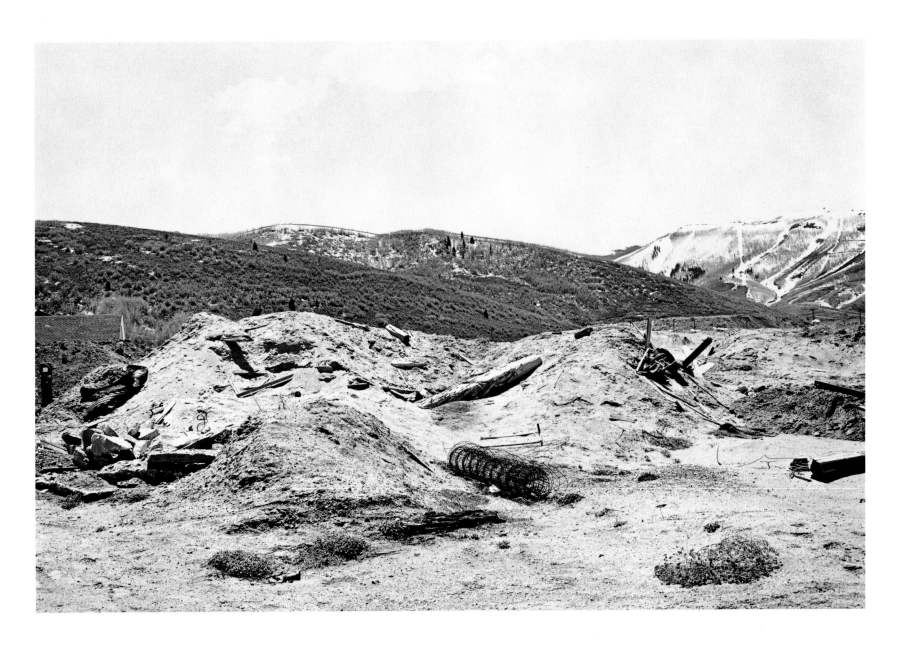

9. Lewis Baltz, *Park City, Utah: Between West Sidewinder Drive and State Highway 248, Looking North*, 1980.

influence attitudes toward nature, as natural resources and their preservation matter not at all if the millennium is about to arrive and we are all going to heaven or hell within Mr. Watt's own lifetime. At the other extreme, exclusive emphasis on "scenic" studies can be construed as a disregard for immediate social problems involving not only an artistic idea of nature but the survival of the planet Earth itself.

Landscape photography, which is coeval with the history of photography as a medium, has depended upon technical processes which directly influence aesthetic outcomes. Considerable attention has been devoted to these technical/aesthetic issues in the histories of American photography, especially the problems involving the wet collodion process, with its weighty glass plates and cumbersome equipment that required wagons and mule-teams for transport into the wilds. There has also been adequate discussion of the color-blindness of early emulsions, as when Alexander von Humboldt lamented the fact that green leaves registered as black, and blue skies fell away as dismal grey or white.

But a much more important social consideration has been almost completely ignored. Powerful ideological factors in America demarcated landscape photography, as well as landscape painting, as *man*'s work. Nature as wildness was considered to have a restorative effect on men who were becoming overly civilized, the equivalent to being *feminized*. The macho ideology was keenly espoused by Theodore Roosevelt, who, having been a physical weakling in his youth, went out West where hunting and ranching were not only work *for* a man but activities that *made* you a man. The prescription was definitely gender-specific: "Whenever the light of civilization falls upon you with a blighting power . . . go to the wilderness. . . . Dull business routine, the fierce passions of the marketplace, the perils of envious cities become but a memory. . . .

The wilderness will take hold of you. It will give you good red blood; it will turn you from a weakling into a man."[21]

Apparently, facing danger was not a prescription for making an individual into a woman, even if the danger of childbirth in the nineteenth century—especially on the frontier—was a much greater hazard than almost any activity in which Teddy Roosevelt engaged prior to his Cuban campaigns. While it was entirely appropriate for women to admire nature, even to enjoy pleasant scenery in the nearby woods, to press flowers in albums, to sketch hillsides, or to write plaintive verses about babbling brooks, it was not comme il faut for women to rush about passionately embracing the Divine Revelation in trees or tramping over harsh mountains into what was then called the "howling" wilderness. And though the lonely woman pioneer, protecting her homestead against Indians and other dangers, was expected to be bravely self-sufficient, the "ladies" of America were supposed to swoon with regularity. "Wilderness . . . acquired importance as a source of virility, toughness, and savagery—qualities that defined fitness in Darwinian terms";[22] social Darwinism was not meant to apply to the "weaker sex."

To be sure, there was no tradition for women in landscape painting. In the century prior to photography, women were encouraged to sketch and to paint in watercolors, just as they were expected to embroider, play the clavier, the flute, or the pianoforte, and to read uplifting literature in order to improve their morals and their conversations. In oils, women painted allegories, sentimental genre scenes, Neoclassical history paintings, nature studies, and portraits. In the nineteenth century, women were even accepted as illustrators for the pictorial press. But there were no grand landscape paintings by women à la Thomas Moran. And, given the problems not only of excessively cumbersome equipment and

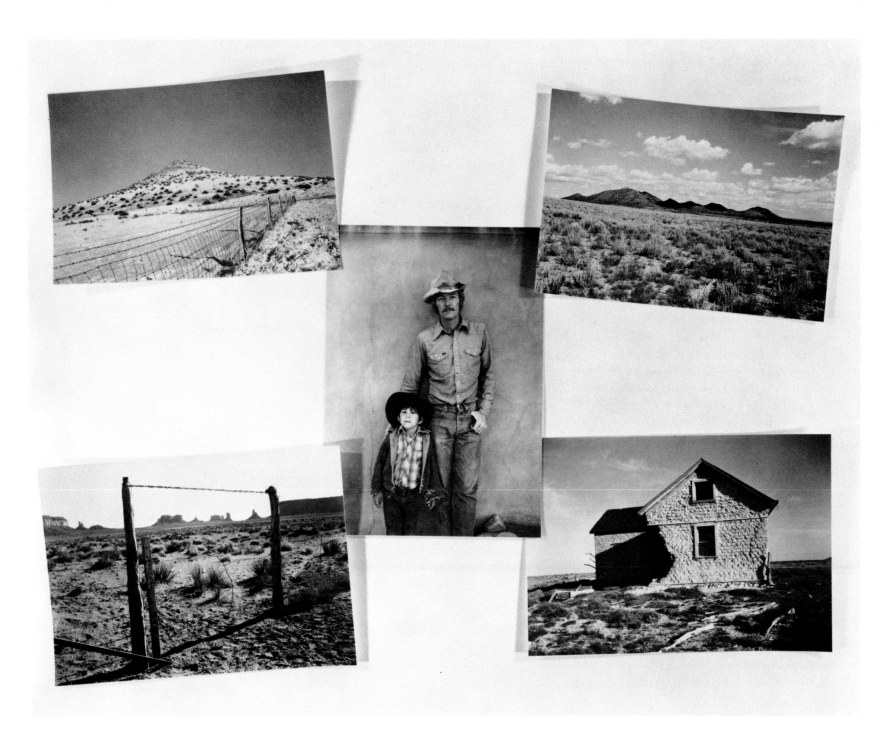

10. Meridel Rubenstein, *Seasonal #1*, 1981.

the real physical dangers of traveling into unsubdued wildness during the wet collodion period, it is not surprising that we discover no female O'Sullivans or Muybridges. It was not until the 1880s, with the introduction of dry plates and smaller cameras, and with the railroad firmly established as a safe means of transportation to the West, that women began to pursue the "grand" landscape as a photographic genre. From then on, women participated along with men in the photographic salons as landscape artists.

Since the style of the 1890s was preponderantely pictorialist, it is not surprising that the images known to us are in a lyrical, painterly style. By the 1900s, the pictorialist style became heavily larded with neoclassical allegory, with both men and women pursuing photographic subjects not unlike the nude-nymphs-in-landscape motifs of painters like Bouguéreau and other French academicians. Several critics today seem to believe that there is a history of gender differences in the creation of all artistic imagery, and have searched for evidence of a specific "female" imagery, in which women artists would reveal distinct views of nature or obsessions with particular aspects of the landscape. To reach any conclusions about such a complex subject would require extensive research far beyond the scope of the present reflections. We hazard the guess that few gender-specific distinctions will be discovered in landscape photography—unlike, perhaps, the genres of still-life and portraiture, especially self-dramatizations à la Cindy Sherman.

A photographic collage by a contemporary photographer who happens to be a woman represents an encapsulated history of the West and its contemporary realities: the open spaces, the landscape as property, the ruin of a house met-aphorically implying the destruction of the American Dream (in which a house of one's own still figures most prominently), and the posed "snapshot" of a Westerner with his child—the maker of new dreams, perhaps, or the person doomed to live out the delusions of the frontier. In its spaced narrative phrases, the collage by Meridel Rubenstein (plate 10) is reminiscent of the compressed conceptualizing of Emily Dickinson, one of whose poems begins:

I cross till I am weary
A Mountain—in my mind—
More Mountains—then a Sea—
More Seas—And then
A Desert—find—[23]

Landscape photography will be found to partake of symbol and allegory, metaphor, and pure form. Emily Dickinson's contemporary Ralph Waldo Emerson was particularly enthusiastic about the symbolism of nature, and attempted a taxonomy of various natural phenomena and their metaphoric equivalences:

Every natural fact is a symbol of some spiritual fact. Every appearance in nature corresponds to some state of the mind, and that state of mind can only be described by presenting that natural appearance as its picture. . . . Light and darkness are our familiar expression for knowledge and ignorance; and heat for love. Visible distance behind and before us, is respectively our image of memory and hope.[24]

The landscape photograph, like poetry, seeks to convey not only feeling but idea; regardless of whether it has as its content things not human, the human interpretation will always govern its meanings.

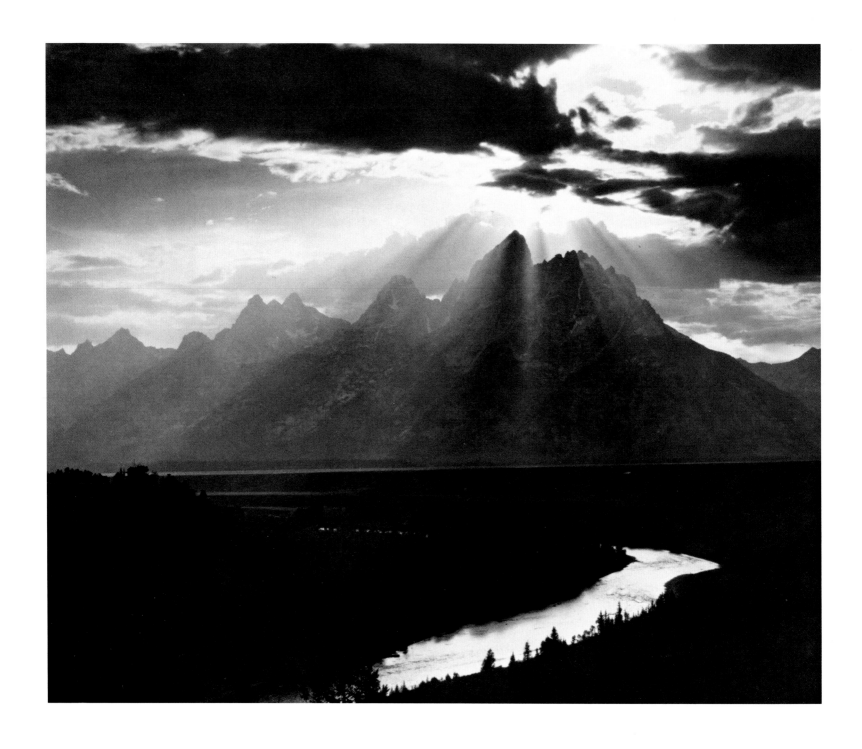

11. Minor White, *Grand Tetons, Wyoming*, 1959.

2 Landscape as God

That the nineteenth century worshiped Nature as God is a truism of art history. Because the various manifestations of Nature were regarded as the direct revelation of the Creator, both landscape painting and landscape photography enjoyed the exalted status of an aesthetic ideal. Since no activity could be more uplifting than the contemplation and praise of the Creator's ingenuity and power, the arts which conveyed these blessings to the general public became the most admired of the visual genres.

Despite the seeming unanimity of ideologies mingling aesthetic admiration with transcendental metaphysics, no single dogma ruled either art or religion. An Eadweard Muybridge photograph of the glories of the Yosemite differs radically from a Timothy O'Sullivan image of desolation along the Fortieth Parallel. This is not merely the accident of subject. The conflict was not simply between painterly beauty and harsh realities, but between underlying assumptions concerning the character of the Deity and the origins, history, and destiny of terrestrial creation.

Nor were these conflicting assumptions limited to the grandiose spectacles of the American West. Secure in his faith that a benevolent Deity ruled the lowland forests, lakes, and piney hills of his New England, Henry David Thoreau nevertheless was jolted by a most unexpected terror. High on Maine's Mount Katahdin, experiencing desolation instead of joyous triumph after his hard climb, he suddenly shivered. "What is this Titan that has possession of me? . . . *Who* are we? *Where* are we?"[1] This existential faltering, this collapse of the tranquility which transcendentalism was presumed to foster, is at the antipode from Walt Whitman's exuberantly confident pronouncement, "I say the whole earth and all the stars in the sky are for religion's sake."[2]

It should come as no surprise that Ansel Adams should have used this quotation from Walt Whitman in the preface to one of his portfolios. 21

The nineteenth-century worship of Nature as God is still with us at the close of the twentieth; but *which* God? Ansel Adams presents us with the towering mountains and sweeping vistas we would tend to associate with a God of sublimity (plate 12). At the same time, Adams photographs the delicate traces of snow on an aspen grove or a patch of wild strawberries exquisite in precise tracery: this would be Ruskin's God, who dwells in every corner of Nature. Yet the power of Ansel Adams's work seems to derive not from Ruskin but from a God found only in wilderness. We know that Adams sought the unspoiled in the generally despoiled twentieth-century landscape. He found his pockets of wilderness in the national parks, and his wilderness images are icons of yet another God.

In praising Ansel Adams for what the public perceives as "some privileged understanding of the meanings of the natural landscape,"[3] John Szarkowski remarks, "I think we are primarily thankful to Ansel Adams because the best of his pictures stir our memory of what it was like to be alone in an untouched world."[4] This is a somewhat startling statement. Not many of us in the late twentieth century, after all, have known "what it was like to be alone in an untouched world." Is Szarkowski suggesting some kind of Jungian universal racial memory? Certainly his statement implies that it is always a positive experience to be alone in an untouched world; yet Thoreau's sensations of dread atop Mount Katahdin are only a modest indication of a history of attitudes toward Nature that are anything *but* enthusiastic. The history of these attitudes is inevitably linked to the history of the shifts in our perceptions of humanity's relationship to God; to changes in what we have believed God expects us to perform on earth; to fundamental alterations in the powers ascribed to God as creator of the visible world; and, ultimately, as we shall dis-

cover, to the development of the idea of landscape as an expressive pictorial motif.

As we indicated previously, *where* we live has a direct impact upon our affection for Nature; but *when* we live is equally important. In 1671 an educated English gentleman named Thomas Burnet, accustomed to the tidy pastures of his native land, set out for Italy on the Grand Tour. Like many country gentlemen in the British Isles, his idea of Nature consisted of well-regulated royal hunting preserves, sturdy groves of once-sacred oaks, and the small cultivated plot. Imagine his consternation when he encountered the Alps: "for the Sight of those wild, vast, and in-digested [*sic*] Heaps of Stones and Earth did so deeply stir my fancy, that I was not easy til I could give myself some tolerable Account how that Confusion came in Nature."[5]

As Marjorie Nicolson recounts subsequent events in her *Mountain Gloom and Mountain Glory*, Thomas Burnet was so devastated by the chaotic spectacle of the Alps that he spent three years writing a book to explain their existence. Whereas today we may think of Switzerland as an expensive playground for skiers, where only an occasional avalanche threatens the prevailing gemütlichkeit, the seventeenth-century traveler confronted the Alps in a spirit of awed astonishment—not at their beauty, but at their ugliness. In a book that would strongly influence the English romantics, especially Wordsworth and Coleridge, Burnet explained what he called *The Sacred Theory of the Earth:*

The Face of the Earth before the Deluge was smooth, regular, and uniform; without Mountains, and without a Sea. . . . In this smooth Earth were the first scenes of the World, and the first Generations of Mankind; it had the Beauty of Youth and blooming Nature, fresh and fruitful, and not a Wrinkle, Scar or Fracture in all its

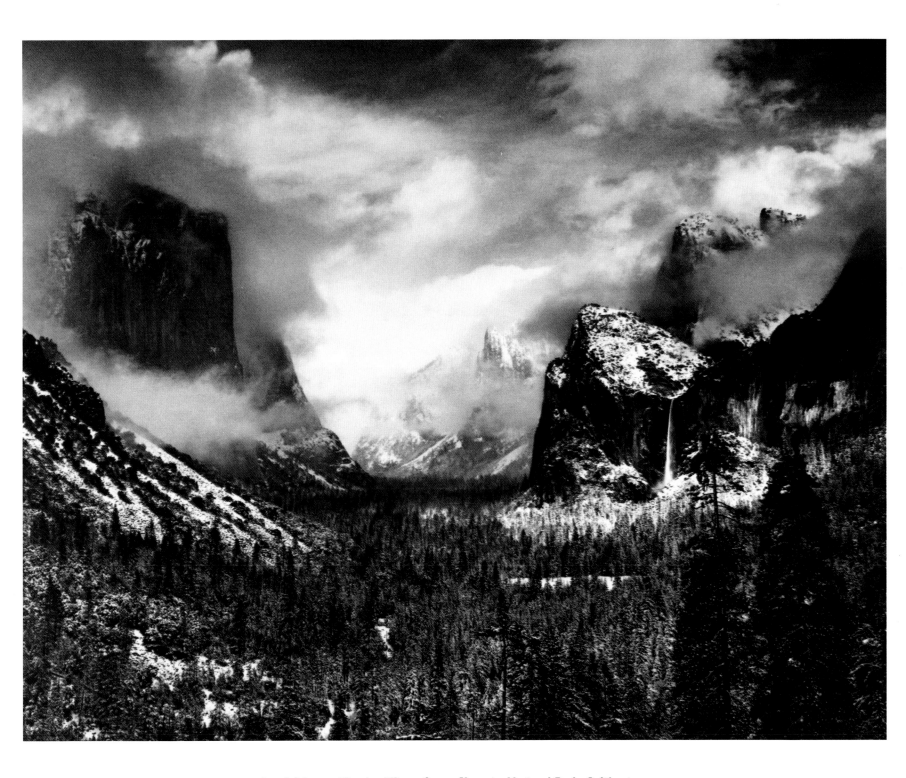

12. Ansel Adams, *Clearing Winter Storm, Yosemite National Park, California,* 1944.

Body; no Rocks, nor Mountains, no hollow Caves, nor gaping Channels. . . .[6]

This smooth, innocent, and perfect terrestrial globe had suffered God's wrath in the biblical Flood, after which the world was broken, ruined, wrinkled, chasm'd, mountain'd, and wretchedly scarred.

In the simplest terms, a cataclysm had engulfed the sinful Earth; the Alps and similar disfigurations were symbols of mankind's earliest depravities and God's consequent fury. To certain kinds of romantic temperaments—John Martin and Lord Byron or Salvatore Rosa come readily to mind—the idea of cataclysm stimulated thrilling, compassionate and melodramatic feelings equal to those elicited by any Greek tragedy. The ruined world revealed the melancholy and insubordinate history of humanity in every mountain range and ocean. And to the religious mind conditioned to expect God's direct intervention in human events, the mountains were the most monstrous relics of our fall from grace.

Such a cosmology could not long survive the burgeoning scientific curiosity about the origin of the planets and the sun. Once our planet had been dislodged as the center, not only of the solar system, but of the heavens as well, investigation of the origins of all natural phenomena proceeded rapidly. The Alpine rocks which had so affrighted Thomas Burnet now revealed the fossil remains of sea animals; was this proof of the Flood or of some more leisurely evolution of mountains heaved up from the sea floor? The discoveries of the Genevan geologist Horace Bénédict de Saussure, published as *Voyage dans les Alpes* in 1779, set the stage for the rational negation of Burnet's imaginative opinions. In place of a vengeful Deity raining destruction now stood the Divine Engineer, the creator of the Earth as a beneficent machine obeying the laws of Nature—

the terms Nature and God having become almost synonymous.

This new, widely influential concept was advanced by James Hutton, a Scotsman who was a farmer by trade and a geologist by avocation. His *Theory of the Earth*, published in 1785, avowed a more kindly God who had nothing but mankind's welfare in mind:

The Author of nature has not given laws to the universe, which, like the institutions of men, carry in themselves the elements of their own destruction. . . . He may put an end, as no doubt he gave a beginning, to the present system, at some determinate period; but we may safely conclude that this great *catastrophe* will not be brought about by any of the laws now existing. . . .[7]

An early evolutionist, Hutton had observed that "the fertile plains are formed from the ruin of our mountains."[8] Erosion processes turned solid rock into soil. Rivers transported the soil from the mountains to the sea, where the mountains were slowly recreated. God had invented a perpetual-motion machine to generate soil for the establishment of beneficial agriculture to support human life. For Hutton, there was "no vestige of a beginning—no prospect of an end."[9] These theories, based on observation rather than pure conjecture, gained wide support in America. Thomas Jefferson, himself a planter and farmer of many acres, absorbed Hutton's explanations:

The passage of the Potomac, through the Blue Ridge, is perhaps one of the most stupendous scenes in nature . . . the first glance of this scene hurries our senses into the opinion, that this earth had been erected in time; that the mountains were formed first; that the rivers began to flow afterwards; etc. etc. . . . It is a war between the rivers and the mountains which must have shaken the earth itself to its center.[10]

By the time Clarence King came to employ Timothy O'Sullivan as photographer on the Fortieth Parallel Survey of 1867–68, this struggle between opposing theories had been only slightly modified by the inclusion of the natural evolutionary processes. It is perhaps only in the context of an ongoing argument over cataclysm and evolution that we can begin to understand the critical emphasis on O'Sullivan's photographs as serving some kind of propagandistic role, even if it seems clear that O'Sullivan was also carrying out his own aesthetic program. The evidence indicates that "O'Sullivan was directed by both King and the geologist S. F. Emmons to make photographs that provided evidence for King's theory of 'catastrophism' and Emmons' more sober principle of 'mechanical geology'—an outgrowth of King's thinking. Catastrophism had deep socio-religious implications, indeed, was overtly anti-Darwinian in all its premises."[11]

Long before Darwin, and long after, there were vociferous antagonisms between sacred and scientific theories of terrestrial origins. O'Sullivan's employer, Clarence King, was not only a devout advocate of cataclysmic theory, a scientist, and an explorer, but he was also profoundly interested in painting and all the visual arts. A Ruskinian with strong opinions about all aspects of aesthetics, he brought to his endeavors a broad knowledge of both science and the relatively new subject of aesthetics.

As a field of philosophical inquiry, aesthetics was the child of the eighteenth century, a period called the Age of Reason as well as being the time of arrival of the so-called Industrial Age. It is odd that the eighteenth century has never been called the Age of Aesthetics, for it not only gave us the term *aesthetics* but was the century which began to categorize those psychological responses to Nature epitomized in the ideas of the sublime, the beautiful, and the picturesque. Just as botanists and zoologists were classifying the various species of flora and fauna, so philosophers embarked on the classification of human passions. The concept that "natural laws" offer explanations for human emotions and events originated in the new theory of God as Machine.

James Hutton was not the first to set forth the idea of natural laws governing physical processes. He was preceded by Edmund Burke's classification of human nature in which no mention of a wrathful God appeared; in fact, *A Philosophical Enquiry into the Origin of Our Ideas of the Sublime and the Beautiful* is a secular work, entirely worthy of the rational spirit of the mid-eighteenth century. In the first edition of 1757, Burke, having determined that two words, *sublime* and *beautiful*, were being used interchangeably and therefore incorrectly, sought remedy "from a diligent examination of our passions in our own breasts; from a careful examination of the properties of things which we find by experience to influence those passions; and from a sober and attentive investigation of the laws of nature, by which those properties are capable of affecting the body, and thus of exciting our passions."[12] This introductory paragraph, with its talk of "the properties of things," and "the laws of nature," implies that Burke will supply a reliable hierarchy of subjects from which artists can select guaranteed effects.

Given Burke's intention that his work serve "the imitative arts,"[13] painters, poets—and, later, photographers—could know certainly that the aspects of the sublime were astonishment, terror, obscurity, darkness, uncertainty, confusion, terribleness, vacuity, solitude, silence, vastness, infinity, with a choice of colors among the blacks, browns, and deep purples. "An immense mountain covered with a shining green turf, is nothing in this respect, to one dark and gloomy."[14]

Obviously, both Thomas Burnet in the Alps and Henry David Thoreau on Mount Katahdin had experienced the *sublime*; their feelings of ter-

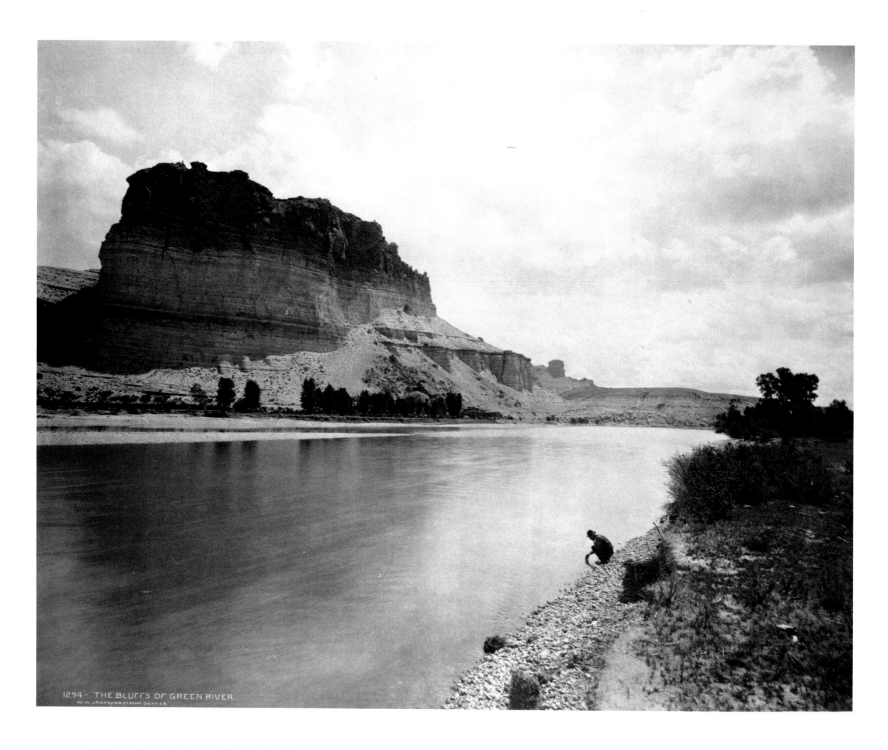

13. William Henry Jackson, *The Bluffs of Green River, Wyoming*, ca. 1885.

ror and confusion assured that exalted status in the aesthetic hierarchy. The merely beautiful was less capable of arousing great passion than these vast and horrifying vistas. The merely beautiful was smooth, tended to be rounded, of goodly proportion, without surprises, and certainly without terror. Beauty, according to Burke, was admirable if not awe-inspiring. It is possible that William Henry Jackson's photograph of the Green River and a distant riverside butte would fulfill some of the qualities of the "merely" beautiful (plate 13).

By the time of the invention of photography, yet another major category of "the properties of things" and the "laws of nature" had been added by William Gilpin and Sir Uvedale Price. This was the idea of the *picturesque*, and in it lingered no residue of a God-determined, God-ruined world. The immediate terrors of a personal God had been displaced by that more remote Grand Engineer whom the Deists evolved out of the technological and scientific ideologies of the day. Nature was now a process set in motion by a reasonable Deity whose infinite powers had been transferred to Nature itself. As Thomas Paine, the quintessential Deist, enunciated the new theology in *The Age of Reason* (1794), "The Word of God is the Creation We Behold."[15]

Not everyone, of course, was pleased by this suggestion of materialism. As the followers of Emmanuel Swedenborg and other Neoplatonists would have it, Nature was but a pale shadow of an ultimate truth—pure idea, God's domain. This metaphysic has survived in our own time, as witnessed by Paul Caponigro's description of his photographs as "the landscape beyond the landscape."[16] Pious Americans of the more conventional affiliations dominating the nineteenth century, and even as late as 1910, were wont to describe natural phenomena in terms of a pre–Age of Reason ideology: "The Grand Canyon is

God's greatest gift of His material handiwork in visible form on our earth. It is an expression of His divine thought; it is a manifestation of His divine love. It is a link, a wonderful connecting link, between the human and the Divine, between man and his Great Creator, his Loving Father, Almighty God."[17] Some of the complexities of Swedenborgian and other metaphysics appealing to contemporary photographers will be addressed in following chapters.

With the definition of the picturesque, Burke's "properties of things" became motifs to be employed not only by painters wishing to arouse emotion but by cultivated persons wishing to regard Nature with appreciative eyes, that is, with the vision to see what in Nature would make a fine picture. Characterized by a residue of ruin-of-the-world theories, the picturesque was a far less threatening version of the sublime. With its blasted trees and rotted stumps, tumbled cottage walls and gushing brooks, the picturesque offered a "taste for greater measure of complexity and intricacy than either beautiful or sublime affords."[18] Eadweard Muybridge's selection of features in his *Washington Towers* in Yosemite offers aspects of the picturesque in landscape photography (plate 14).

Photography, with its remarkable capacity for registering texture and detail, and therefore for recording the complexity and intricacy of Nature as no other medium preceding it, seemed destined for a picturesque career. But the picturesque was not to be construed as a license to record mildly ruined scenes somewhere between the beautiful and the sublime, midway between smoothness and regularity and breath-stopping visual chaos, without regard for academically approved compositional values.

Could photography match the imaginative powers of painting? William Gilpin, writing in 1794 on *Picturesque Beauty; On Picturesque*

14. Eadweard Muybridge, *Washington Towers, Yosemite*, 1874.

Travel; and On Sketching Landscapes, reminds us that the camera obscura was in use long before Fox Talbot's picturesque honeymoon:

There is still another amusement arising from the correct knowledge of objects; and that is the power of creating, and representing *scenes of fancy;* which is still more a work of creation, than copying from nature. The imagination becomes a camera obscura, only with this difference, that the camera represents objects as they really are: while the imagination, impressed with the most beautiful scenes, and chastened by the rules of art, forms it's [*sic*] pictures, not only from the most admirable parts of nature; but in the best taste.[19]

From its inception, photography was to be burdened with many of the implications of this paragraph. The camera represents things as they are. The imagination is impressed by the most beautiful scenes but must conform to established rules of art, meaning painting. Some parts of nature are more admirable than others. Pictures must be formed in the best taste. The camera obscura, long the preferred field aid for the landscape painter, now ordinary luggage for the activities of "picturesque travel," was creating a set of expectations by which photography would be judged.

Which parts of nature would American photographers and their audiences find most admirable? If the camera merely represented nature as it was, how would it be possible to apply the rules of art? What constituted the best taste? Which rules of art, whose taste?

The mid-nineteenth-century aesthetician whose influence was most pronounced in America was John Ruskin, a fanatical devotee of the Alps. Unlike Thomas Burnet, Ruskin found the Alpine crags exalting, proof of the existence of God, not of God's wrath. For such a romantic, the Alps were sublime. All mountains, in fact, were sublime: mysterious abodes of the ancient gods of Olympus as well as the omnipotent deity of Mount Sinai. That Ruskin's mountain worship has continued into the twentieth century is amply confirmed by many photographs, among them a spectacular vista by Minor White (plate 11). This transcendent glorification of mountain peaks as soaring, sun-halo'd, cloud-piercing intimations of God is perhaps becoming exhausted as a metaphor for spiritual awe.

In Ruskin's time, however, these hyperbolic visions were still new, and he was unashamed of proselytizing his admiration for mountains in *Modern Painters*, a monumental and controversial work whose parts appeared not long after Fox Talbot's own fascicles of *The Pencil of Nature*, in the 1850s. Besides extensively cataloging the various shapes of crags and cliffs, and sermonizing on the geology of mountains, Ruskin recognized a salient fact of his era: "The admiration of mankind is found, in our time, to have passed from men to mountains, and from human emotion to natural phenomena."[20]

It was hardly surprising, after the bloodshed and violence of the French Revolution, that humankind would continue neither to trust nor to admire its own species. Since God had been transformed into an eternal Machine, there was little to admire or love in that remote concept. Perhaps this is why both "sweet Jesus" as a figure of forgiving, all-embracing love, and the mountain as a symbol of the continuing power of gods older than Sinai became objects of excessive Victorian veneration.

Despite the acuity of his understanding that admiration had passed from humankind to mountains, Ruskin was hardly for expelling us from the wonderful landscape he was classifying. On the contrary, he believed that "all true landscape, whether simple or exalted, depends primarily for its interest on connection with humanity, or with spiritual powers."[21] "Banish your heroes and nymphs from the classical land-

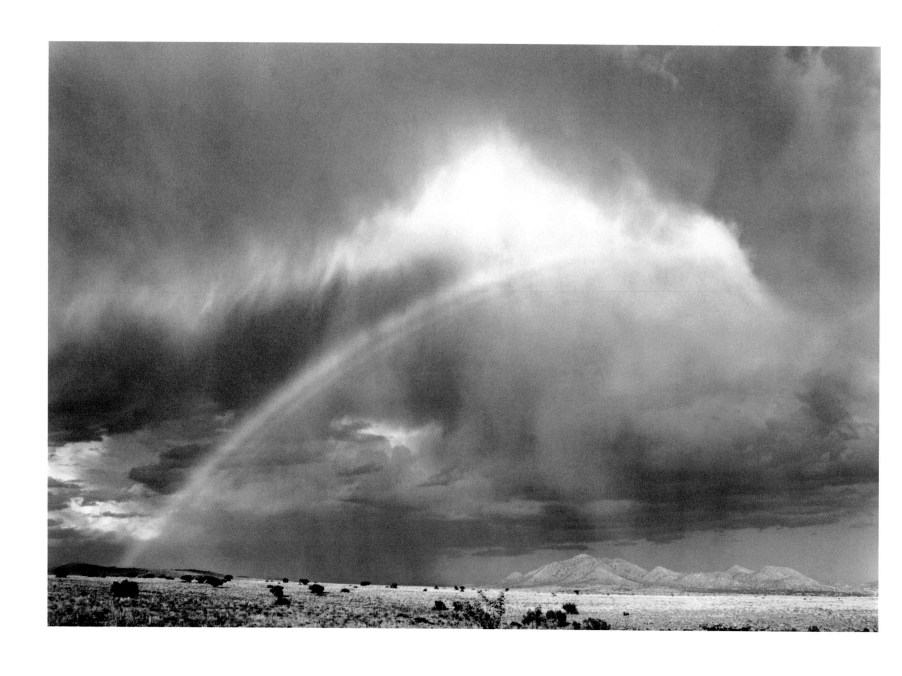

15. William Clift, *Rainbow, Waldo, New Mexico*, 1978.

scape—its laurel shades will move you no more. Show that the dark clefts of the most romantic mountains are uninhabited and untraversed; it will cease to be romantic."[22]

Not every modern landscape photographer would agree. For some of the fin-de-siècle pictorialists, eager to be identified with the fine arts painters of their day, it was true that no landscape was complete without its nymphs and fauns, implied if not visible. Imogen Cunningham epitomized that pagan aspect in her early pictorialist work. Also witness the many nude women posed decorously in outdoor surroundings by photographers from Edward Weston to Harry Callahan. But, as John Szarkowski has noted, we tend to think of the "pure" landscape as being uninhabited. No humans, nymphs, or even animals grazing peacefully in Arcady intrude into any of Ansel Adams's titanic renderings of Yosemite, or into the romantic grandeur of William Clift's vistas of the mesa country—even when they display a giant rainbow (plate 15); nor can they be seen disrupting the perfect order of a Michael A. Smith canyon (plate 3). And when four exceedingly distant and minute figures make their arduous way across a snow-covered mountain ridge in one of Bradford Washburn's astonishing images, he notes that curators promptly remove that print from the category of the "fine arts" photograph, relegating it to some presumably lesser category of "science" or "travel." This last diminution of the value of the human presence is ironic because Washburn, under extremely difficult and dangerous conditions, composes and stage-directs his dramatis personae as carefully as any painter (see plate 16).[23]

It would seem that the inclusion of a human figure, clothed in appropriate fashions of the day and season, removes the photograph of Nature from the generalizing, abstracting experience which would place the contents of the photograph in some iconic eternity. The human figure alters the context of the act of viewing; whether through aesthetic conditioning or through some intense human desire typical of the alienated, overcrowded twentieth century, we want, like Ralph Waldo Emerson, to become a "transparent Eyeball,"[24] a creature abstracted out of himself into the Divine Presence. A nymph no matter how seductive, a woodsman in a plaid mackinaw, a casual hiker crunching along the Mohawk Trail, would destroy the transcendental mood of meditation and catapult the viewer back into the present and the discouraging world of Fact. Information, acts of identification, fact—these are distractions from a behavior rather like that of a spectator at an absorbing drama where the self is momentarily forgotten.

A picture of Alvin Langdon Coburn perched on a ledge photographing the Grand Canyon (plate 17) indicates how the human presence obscures grandeur. And a similar ledge, topped off by two cavorting women dancing their way to perdition, is too hilarious and irreverent to remind us either of the Divinity in Nature or the sublimity of "great art." George Fiske (plate 18) plainly mocks our pretensions about Nature and the grand scene. Insufferable impropriety! How could an act of transcendentalist meditation take place under such circumstances—the implication is that people might even *enjoy* themselves. Purists might tolerate the intrusion of a few human elements into the landscape—the lone figure, sufficiently tiny to be disregarded, in the W. H. Jackson Green River print (plate 13) could be accepted, even though it hinted at fact (time, specific place, the mortality of humans versus the supposed eternal verities of nature). But humor? Never. Nature was a cathedral, not a dance hall. And certainly humans used in photographs simply to provide a sense of scale for all those impressive natural monuments were to be scorned as measuring rods, hardly considered as ornaments in a work of would-be art.

Obviously, there were rules to be obeyed in looking at Nature, since Nature was being admired as Art. (Later, of course, Oscar Wilde was to supply his most astute aphorism: Nature Imitates Art.) And these rules applied to photographs as well as to paintings. At this point in the nineteenth century, painting was vying not only with photography but with Nature itself. Nature, art, and photography were in competition, with photographers winning gold medals at Paris expositions for their spectacular landscapes. But here again, the question was whether it was the content—the view itself—or the craft of the photographer that was being applauded. Typically, Walt Whitman enthused:

> Talk as you like, a typical Rocky Mountain cañon, or a limitless sea-like stretch of the great Kansas or Colorado plains, under favoring circumstances, tallies, perhaps expresses, certainly awakes, those grandest and subtlest element-emotions in the human soul, that all the marble temples and sculptures from Phidias to Thorwaldsen—all paintings, poems, reminiscences, or even music, probably never can.[25]

Typically also, Clarence King likened the Sierra Nevada range to a work of art:

> As I sat on Mount Tyndall, the whole mountains shaped themselves like the ruins of cathedrals—sharp roof-ridges, pinnacled and statued, buttresses more spired and ornamented than Milan's; receding doorways with pointed arches carved into blank facades of granite, doors never to be opened, innumerable jutting points with here and there a cruciform peak, its frozen roof and granite spires so strikingly Gothic I cannot doubt that the Alps furnished the models for early cathedrals of that order.[26]

This sophisticated admiration for the architectural resonances of a mountain chain would scarcely suffice for the majority of Americans. They, like Ruskin, believed that it was impossible to judge a work of art as beautiful without simultaneously judging its moral worth. Can we look, then, on O'Sullivan's photographs as some kind of Ruskinian "sermons in stones"? The all-consuming controversy over painting in the mid-nineteenth century concerned the issue of moral worth. Could a photographer, necessarily concerned with the appearance of things in Nature, possibly convey their philosophical essence?

When the Reverend Samuel Osgood addressed the American Art Union in 1851, the title of his lecture was "Art, the Interpreter of Nature; Nature, the Interpreter of God."[27] William Stillman, a painter turned photographer, founded an American Pre-Raphaelite journal called *The Crayon*, in which he stated: "No man can revere Nature, save as he feels it to be only a form by which something higher than himself is manifested to him."[28] *The Crayon* adhered strictly to Ruskinian notions of truth to Nature as a prerequisite for morality in art. "Art is a representation not of what the eye sees, but of what the soul seeks."[29]

For all that he is known primarily as O'Sullivan's employer on a geological expedition for the United States government, Clarence King was a charter member of a Ruskinian group, The Society for the Advancement of Truth in Art. Like his colleagues in that group, which published a prosletyzing journal called *The New Path* in 1863, King believed Nature to be "a veil drawn before man's eyes, gross enough to render bearable the intense light shining from the godhead."[30] He was one of the most vociferous advocates of Ruskin's ideas in America, and O'Sullivan was by no means the first photographer with whom King had worked, or indeed the last. It may seem somewhat unbelievable that the same man who requested O'Sullivan's Fortieth Parallel Survey series should also have encouraged the painter Albert Bierstadt to join him on a brief expedition to the Sierra Nevadas, or that it was "at the sug-

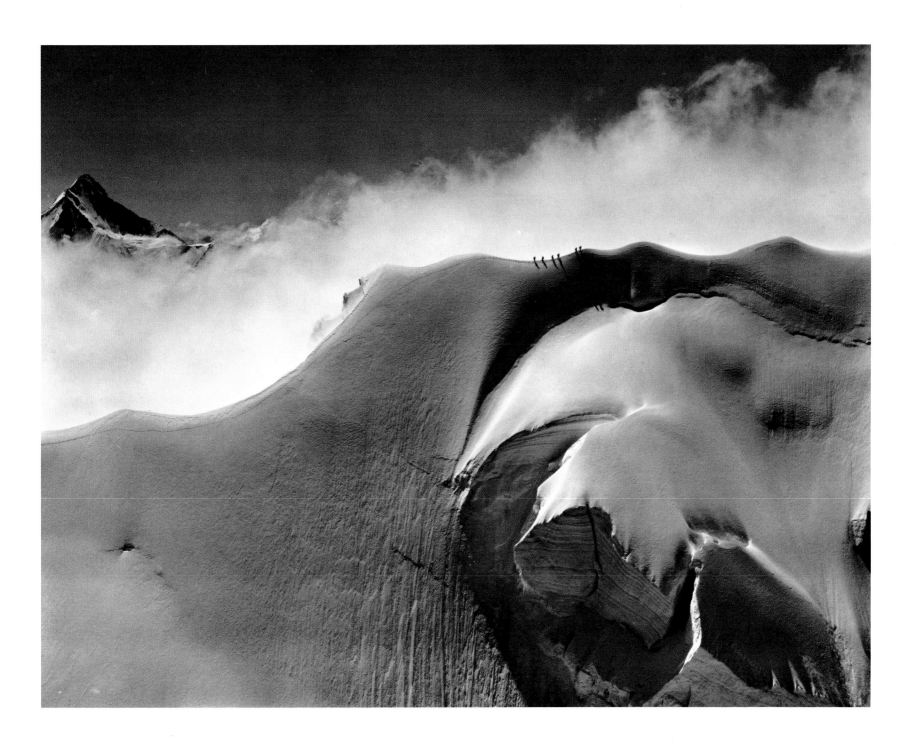

16. Bradford Washburn, *After the Storm*, 1960.

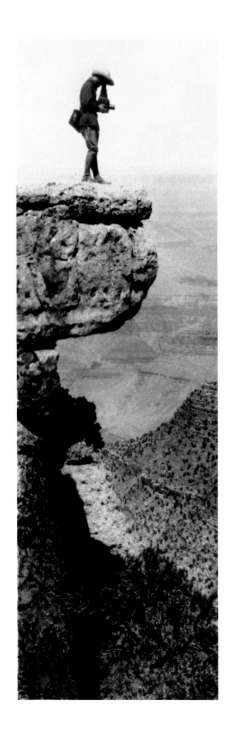

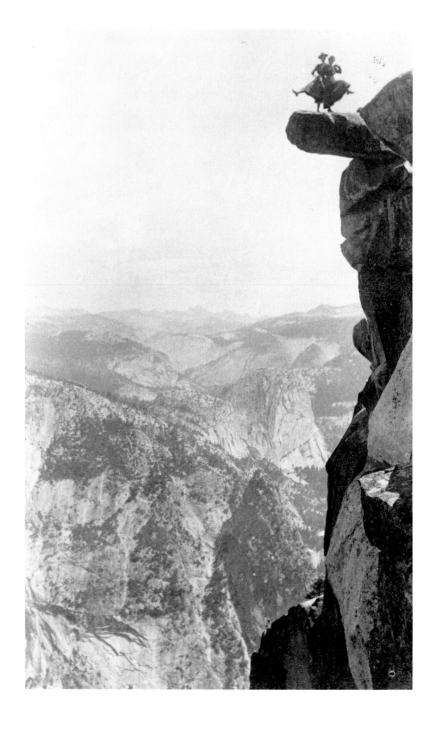

17. Fannie Coburn, *Alvin Langdon Coburn Photographing at the Grand Canyon*, 1911.

18. George Fiske, *Dancing Girls at Glacier Point, Yosemite*, between 1895 and 1905.

gestion of Mr. Clarence King,"[31] that Eadweard Muybridge was persuaded to photograph the glacier channels at Lake Tenaya. But the fact is that King had already worked closely with the photographer Carleton E. Watkins, whose painterly eye and strong sense of traditional landscape composition may have developed directly from his association with King.

As for Muybridge, he was so driven to outdo Watkins in pictorial values that he sought out Albert Bierstadt for guidance. In 1873, upon Muybridge's completion of "a series of Yosemite and other points of interest, which will attract attention in any gallery in the world,"[32] a San Francisco paper reported:

The artist has devoted several months to the work of getting the negatives, sparing no pains to get views from points calculated to produce the best pictures. . . . The view of Temple Peak presents an effect far beyond what had been thought possible in photography. This should be taken as the subject for a great painting, and probably will be by Mr. Bierstadt, who made several suggestions to Mr. Muybridge, while in the valley, and who is, in fact, a patron and adviser.[33]

Clarence King, however, would not have been pleased by this relationship between Albert Bierstadt and Eadweard Muybridge, despite his friendship with both. Bierstadt had notoriously exaggerated Nature, therefore falsifying God's truths, in his gradiloquent paintings of the Rocky Mountains. Watkins's more austere landscapes were preferable to Muybridge's additions of cloud effects, for example, through the use of a second negative.

King was a connoisseur, an art historian and art theorist, a man with definite artistic pretensions. It has been assumed that his only influence on Timothy O'Sullivan was in his role as scientist. The truth lies elsewhere: "King's biographers speak of his discoursing on art and literature

around the evening campfire during the Fortieth Parallel Survey."[34]

O'Sullivan is the subject of much controversy along these lines. Joel Snyder would have him partaking of the picturesque aesthetic, with a leaning toward the terrors of the sublime (see Snyder's *American Frontiers*).[35] Weston Naef, on the other hand, states firmly that O'Sullivan's views "are among the least picturesque of all western landscape photographs."[36] "This is partially explained by his relative isolation from a critical milieu based on the esthetics of painting and on his financial dependence on meeting the needs of government surveys rather than those of a marketplace where photographers were in competition with painters."[37] Was O'Sullivan merely serving an indifferent God of Fact—the more prosaic persona of "Truth"? Or was there a different God residing in the bleak deserts and overpowering canyons he recorded? Joel Snyder's analysis of O'Sullivan speaks of an Old Testament deity whose wrath was demonstrated by the evidence of catastrophe. Yet the wilderness, an entity contrasted to the civilized farmer's clearing, had retained a significance as "the environment in which to find and draw close to God."[38]

As Roderick Nash eloquently informs us, Americans came to regard the wilderness of their enormous inner continent in a variety of ways. The presence of indigenous populations being ignored, wilderness was long considered a frightful vacuity harboring dangers from beasts and the unknown. As the pioneers conquered the mountains and the forests, forced to traverse the awesome deserts to do so, the wilderness was viewed as "a testing ground where a chosen people were purged, humbled and made ready for the land of promise."[39] The land of promise was that new Canaan—California. But the smaller wildnesses of nearby forests, gorges, caves, leaf-strewn glades, or ungrazed pastures were also re-

36 vered as places of retreat from ever-encroaching, corrupting civilization. In fact, the beginnings of appreciation for the pleasures of the pathless woods were to be found primarily among "writers, artists, scientists, vacationers, gentlemen—people, in short, who did not face wilderness from the pioneer's perspective."[40]

Wilderness was direct contact with a Nature that by then had acquired synonymity with Truth, Beauty, God, and Freedom. Yet there was something else in wilderness which related neither to the fierceness of Old Testament deities nor to New Testament sweetness and light. It was epitomized in the words of Walt Whitman who, in 1876, retreating to an undeveloped wood near Timber Creek, New Jersey, to restore himself to health, characterized the experience of wilderness as "the chance to return to the 'naked source-

life of us all—to the breast of the great silent savage all-acceptive Mother.' "[41]

Since we bring to photographic images who we are, what we know, and all of our unconscious conditioning, it is unlikely that many nineteenth-century photographers were attempting to portray God as "Mother"; nor were their audiences projecting such symbolism into their pictures. In a predominately Protestant nation, lacking the worship of, say, the Virgin Mary, "God" was either male or an abstraction of generative power. Only the brash, unconsideringly honest Whitman could have ventured to evoke the name by which so many Americans identify the nonhuman world: Mother Nature, an anthropomorphism observed in other cultures as ranging in temperament from Lilith and Demeter to Kali—goddessess of the earth, generation, decay, and regeneration.

19. Joe Deal, *Albuquerque*, 1975.

3 Landscape as Fact

When the steam locomotive came chuffing and shrieking into the American consciousness, its clamor disturbed not only the pastoral idealist savoring the quiet of his garden, but another figure characteristic of transcendental iconography. This was the person (or persons), viewed from behind, totally engrossed in contemplating a sunrise, a sunset, or a mist rising from a peaceful harbor. In the paintings of Caspar David Friedrich, for example, these static, faceless individuals, posed in prayerful rapture or absolute absorption, are understood to be "both literally and figuratively on the brink of some elemental and mystical experience in nature."[1]

These mysterious figures were the embodiment of Ralph Waldo Emerson's "Transparent Eye-Ball"; they were humans overwhelmed by the majesty of the created world, surrendering their individuality to the infinity of a God-given universe. But Emerson was not so removed from

the facts of life that he did not recognize the power of man-made technologies.

I hear the whistle of the locomotive in the woods. Wherever that music comes it has its sequel. It is the voice of the civility [i.e., urban civilization] of the Nineteenth Century saying "Here I am." It is interrogative: it is prophetic: and this Cassandra is believed: "Whew! Whew! Whew! How is real estate here in the swamp and the wilderness? . . . Whew! Whew! I will plant a dozen houses on this pasture next moon and a village anon. . . .[2]

Shaken out of his transcendental reveries of a quasi-religious fancy, the pastoral idealist and eulogizer of wilderness was brought back to the world of fact. In that world, unquiet and chaotic, the railroad was destined to transform the wilderness as well as the garden, bringing enterprise and exploitation into both versions of primeval

Eden. The transparent eyeball could no longer dissolve into unity with a beneficent Nature; it was forced to look at railroad cuts and mining towns, starving Indians and stripped woodlands. Scouting the routes ahead into this new world of hard material fact were the photographers, who no longer concerned themselves with the purity of untouched Nature of sublimity. They were assumed to be securing documents of utility with strictly material benefits.

Timothy O'Sullivan's photograph *Soda Lake* (plate 20) was taken on a geological survey for a government as rapacious for information as any capitalist entrepreneur, in fact, in the service of the mining, ranching, and railroad interests. Two of O'Sullivan's explorers stand transfixed on the right side of his panorama. They are staring off, presumably in wonder, at the immensity of the Carson Desert and its inhospitable waters. On the left of the panorama, which is not as often reproduced as the familiar right side, another two figures stand, guns at the ready, possibly conversing about the view; one figure, at least, is in profile facing the other. Are they hunting? Fearful of Indians?

The two halves of the picture are startling in their differences. One beckons us to contemplate vast unknowns; the other brings us back sharply to the problems of survival in a wasteland. The right side of O'Sullivan's peculiar image epitomizes an intensely passive receptivity which, in a Friedrich painting, would conceivably become "the vehicle of an apprehension of the fundamental beneficence of the natural world."[3] The apparent timelessness of the right side of the photograph is totally contradicted by the left side, where the two men have intruded upon the scene by carrying along products of their technology—in this case, mid-century rifles. They are about to act, or at least ready to act. In a moment, a shot will ring out and a jack-rabbit will fall. Even though one of the men on the right holds a rifle

by its barrel end, he seems removed from any intervention in the scene spread before him.

All the aforegoing can be construed as art historical interpretation. Whatever else it might be, it is nothing more than interpretation. We can never know what O'Sullivan's intention was, nor would knowing his intention help us to experience or understand the immediately present artifact called *Soda Lake*. Various scenarios could include the possibility that O'Sullivan simply directed his fellow explorers to stand or sit at the places he selected for the sake of indicating the enormous scale of the lake. Even so, the distance across the lake, rather than its width, remains difficult to ascertain. The light-sensitive wet collodion emulsion was relatively slow. Therefore we are prevented from seeing if there were any fleeting waves or shimmering currents on the surface of the lake. *Soda Lake* appears as a luminous, blank mirror. The sky, too, is so suspiciously empty of all clouds, or even differentiation in tonality, that we bring to bear the knowledge that O'Sullivan frequently masked out his skies. The wet collodion was unresponsive to blues and other colors. *Soda Lake*, at best, is a partial "fact" of a historical moment. It is a landscape of symbols which we interpret according to our own contexts.

As Henri Pirenne observed, historical facts can only appear in a context of interpretation. Narration can only proceed with interpretation; interpretation rests upon theory. A photograph is as much an act of interpretation as it is an artifact.

Since they lack three-dimensionality, color, and motion, black and white photographs can never be truly realistic; hence to strive for superficial realism is a waste of time. In photographs, reality is expressed through symbols: projection stands for space, gray shades represent colors, blur signifies movement, halation expresses the radiation of direct light. They are abstractions in the same sense that speech and writing are, in

which specific sounds, letters, and words symbolize specific concepts.[4]

In that paragraph, Andreas Feininger resolutely rejected all pretense that photography involves, or has the capacity to transmit, objective "facts." Yet there is an implication which Feininger's straightforward statement does not address. Simply put, even if photography *could* transmit objective "facts," would these facts not require interpretation by the spectator? We are beginning to recognize the limitations of those critical approaches which have attempted to clarify and define exactly *how* a photograph "means." We cannot consult a thesaurus of photographic meanings in the way we consult an unabridged dictionary. Words themselves depend upon context—a sentence, a paragraph, use by a specific writer at a specific time in history—for their meanings. Meaning depends on a variety of historical interrelationships. "The understanding of photographs is . . . accomplished through narrative, as bits of optical data are interpreted and placed within a narrative context according to the cues of extrinsic information."[5]

In examining a landscape photograph as a historical "fact," we are forced to consult its extrinsic context, a context transmitted to us through words: *who was taking it* (O'Sullivan, a photographer with a considerable oeuvre and reasonably well-documented habits of picture-making); *when it was taken and by what process* (1867, using the wet collodion process on a glass negative); *for what purpose it was taken* (to provide a government agency with knowledge that would lead to the opening-up of the American West to railroads, entrepreneurs, and urban development); *where it was taken* (in the Carson Desert, Nevada, a wasteland where pure water to develop pictures was hard to find); and *what it is* (a panoramic view of an alkaline lake in that desert, with three standing figures carrying rifles, one

seated on brush-covered, hilly ground, etc.). All of this knowledge—or perhaps it would be better to call it "information"—still leaves out a most important member of the transaction: *who is looking at the picture*, under what circumstances, at what moment in history, for what purpose, and so forth. The entire intellectual, ideological apparatus of each individual—socioeconomic background, political ideologies, religion—enters into the transactional search for "meaning."

As Alexander von Humboldt observed in his *Cosmos* (1849):

It may be a rash attempt to endeavor to separate into its different elements, the magic power exercised upon our minds by the physical world, since the character of the landscape, and of every imposing scene in nature, depends so materially upon the mutual relation of the ideas and sentiments simultaneously excited in the mind of the observer.[6]

The subtleties of this Kantian psychology of perception escaped many nineteenth-century advocates of the camera's verisimilitude to nature. It was as if they believed the machine was capable of producing an absolutely perfect isomorphic replication of the landscape. Reading publishers' advertisements for nineteenth-century and early-twentieth-century photographic books, we usually find two proclamations: first, of course, that the advertised book is the most magnificent ever produced; and second, that "the publishers have their reward in the assurance that the scenes are depicted with unerring fidelity to nature as she really is."[7] One such publisher even went so far as to castigate Turner's paintings, for providing "only what he sees, and nature is so perfect in herself as to defy even the powers of a Turner."[8]

This last publisher saw no contradiction between claiming that the camera would present "nature as she really is" and an admission on the

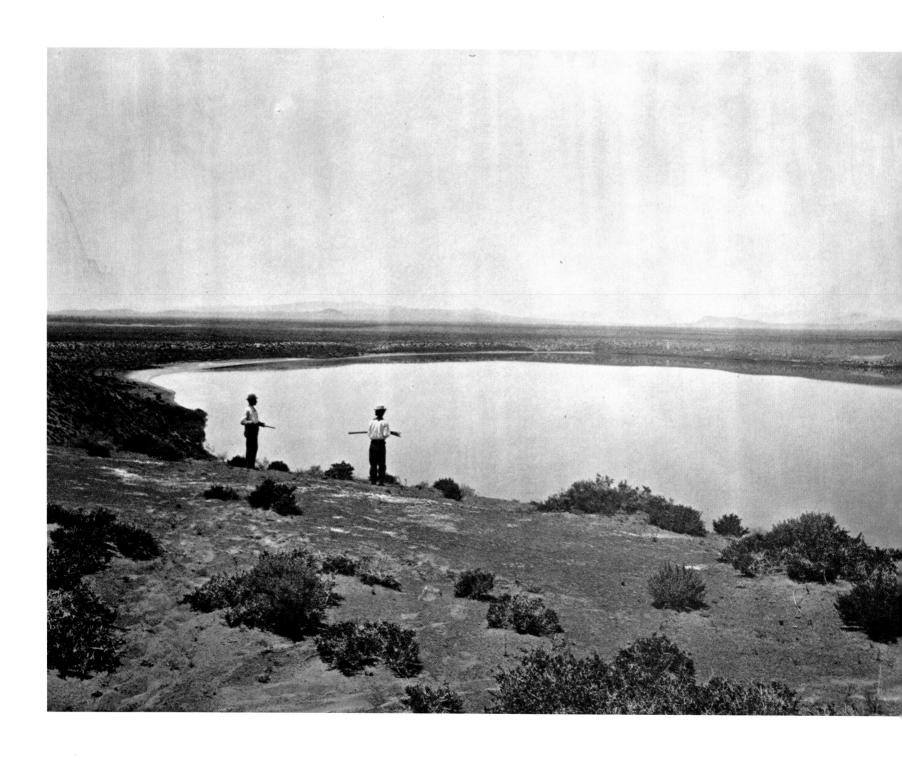

20. Timothy O'Sullivan, *Soda Lake, Carson Desert, near Ragtown, Nevada,* 1867 (right and left).

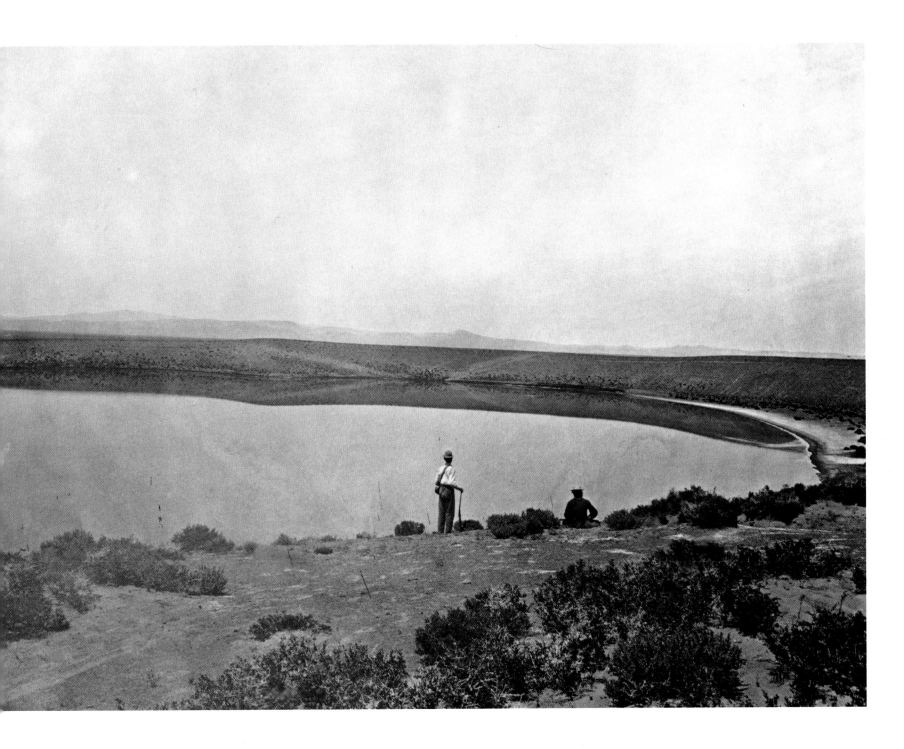

21. Robert Adams, *Newly Occupied Tract Houses, Colorado Springs,* 1974.

very next page that changes in light and atmosphere make a view seem different from moment to moment. If we push these contradictions far enough, we are left with the bewildering notion that the camera somehow extracts what amounts to a Platonic ideal form behind the shifting variability of Nature. The publisher even claimed that the camera never makes a mistake, that it presents scenes from nature exactly as they are, without the fallability of an artist's brush.

This may seem to be beating a dead horse, but the continuing confusion about how a photograph transmits meaning relates directly to recent critical argument over Robert Adams and his strangely "empty" pictures in his book, *Denver* (plate 21). Leo Rubenfien, for example, challenges the purported "transparency" of these images, agreeing with Susan Sontag that the notion of a purely transparent art free of any residue of the artist's interfering personality is a fantasy of the twentieth century. Rubenfien argues: "Adams' work fails to understand that a picture is responsible for its own meaning, that it must create that meaning with rhetorical devices, and should ultimately be much larger than the flux of detail that the world offers it for material."[9]

Exactly what Rubenfien may be advocating here is not easy to discern, at least not in the specifics which he would expect Adams to incorporate in his work. Philosophers and social psychologists from the time of Kant have argued that no communicating artifact—in this case, a picture—can be responsible for its own meaning. "Meaning" is ascribed to pictures, as to words, by idiosyncratic individuals out of their own vastly differing socioeconomic, political, and religious contexts.

Joe Deal (plate 19), one of the group of New Topographers which included Robert Adams and Lewis Baltz, provides another insight into the photographer's longing to let the camera do the talking:

One of the things I've often thought I aspire to be is a disembodied eye. That of course is a delusion. But invisibility is an important quality of how my own prejudices enter into the work. Transparent might be a better word. My presence is always there, but not in the sense that it is calling attention to itself or proclaiming its importance in interpreting for the viewer what was before the camera.[10]

Rubenfien may have been asking Robert Adams to make his presence felt in the photograph to interpret for the viewer what was before the camera, in other words, to present a clearly readable point of view which embodies an opinion.

It would seem that Ralph Waldo Emerson's "Transparent Eye-Ball" wanted transforming into a machine which would not necessarily record the presence of God, but the absolute materiality of the physical world, or what some of us think of as undisputed fact. The assumption is that the viewer of a picture produced by such a machine would be drawn unavoidably to certain conclusions about the facts so presented. In that sense, the vaunted mechanical exactitude of the camera leads to some unexpected generalizations. An 1840s Cincinnati newspaper proclaimed about the daguerreotype: "Its perfection is unapproachable by human hand and its truth raises it above all language, painting or poetry. It is the first universal language addressing itself to all who possess vision and its character alike understood in the courts of civilization and the hut of the savage."[11] Truth equals truth to Nature; photography becomes a "universal language" because it is truthful to Nature. But what Nature is—in the sense of the phenomenological world outside our own bodies—is *not* understood in the same way in the courts of civilization as in the hut of the savage. There has been some question about whether the American Indians understood the first photographs, and the belief of so-called savages that the camera steals your soul has been

widely recorded. There may be no logical connection between the idea of camera verisimilitude to Nature (even if this were possible, which it is not) and the idea of a *universal* language.

Even if we could transform Ralph Waldo Emerson's transparent eyeball into the perfect machine for recording Nature "as she is," we would encounter the problems raised by Ralph Waldo's distant cousin, Peter Henry Emerson. He is usually mentioned in connection with photography as art rather than photography as fact, yet his notions about differential focus—which led inevitably to diffused and blurred Pictorialism by the end of the century—were based on what he believed was the way the human eye actually sees Nature: "The principle object in the picture must be fairly sharp, *just as sharp as the eye sees it and no sharper*, but everything else, and all other planes of the picture must be subdued, slightly out of focus, not to the extent of producing *destruction of structure*, or fuzziness, but sufficient to keep them back and in place."[12]

The difficulty here is that while we may look at Nature in this way—that is, with a lessening of detail in the corners of our eyes and full focus straight ahead—we do not, *cannot*, look at photographs this way. Our eyes wander all over a photograph. We do not stand stock still with our eyes fixed on one area. We examine the corners of photographs with as much interest as the center. Furthermore, since the photographic print is a two-dimensional object, essentially flat, we are constantly enduring the stress of pretending that a display of light and shade is actually three-dimensional, spatially cutting in and out of our experience of the flat piece of paper.

Even Peter Henry Emerson came to recognize that there were "two truths to Nature—the perspective or mathematical truth and the psychological or visual truth."[13] Even as Emerson attempted to establish a mode of mimicking,

rather than recording, physiological responses to Nature, he observed:

Nature does not jump into the camera, focus itself, expose itself, develop itself, and print itself. . . . When an artist uses photography to interpret nature, his work will always have individuality, and the strength of the individuality will, of course, vary in proportion to his capacity . . . the point is, *what you have to say and how you say it.*[14]

Peter Henry Emerson also stated that a photograph is an index to the photographer's mind, that it is a type of confession on paper.

What shall we do, then, with the millions of photographs we accept as "fact"? Take, for example, two typical photographs by Andrew Joseph Russell, appointed as the official photographer for the Union Pacific Railroad's Western Division in 1868 (plates 22, 23). Russell is considered to be one of our nation's finest photographers, presumably because his pictures rely on edge-to-edge sharpness, factual (meaning "inartistic") subject matter, and a professional ability to use all the available means of photography—including chiaroscuro and contrast—to reveal the important features of a view. *Malloy's Cut* (1867), taken near Sherman, Wyoming, presents us with a solitary man standing in a posture often reserved for conquerors or explorers like Balboa, his stance revealing self-confidence, his costume probably that of a railroad engineer rather than a simple laborer.

The dark diagonal shapes of the land, cut through to permit the passage of the clumsy railroad ties, which resemble jagged teeth, thrust into an empty distance into which the metal tracks are inexplicably curving. Their curvature is inexplicable because we cannot tell what geographical feature has prevented them from shooting straight off into the empty distance. The man is standing in the optical middle ground and near

the exact center of the picture. There are no clouds tricked in afterward à la Muybridge; no, they would sentimentalize this stark portrayal of man's conquest of the land by technology. The violently receding diagonals of the track pierce the middle distance with great energy and force. The details of the rock textures on the right indicate how obdurate Nature can be, and how much physical labor must have been involved to displace her.

The railroad picture *Citadel Rock, Green River* (1867/68) presents us with the facts of "temporary and permanent" bridge construction as the train moves into more dramatic scenery. Here the compositional elements of the picture are more complex: many rhythmic elements beat back toward the towering butte in the distance; the numerous triangles of tracks and the pyramidal shapes of the construction blocks reverberate against the pyramids of the butte's underpinnings. But what a stroke of genius to take the picture in this way, with the water tower and the train dramatically off to one side, while the butte serves as the visual linchpin to keep the picture from falling away on the right! The railroad workers have been told to stand still; most of them are facing the camera, perhaps wanting to be part of the record of this westering adventure.

The more we look at *Citadel Rock*, however, the more difficult it becomes to keep our attention on the factual details of the railroad construction. The butte, that linchpin, keeps pulling us away toward its solitary grandeur, toward an uneasy tension between a historical moment—the train stopping, the men posing, the smoke billowing—and a phenomenon (the butte and its surroundings) which our education and our conditioning have taught us to revere as an emblem of slow time. Russell may have had only the desire, and the assignment, to take an interesting picture for the sake of the folks back East, but the fact that he was a painter before he was a photographer easily leads to the conjecture that he was both interested, and skilled, in symbolism.

If Russell's railroad photographs reveal his training as a painter, we may feel that the purity of his record-making has been spoiled for us. Yet we have only our own conditioning to blame. We are the products of a scientific age which, notwithstanding Heisenberg's principle of uncertainty,[15] is still spellbound by the idea of objectivity. Despite the obvious facts that when a photographer seeks a vantage point he must select out of hundreds of possible views of a subject the few that are most appropriate for still photography and the available technology for picture-making, and that out of these hundreds he must select even fewer which represent an understanding of what is significant or relevant or has the potential to make a communicable visual statement, and furthermore he must make that selection on the basis of education, biases, sometimes even physical size, we still dream, like Joe Deal, of being able to capture facts (more significantly, *truths*) without the intervention of a human agency of any kind, without interpretation, without opinion. In our search for irreducible realities, which we had hoped photography would help us demonstrate, we exhibit a type of human desperation in the face of both flux and subjectivity.

Sir Herbert Read once conjectured that the entire enterprise of picture-making began, not so much out of an attraction to primitive magic, but out of the human need to stop flux long enough to be able to understand and study the dynamics of process. Ceaselessly in flux, Nature has never quite capitulated to the making of landscape pictures.

When the stereograph became popular in the 1850s, it was hailed as the truest aid to the enjoyment of visual facts. The two halves of the picture seemed to leap into three-dimensionality,

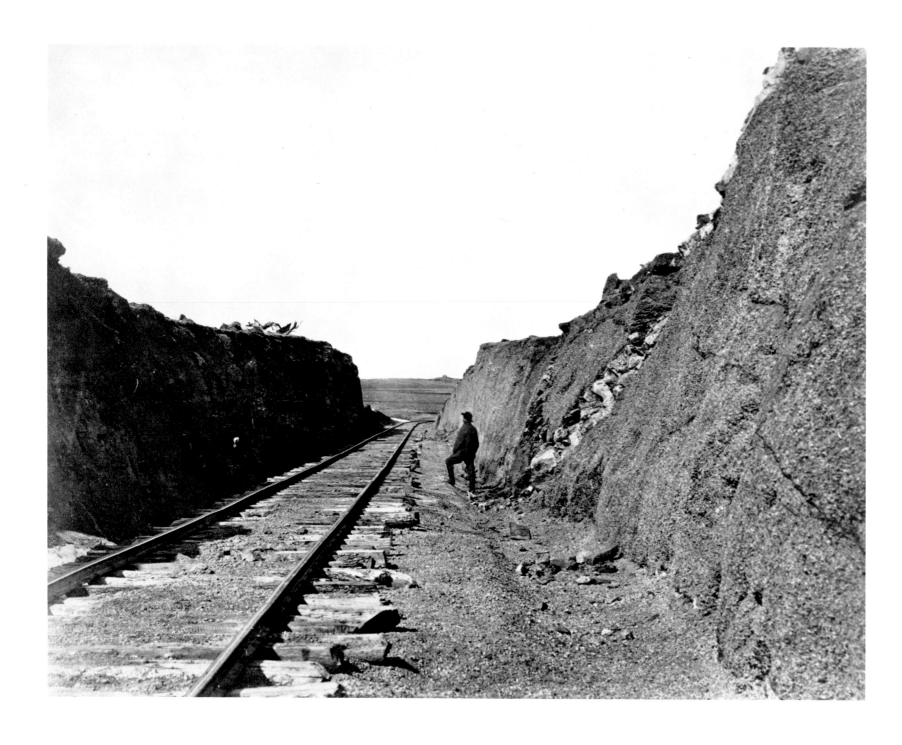

22. A. J. Russell, *Malloy's Cut, near Sherman, Wyoming,* 1867/68.

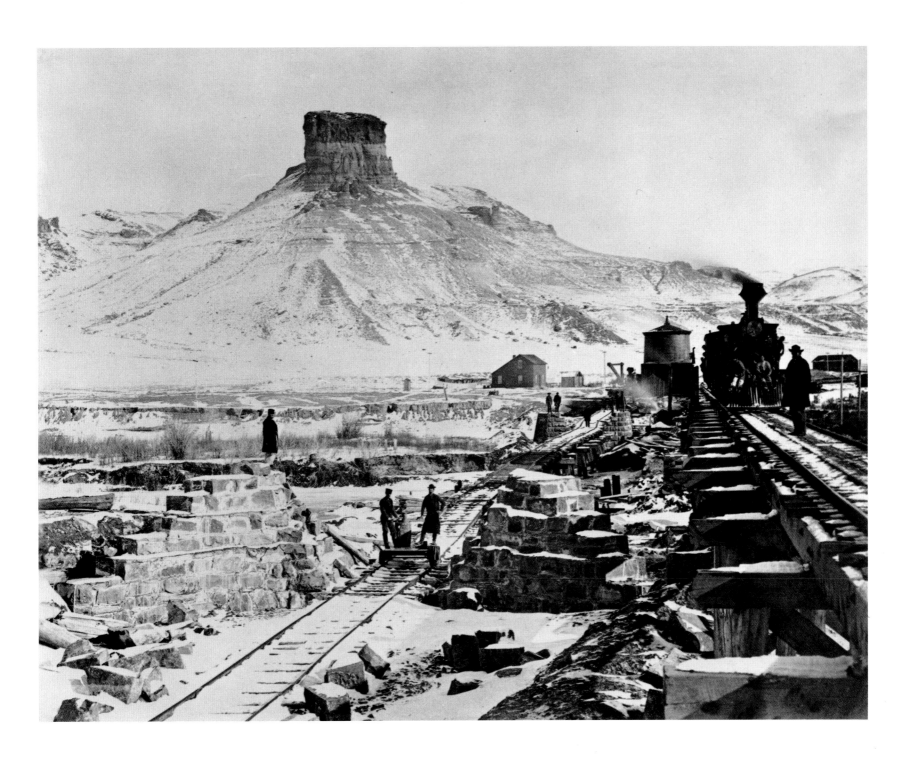

23. A. J. Russell, [Railroad Construction with] *Citadel Rock, Green River, Wyoming,*
1867/68.

even if all the planes of that dimensionality were most curiously parallel to the frontal picture plane. Landscapes of every sort and variety, scenes of exotic locales like the Nile or Jerusalem, the East as well as the West, were captured by stereoscopic cameras and distributed cheaply in paper prints mounted on cardboard. Artistic composition was not demanded, so long as the subject was satisfactorily three-dimensional. Yet even cold facts induce their own peculiar species of difficulty, and simple-minded recording soon proved inadequate to the problems of transmitting intelligible visual information. In the case of the Kilburn Brothers' stereographs of the White Mountains of New Hampshire, their early work (plate 24) produced landscapes in which critical opinion observed an interchangeability between views of Mount Webster and those of Mount Cannon, and the rapids on various rivers resembled each other to an astonishing degree.

The views that replaced this first undistinguished Kilburn series were much more concerned with showing an individualistic quality for each scene depicted. . . . In some cases, this was through the recognition of the distinctive shapes or profiles of the more dramatic mountains and landmarks as they might be viewed from the most popular vantage points. Kilburn also learned how to use popular pictorial conventions that could give each view its own identifiable appearance, if the subject did not have any unusual topographic characteristics.[16]

The popular pictorial conventions included the addition of a figure, a boat, or a cottage— anything that might make the scene seem picturesque. The commercial value, of course, was that "the greater the difference between each view, the more likely that a vacationer would purchase more than one."[17] Vacationers sojourning in the White Mountains wanted mementos of their visit, something to reassure them of its reality and later to revive their memory of places sometimes more pictured in fancy than experienced in fact. It was hardly scientific objectivity they purchased; it was a map, a symbolic transmutation, the essence of a swiftly passing day in the mountains. Essences, however, are not "facts"; they are ideal forms suited for both memory and picture-making.

As for the stereographic photographers themselves, they were encouraged at every turn to seek the picturesque solution to the making of saleable items.

The foreground being one of the main points in a picture, and generally required to be bold and effective, can, if not naturally so, be made so in a great measure by a little labor in the way of rolling up an old log or stump in an effective position, or placing a bush or clump of large-leaved weeds where they will be of service in making a proper balance or contrast as may be needed.[18]

The nineteenth century might forgive such minor trespasses in the name of more effective picture-making, even pardoning Eadweard Muybridge when he cut down trees to secure a better view of some distant vista. The twentieth century, however, having become completely seduced by the ideas of objectivity and camera fidelity, could not forgive Arthur Rothstein when he moved a cow's skull into the foreground of a picture of the Dust Bowl landscape. Since all pictures are judged within a nexus of expectations, both culturally conditioned and resulting from the verbal context in which most informational pictures exist, a photograph that claims to be a representation of some truth cannot be allowed to tamper with even the smallest detail. Although sophisticated audiences today recognize the distortions inherent in the use of different camera lenses and the stylistic conventions of pictures produced by very wide-angle or zoom lenses, we still seem to be expecting facts.

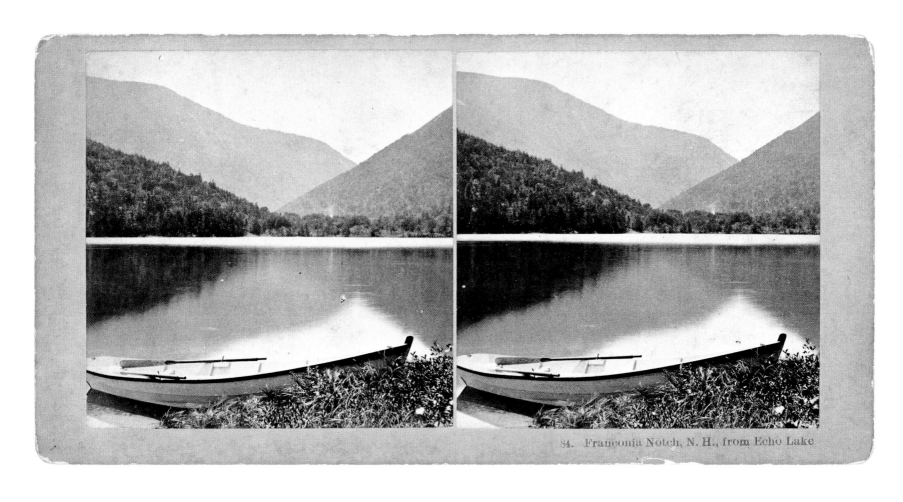

84. Franconia Notch, N. H., from Echo Lake

24. Kilburn Bros., *Franconia Notch, New Hampshire, from Echo Lake* (stereograph),
ca. 1876.

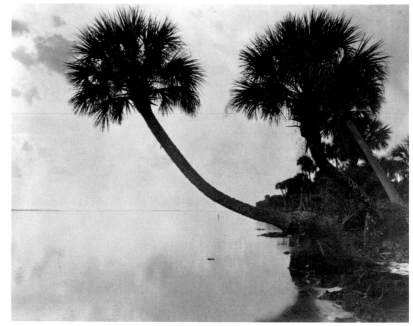

25. William Henry Jackson, [Beach with Royal Palm]
Lake George, Florida, ca. 1900.

26. William Henry Jackson, [Curving Palms]
Indian River, Florida, ca. 1900.

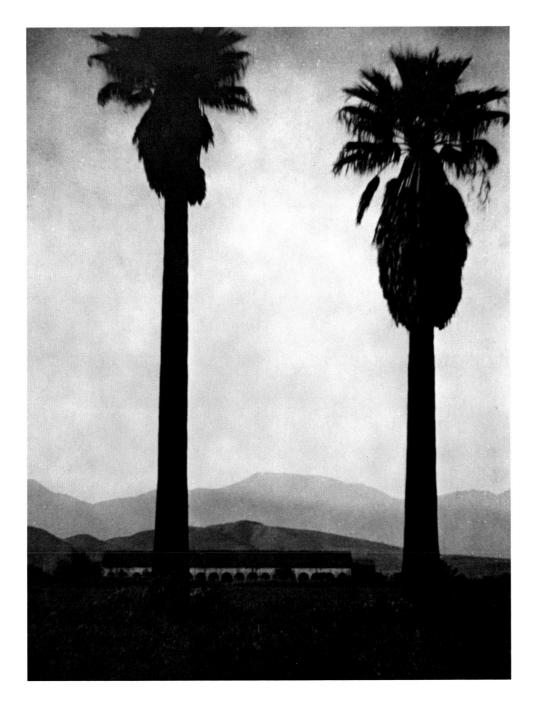

Surprisingly, we have certain pictorial conventions in mind even when we are sure that a photograph represents a landscape of fact. Three photographs containing palm trees as their central motif reveal some of these conventions (plates 25, 26, and 27). The first image, of a bright, daylit, almost empty beach with a single distant palm tree seems more straightforward than the other two, more informative than arty. This response seems to derive from our implicitly accepted conventional view that facts exist in a neutral context and that they are not supposed to be confused with "art." The second image, of two palms bending decoratively across a blank sky, in no context, might elicit questions for information such as, "What kind of palms are these?" or "Do all palms curve in this graceful way?" The third photograph, of two upright palms silhouetted handsomely against distant hills and the dark sky of twilight, says "art." It says "composition." It should, however, also say "This is the way palms of this type look at sunset when you face the mountains in lower California (if you discovered that was where the picture was taken)." The more sentimental of us, perhaps, will be prone to accept this third image as the fact of a remembered mood. Only those of us who are addicted to an f64 kind of sharpness and detail will reject the third image as non-fact.

While there may be no surprise in discovering that the first image is by William Henry Jackson, one of the stalwart western explorer-photographers, and the third is by Alvin Langdon Coburn, an outstanding pictorialist loyal to decorative composition, we may be somewhat surprised to learn that the second image is also by William Henry Jackson. What may be an even greater surprise is that both photographers were also painters.

The pictorial conventions in landscapes of fact were most obviously those of sharpness and

27. Alvin Langdon Coburn, *Giant Palm Trees, California Mission*, 1911.

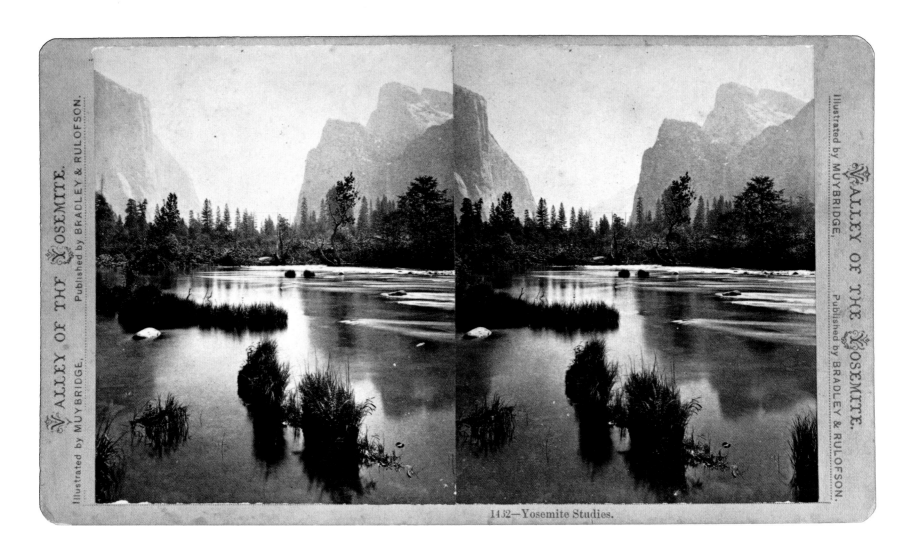

28. Eadweard Muybridge, *Yosemite Studies, No. 1462* (stereograph), ca. 1874.

detail, but they also included abundance of detail as a prerequisite. Information is quantifiable; photography itself has always been considered more informative than other graphic media because it can supply such a quantity of information. Fact is associated with scientific precision, which always implies specifics rather than generalities. Visually, scientific precision is identified with purity of vision. "Photographers today generally claim to be finding, recording, impartially observing, witnessing, exploring themselves—anything but making works of art."[19]

The argument about the impartiality, objectivity, and scientific purity of fact as opposed to the bias, subjectivity, and distortions of fancy came to a head long before John Szarkowski's *Mirrors and Windows* exhibition of 1980, which was abused by critics who found the separation of prints into the two categories—Mirrors, subjectivity; Windows, objectivity—arbitrary and unworkable, if not misleading. Long before, the Farm Security Administration (FSA) photographers of the 1930s were pushed to defend themselves against accusations of partiality toward their subjects. In defining their mission, which was to bring the plight of economically depressed Americans to the attention of the general public, they were forced to define themselves by a term more easily understood in the cinema of the time: documentary. While the issues of documentary photography properly belong to our chapter on propaganda, a brief discussion seems appropriate here, at least to the extent of distinguishing "document" from the concept of the "documentary." The two terms are not synonymous.

The visual document has been accepted by historians as an artifact to be studied in the context of verbal documentation. But a documentary photograph is not equivalent to what is generally considered to be a "factual" photograph. Dorothea Lange, one of the FSA group, argued that a documentary photograph carries "the full meaning of the episode or the circumstance or the situation . . . that can only be revealed by a quality the artist responds to."[20] Here we find full recognition of the role of the artist in interpreting facts. What those qualities are that Lange refers to is more difficult to verify; these have to do with how form per se influences our reception of content, and with certain psychological cues that we receive from subject matter in the context of texts. (See chapter 5, Landscape as Pure Form.) In any event, a documentary photograph is acknowledged to have an intentionally persuasive effect; the "document" is presumed to remain neutral as a transmitter of unadulterated fact.

"Fact," of course, is what government surveys were supposed to discover, and the various agencies involved in the nineteenth-century western expeditions could only hope that the facts would be persuasive to individuals who were considering the possible colonization or exploitation of the West. The swiftly multiplying railroads encouraged landscape photography for two purposes: the presentation of picturesque scenes was regarded as an inducement to colonizers to leave the bustling cities, and the collection of geologically accurate records served military and industrial expansion. Occasionally, the substance and style of these images coincided. Eadweard Muybridge and Timothy O'Sullivan alike produced stereographs intended for cheap distribution among people who could never have afforded their mammoth views. These stereographs demonstrate how artistic, how picturesque, these presumed transmitters of pure fact could be (plates 28, 29). The general public was still gasping over the subjects of these pictures, stunning Yosemite or bizarre Grand Canyon, without wondering how much their delight or their edification was manipulated by painterly effects. Today, *Arizona Highways*'s always brilliant reproductions of striking color photographs work that same magic.

29. Timothy O'Sullivan, *Grand Cañon of the Colorado* (stereograph), ca. 1871.

Ultimately, what determines the "fact" of a landscape photograph is the use to which it is put. If you are willing to set aside the aesthetic pleasure you receive from, say, a tour de force like Ansel Adams's *Moonrise, Hernandez* (1944), you can examine the picture for its content and it will yield up many "facts": the cemetery crowded against the farm buildings; the famous church, rather small in scale compared with the other edifices; the oasis cluster of trees indicating the presence of water; the monotony of the creosote bushes maximizing their survival by regular dispersal; the distant mountains bearing traces of snow. An astronomer might be able to tell you what time of year this was from the position of the moon. Of course, all of these facts would be modified by a knowledge of what filter the photographer used to achieve that solid velvet black of a sky, and what lens compressed the depth of field between the cemetery and the farm.

Marcel Duchamp once said that art is anything that is considered in an art context. The same could be said for fact: it is anything which is considered in a factual context, no matter what its original intention.

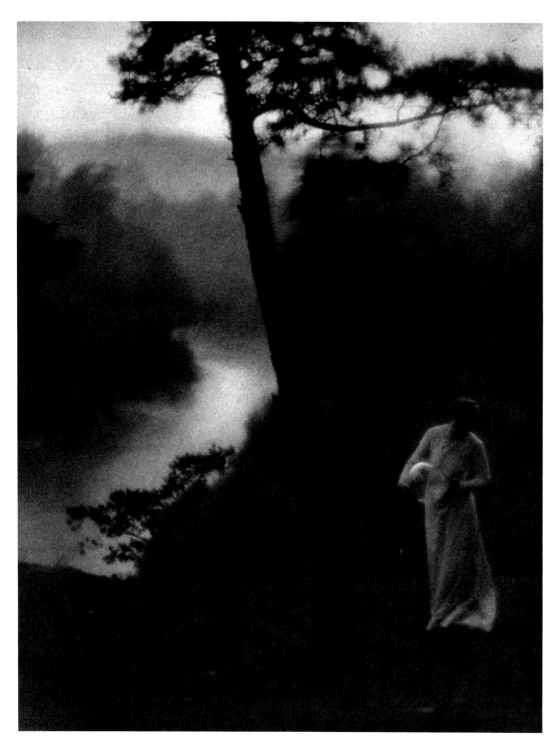

30. Clarence White, *Morning*, 1905.

4 Landscape as Symbol

I wish to be, not Nature, but parallel to Nature.
—Puvis de Chavannes

A landscape; but is it a landscape? A woman in white, holding a large transparent globe like an airy bubble, her face averted, stands to one side of a tilting pine tree on a promontory, below which we see the vague curving outline of a river, mist-shrouded vales, and massed, anonymous trees: *Morning* by Clarence White, 1905 (plate 30).

This is not a representation of hard "fact." This woman worships no idol, no visible god. We are in some mysteriously hushed world of reverie where nature's forms are the merest excuses for a mood of subdued contemplation, a distillation of gentle melancholy. It is a mood associated with the word *poetic*—more specifically, *lyrical*. We may bestir ourselves to ask, Of what, pray, is the bubble-globe a symbol? Or is this an allegory to which we have been given no clue? Is it a photographic equivalent of what the Germans liked to call *Gedankenmalerei*—"thought painting"? Whence comes this delicately etched mood, this off-centered white-clad woman poised as if to walk forward yet forever still?

Clarence White was one of the more gifted members of the group known as the pictorialists, who are usually stereotyped as earnest proselytizers for "photography as art." The arguments about this single issue raged so heatedly in the nineteenth century, hardly abating until our own time, that the pictorialists' other aims have been almost totally obscured. The primary criticism was that they seized on any new method or technology to demonstrate that photographic prints, like painting or the graphic arts, could contain evidence of the artist's handiwork, as if this alone were the guarantee of "art." Gum bichromate, bromoil, scratching on the negative, smudging—anything seemed to do as long as it announced: "I, the artist, am not a machine; the camera is merely my servant." Unlike the traditionalists, 59

whose criterion for excellence in photography was crisp detail, sharp focus, and the brilliantly glossy surface of silver prints, the pictorialists swore by platinum's velvety grayness, soft focus, and generalized forms.

The intellectual climate that encouraged pictorialist subject matter, technique, and form has remained largely unexamined until very recently. For the question to pose the pictorialists was not simply, "Is photography an art?" but, rather, "What kind of art is photography emulating at this point in history?" And another question would surely be, "Why are photographs by pictorialist landscapists so often likened to poetry?"

As we briefly mentioned earlier, pictorialism developed between the years 1880 to 1900, when both the French Barbizon painters and the impressionists were having their maximum impact on American attitudes toward the visual arts. It has been the general misconception that these styles of painting were responsible for the vagueness of photographic imagery during those decades, and afterward as well. Although the two movements were often identified, incorrectly, as having one influence, the Barbizon landscape and its homilies on peasant life, Corot's lyricism and poeticized stage scenery, and Jean-François Millet's sturdy farm folk were sharply different from Monet's color vibrations or the sensual immediacy of Renoir. Barbizon painting reveled in the quiet pleasures of Fontainebleau, with its shadowy glens, dappled oaks, and sun-specked deer, while the impressionists rejoiced in the bustle, noise, and glamour of Paris, the River Seine, and public parks. If anything of Barbizon painting came to influence pictorialist imagery, it was the presence of subjective nostalgia and conservative regret, with a touch of rural morality and idyllic remembrances of the farm life which the expanding cities were putting to rout. Barbizon painting was the perfect art for soothing bourgeois anxieties, perfect for an age in which, as Peter Bermingham noted, Nature was now written with a lower-case "*n.*"[1]

Much had changed since Ralph Waldo Emerson had warned, "You cannot freely admire a noble landscape if laborers are digging in the field hard by."[2] But, in fact, neither Barbizon democratizing nor impressionist cosmopolitanism could satisfy a group of artistic Americans who were seeking a more spiritual form of beauty. Harsh fact, stern science, and the ruthless competition of the marketplace were crushing the spirit and the life of emotions, and the reaction was inevitable.

What should be of most account for us all is not external fact, but the supra-sensuous world. "What we know is not interesting"; the really interesting things are those we can only divine—the veiled life of the soul, the crepuscular region of the sub-conscious, our "borderland" feelings, all that lies in the strange "neutral zone" between the frontiers of consciousness and unconsciousness. The mystery of life is what makes life worth living.[3]

This was written as an introduction to Maurice Maeterlinck's *Treasure of the Humble* (1895), but it could have appeared as easily as part of a symbolist manifesto by the third group of painters and poets who were to influence the pictorialists in America. Eagerly absorbed by intellectuals in cities like Boston, where the photographer F. Holland Day and his coterie found him an inspiration, Maeterlinck offered encouragement to escape the limitations of realistic photography. The symbolist credo was rejecting Emile Zola's notion that art is a corner of the universe viewed through a temperament. Mere subjectivism no longer sufficed. What was needed was a new art that would discover ways to objectify the inner feelings. The imagination had to be liberated. Emotions had to be expressed. The nuances espoused by the French symbolist poets had to find

form. Furthermore, the phenomenological world was discarded as a container of "truth." It was what lay beyond, and deep within the self, that revealed God. For photographers like F. Holland Day (who was also publishing the English Metaphysical poets), his protégé Alvin Langdon Coburn, and his colleague and friend Clarence White, the symbolist doctrine could have been stated in a single sentence: "We grope among shadows towards the unknown."[4]

The idea that there was something worth groping for was not new, nor was the "unknown" to be encountered entirely apart from theology. The roots lay in the romantic individuation of experience and the long search for correlations between the visible world and the inner emotions and psychological responses. Samuel Taylor Coleridge had observed in his *Anima Poetae,* "In looking at objects of Nature I seem to be rather seeking a symbolical language for something within me than observing anything new."[5] The development of the "art-for-art's-sake" movement was the sequel to Coleridge's search for a symbolical language for something within himself; art no longer had to provide "an interpretation of, or comment upon, the world of everyday experience."[6] Subjectivism alone could not suffice; the ideology antagonistic to "fact" in the everyday world was, and still is, Neo-platonic, Swedenborgian, spiritualistic, metaphoric, allegorical—in other words, symbolic.

An American Swedenborgian had been adopted by the French symbolist poets as one of their own: Edgar Allan Poe. Baudelaire and Mallarmé, in particular, found Poe's morbid frissons and gothic imagery exactly suited to their visions of the supernatural shivers present in every nuance of Nature. Like Poe, they too were Swedenborgians, and their *idéisme* was articulated by Baudelaire in his definition of Swedenborgian "correspondences": "[There are] the affinities which exist between spiritual states and

states in nature; those people who are aware of these correspondences become artists and their art is of value only in so far as it is capable of expressing these relationships."[7] Swedenborg's mysticism was further encapsulized by Baudelaire when he declared, "Natural things exist only a little; reality lies only in dreams."[8] For the followers of the eighteenth-century philosopher Emmanuel Swedenborg, the visible world was but a pale shadow of truth, which existed in a world just beyond misleading material appearances, something like a phantasmic twin sister viewed in a mirror, more perfect, everlasting, yet completely dematerialized.

Swedenborg's philosophy had directly influenced the American painter George Inness, whose landscapes, in turn, presented the pictorialist photographers with several methods by which Nature could be made to render up intimate tremors of the soul. A description of Inness's late symbolist works is easily applied to Clarence White's *Morning* (plate 30), Wilbur Porterfield's *September Morning* (plate 31), or Paul Caponigro's pictures in his Redding, Connecticut, series (plate 32):

The lack of dramatic emphasis within the scene and the self-immersion of the figures contribute to a mood of quietness; the gray-hued tonality and the all-enveloping mist endow the quietness with a strange remoteness. Not only does what we see in these late landscapes seem like the reflections, the spectral afterimages of another, more sharply etched landscape . . . but the strange remoteness is produced by something else, which is a bit harder to get at when we try to put our finger on it. And that is the sense of measured cadence; even more than that, it is as though this painted world operates through some slowed-down pace, through some frame of reference that is alien to ours.[9]

In Paul Caponigro's dualities of reflections, oddly stilled water, and delicate trees, we find a perfect

31. Wilbur Porterfield, *September Morning*, 1906.

32. Paul Caponigro, *Redding, Connecticut, Woods Series*, 1968.

33. Edward Steichen, *Moonlight—The Pond*, before 1906.

statement of what he calls "the landscape beyond the landscape." It is almost as if the trees reflected in the water are intimations of that other, parallel universe of which Swedenborg preached.

Because their images employed an all-pervading and subdued tonality, Wanda Corn has placed the pictorialist photographers within the American art movement she calls tonalism. It is a term of relatively recent adoption, but it correctly recognizes the correlation between the late paintings of Inness or the shimmering landscapes of Tryon and their photographic counterparts. As the turn-of-the-century critic Charles Caffin noted, these images—whether in painting or photograph—were dominated by one color, or tone, and related to each other in what the French termed an *enveloppe* of atmosphere, an "even, subtle luminosity," of specific effect: "looking at objects through a great gauze veil—the veil in nature being produced by sunlight diffused through the atmosphere which 'tones' in a uniform light all the objects seen."[10]

Photographers did, in fact, occasionally apply gauze directly over their camera lenses to harmonize and subdue all the elements of their pictures, giving them a suitable atmosphere suggesting delicate, vague, indecipherable moods. But pictorialists like Clarence White, Coburn, and Edward Steichen also relied upon uncorrected lenses, including a soft-focus protrait lens, to diffuse and dematerialize the landscape. The object was to create, by any means available, "a mood of dreaminess and detachment."[11] Many Pictorialists sought to shoot only at those times of day or under atmospheric conditions which they found especially "harmonizing:"

Because I found nature most beautiful in twilight and moonlight, all my efforts were directed toward finding a way of interpreting these moments. By taking a streetcar out to the end of the line and walking a short distance, I could find a few wood lots. These became my stamping grounds, especially during autumn, winter and early spring. They were particularly appealing on gray or misty days, or very late in the afternoon and at twilight. Under these conditions, the woods had moods and the moods aroused emotional reactions that I tried to render.[12]

Edward Steichen's reminiscences about his pictorialist days embody many of the aims of tonalism. He was a painter, of course, and continued to paint for some years after taking up photography. Living in Paris during the apogee of Maeterlinck's influence at the turn of the century, and exposed to the works of symbolist painters and poets there, Steichen was most inventive in his techniques, turning his landscapes into renderings of mood (plate 33). To the critic Sadakichi Hartmann, however, Steichen's early landscapes seemed more like sketches than finished pictures, and he decried that too much was left to the imagination of the spectator. That, of course, was precisely the goal of the pictorialists, the tonalists, and the symbolists: to stimulate the imagination. Although he missed that major point, Hartmann was not blind to Steichen's excellence, however: "To me Steichen is a poet of rare depth and significance, who expressed his dreams, as does Maeterlinck, by surface decoration, and with the simplest of images—for instance, a vague vista of some nocturnal landscape seen through various clusters of branches . . . can add something to our consciousness of life. His lines, blurred and indistinct as they generally are, are surprisingly eloquent and rhythmical."[13]

Three ideas emerge from this statement: that a photographer, using a machine, could create poetry like the dreams of Maeterlinck; that the methods both used were "surface decoration," in other words, decorative forms; and, finally, that the poetry's content—visual or verbal—was somehow vague and indistinct, but at the same time was presented with a rhetoric both "elo-

quent and rhythmical." These characteristics place Steichen squarely in the realm of symbolism.

Among the doctrines of symbolism as an art movement set down by Albert Aurier in 1891 was the primary requirement of "decorative form," since it was believed that decorative art, being free of naturalistic and representational illusionism, was "at once synthetic, symbolist, and ideative."[14] The decorative impulse of symbolism was supported by the study of Japanese and Chinese arts and their underlying philosophies. In America, the foremost proselytizers for these arts were Ernest Fenellosa and his assistant at the Boston Museum of Fine Art, Arthur Wesley Dow. The specific compositional devices of Oriental art, as taught by Dow, are evident in Clarence White's *Winter Landscape* as well as in his famous *Morning*. Alfred Stieglitz's incomparably decorative landscape with the Flat-Iron Building also exhibited the influence of *japonisme*, while Coburn's *The Dragon* flattened out the winding Ipswich River into mysterious floating shapes like those encountered in Chinese paintings.

All four of these photographs appeared in the first two years of publication of *Camera Work*, Alfred Stieglitz's paean to pictorialism, along with reproductions of landscape paintings by the tonalist D. W. Tryon and the allegorical and decorative Puvis de Chavannes. In the next two years—1906 and 1907—a number of European photographs in the Barbizon style were reproduced, but these were aesthetically outclassed by tonalist and symbolist works like Steichen's *The Big White Cloud*, his *Road into the Valley—Moonrise*, moody pagan figures in landscape settings by George Seeley, and decoratively *japoniste* landscapes by Joseph Keiley with titles like *A Garden of Dreams*. By 1909, *Camera Work*'s readers were also offered erotic allegorical nudes in landscapes by Anne W. Brigman, as well as a picture of a naked child being held against a

mammoth tree trunk by a gauzily clad mother, titled *Nature*, by the photographer Alice Boughton.

The first years of *Camera Work* ran the gamut of what is generally called "white symbolism." White symbolism involved misty landscapes; sensual but not pornographic nudes; mothers with children representing aspects of life, death, and rebirth; costumed maidens harking back to medieval pageants; and pastoral animals. Black symbolism, redolent of death and corruption, employed violent images of sex, torture, and satanic revels, all to be found abundantly in the paintings of Gustave Moreau, Xavier Mellery, Felicien Rops, and, most conspicuously, in those of Fernand Khnopff, Edward Munch, James Ensor, and Franz von Stuck. Despite his personal predilection for the grossly sensual and sadistic Sphinxes of Franz von Stuck and the ominous landscapes of Arnold Böcklin, Stieglitz never allowed *Camera Work* to venture far from the Puvis de Chavannes tradition of white symbolism, closely allied to and frequently indistinguishable from academic allegory.

Historically, Symbolist painters like Paul Gauguin, Maurice Denis, Jean Delville, and Fernand Khnopff, rejected pure landscape—divorcing themselves completely from the Barbizon School and impressionism—in favor of the imagery of Puvis de Chavannes, images which dealt with the psychology of human nature, mythology, and states of mind. They tended to include figures in their landscapes, often in allegorical contexts. Specifically endowed with universally recognized symbols (for example, a virgin would be denoted by a young maiden holding a pristine while lily), allegorical symbolism was more specific than the more mysterious women in Clarence White's photographs. One theorist attempted to define the differences between allegory and symbolism: "Allegory, like symbol, expresses the abstract by means of the concrete. Both devices

are based on analogy, and both contain an image.
. . . Symbolism involves an intuitive quest for the
ideas latent in a particular form."[15]

Symbolism's intuitive quests were to lead di-
rectly to abstraction and "pure form," but during
the decades when photographers were searching
for means to free themselves from obedience to
Nature, allegory, especially the inclusion of mel-
ancholy figures in a pale or diffuse landscape,
seemed the surest road to the rendering of non-
factual moods. Not pure allegory, since humanity
had moved beyond a reliance upon academic uses
of the Hellenic pantheon and Roman deities to
stand for Love, Honor, Beauty, Strength; this al-
legory used the human figure to evoke a mood
of contemplation on the part of the viewer through
a kinesthetic identification with pose and de-
meanor, repose and gesture. As one philosopher
described this process, we tend "to divide and
arrange time according to some kind of rhythm,
space by some kind of symmetrical outline. . . .
The world becomes akin to us through this power
to see in form the joy and sorrow of existence
that they hide."[16] The hypothesis is that we re-
member the activities of our own bodies as we
move through time and space and are impelled
to recollect these as we unconsciously imitate the
physical actions of others or the postures and
imagined gestures of trees and other landscape
phenomena. Thus, the languid figures so prev-
alent in, say, the semilandscapes of the pictori-
alist George Seeley do not really ask us to recall
ancient Greek mythology so much as they insin-
uate languidness into our own feelings.

As much as they search for methods of ex-
pressing emotions or vaguely experienced "ideas,"
symbolists have always longed for something
which has been characterized as the fourth di-
mension, beyond time and space. For example,
the contemporary photographer Wynn Bullock
rejects the *now* of time:

Seen in this way the meaning of a particular
tree is imprisoned in an attitude of mind that
tends to limit its reality to its surface appearances.
The five senses on a physical level can only react
by outside stimulation in the ever-recurring *now*.
They cannot bring back the past or respond to
the future reality of anything because three-
dimensionality is the function of the senses. So
reality to the physical senses always remains only
a tiny fraction of the reality of the tree.[17]

Semanticists also encourage a similar rejection
of the surface appearance in the *now*. Alfred Kor-
zybski spoke of any object like a tree defying per-
manence, as it is in reality Tree 1, Tree 2, Tree
3, Tree 4, denoting the passage of time and the
changing states of the material world. Bullock
relates this idea to the problem of expressing any-
thing in photography beyond the immediate *now*.
But he also believes that once the artist becomes
aware of the difference between seeing only the
three-dimensional *now* and events existing in time
and space, "only then does the mind search for
and find symbols to express this added dimen-
sion."[18] Linda Connor's mysterious landscape
(plate 34) also seems to be seeking a dimension
beyond the *now*, symbolically departing into
other-worldliness.

While the pictorialist symbolists created this
added dimension as a dream world, by dema-
terializing objects, diffusing their specificity with
gauzes, uncorrected lenses, or atmospheric mists,
the symbolists associated with surrealism pre-
sented images that were often hard as nails, con-
crete and detailed, photographed with sharp
contrast. A profoundly political movement in its
origins, surrealism was determined to achieve the
poet Rimbaud's ideal of the "systematic der-
angement of the senses."[19] By this derangement,
human freedom would be enhanced and the
imagination liberated from the dehumanizing
impact of rationalistic technology and conformist

34. Linda Connor, [Woods], 1979.

society. As Baudelaire had suggested that reality was only in dreams, then surrealism was "nothing less than the objectification of the very act of dreaming, its transformation into reality."[20]

André Breton, the founder of the surrealist movement and the writer of its manifesto published in 1924, categorically rejected the Swedenborgian notion of "correspondences," according to the natural world is merely a faint glimmer of a true, ideal world. Poetry, acting as synthesizer of dreams and the unconscious, now began to play the central role in solving human dilemmas. The imagination would reclaim its rights, not in the misty melancholia of fin-de-siècle symbolism, but in totally free artistic combinations: "Oneiric values have once and for all succeeded the others, and I demand that he who still refused, for instance, to *see* a horse galloping on a tomato should be looked on as a cretin. A tomato is also a child's balloon—surrealism, I repeat, having suppressed the word 'like.' "[21] Both the Freudianism on which it depended—a complete reliance on the unconscious—and the desired dialectical transcendence of polarities of good and evil, life and death, or mind and body, proved a difficult ideology for would-be surrealist landscape photographers. Given the propensity of the camera to capture at least some aspects of the phenomenological world on film, how could the dream be created? Even Breton acknowledged that "A landscape into which nothing earthly enters is beyond the reach of our imagination."[22] It could only be through the juxtaposition of real objects from the landscape and nature through the principle of collage that the surrealist landscape could be enacted.

The most familiar of American photographic symbolists, Jerry Uelsmann, has relied upon juxtaposition for images that have often been characterized as "surreal." His multiple images, created sometimes by total previsioning of the final image and sometimes by intuitive discovery in the darkroom, consist of "earthly" objects in oneiric (that is, dreamlike) combinations. While agreeing that his images deal with the real world, Uelsmann sees his haunting pictures as being involved "with a kind of reality that transcends surface reality. More than physical reality, it is emotional, irrational, intellectual, and psychological."[23]

Like the painter Magritte, Uelsmann often presents concrete phenomena juxtaposed without metaphor. In a famour Magritte image, an enormous green apple fills a room; yet it remains an apple. That essence is both its humor and its threat. In Uelsmann (plate 35), a house set between drought-parched earth, felled trees, and a sky that consists of the upside-down surface of a pool is still a house, but it is a house dreaming of water. In other images, a cathedral sprouts from a tree-stump, a solid orb floats—à la Magritte—above a perfectly ordinary beach, and elsewhere a figured tapestry becomes a forest floor. To at least one writer, the cathedral and the tapestry suggest "the intuitive link between nature and religion, vision and creation, which permeates medieval art."[24]

If we accept the fact that medieval art told stories, using symbols to convey conventionalized meanings, we should be able to "read" Uelsmann's images in a literal way, rather like reading the successive lines of a poem. There is some indication that this may be possible. Paul Caponigro has suggested that photography's potential as image-maker and communicator is "really no different from the same potential in the best poetry where familiar, everyday words, placed within a special context, can soar above the intellect and touch subtle reality in a unique way."[25] Aside from the fact that poetry of a high order much admired by literary critics, like Ezra Pound's *Pisan Cantos*, cannot be said to use "familiar, everyday words," there remains the enduring difficulty inherent in the interpretation of symbolist imagery.

35. Jerry Uelsmann, [Multiple image], 1978.

Medieval art was religiously communal, relying upon a socially accepted thesaurus of didactic meanings gleaned from Christian theology and the Bible. The symbols of lamb for Jesus, dove for the Holy Spirit, a winged figure for angel, the lion for Saint Mark, and the rose for the Virgin Mary, were accepted notations in the overall rhetoric of the church. But the critic and historian Peter Bunnell denies the possibility of assigning such set meanings to Uelsmann's symbols. Like dreams, "they have either no meanings or several meanings."[26] Bunnell goes even further to suggest that photographs can have "double meanings, implied meanings, unintended meanings, can hint and insinuate, and may even mean the opposite of what they apparently mean."[27] While it may be more accurate to say that meaning is ascribed by the intellect of the viewer, Bunnell's statement helpfully liberates Uelsmann from the obligation to "mean" something specific.

Many of these issues concerning the nature of meaning and the meaning of nature can be explored in four photographs by Paul Vanderbilt (see plates 36–39). They have been selected arbitrarily from his extensive oeuvre in landscape.

Each of these pictures can be looked at as representing specific places and times as well as types of events often seen in American farmlands. The cloud towers over the field of corn. The wooden fence undulates away over a winter field, its diagonal drawing us into the picture. A bright road snakes swiftly through the landscape to the farmhouses beyond. A row of trees is silhouetted against the sky above a flooded river. Is the cloud a symbol of rain, of threat, of heavenly presence, or is it a complex statement about the relationship of clouds to the life of agriculture? Are we to grieve over the fallow land constrained by the wooden fence or simply march into the picture to take possession? Does the road signify, according to Whitmanesque cliché, openness and freedom or, rather, toilsome plodding toward dis-

tant destinations? Are the trees merely conveying a mood or giving us a specific message about the fleeting aspects of life? Or are all of these meanings possible? What mood does each picture engender? Vanderbilt is obviously a visual poet, selecting his forms with scrupulous attention. His base of operations was the upper Midwest—specifically, Wisconsin. Are we to demand labels for each site he photographed, and to what use would such labels be put? Is there only one way in which these pictures can be experienced? Is there only one symbolic message? If all photographs are symbols because they are not Nature but artifacts, what clues do we need to share the experience which the poet/photographer has set before us? Or is sharing not the goal?

Possibly no photographer ever worked as valiantly as did Minor White to liberate both the act of photographing and the experience of looking at a photograph. A mystic and a poet, Minor White searched Swedenborgianism, Zen Buddhism, the psychology of vision, Korzybskian semantics, Sumiye painting, the metaphysics of Gurdjieff, and the teachings embodied in Tao, for cues to meaning and symbol. He found most useful Jacques Maritain's suggestion that "Ideas, with a capital 'I,' come from outside as well as inside. . . . There seems to be an independent source of Ideas originating with the depth mind. This simultaneous exterior and interior source [is] poetic intuition."[28] For Minor White, the struggle to give form to poetically intuited ideas was heroic and on a level with deep religious experience. At the same time that he wrestled with form like a latterday Jacob wrestling with the Angel, he often spoke in phrases acceptable to symbolists of any era, pictorialist or surrealist: "Camera and Eye are together a time machine with which the mind and human being can do the same kind of violence to Time and Space as dreams."[29] While oneiric qualities manifest themselves most powerfully in his surreal close-ups

36. Paul Vanderbilt, [Cornfield with clouds, vicinity Carver, Wisconsin], 1967.

37. Paul Vanderbilt, [Winding road, vicinity Gilman, Wisconsin], 1963.

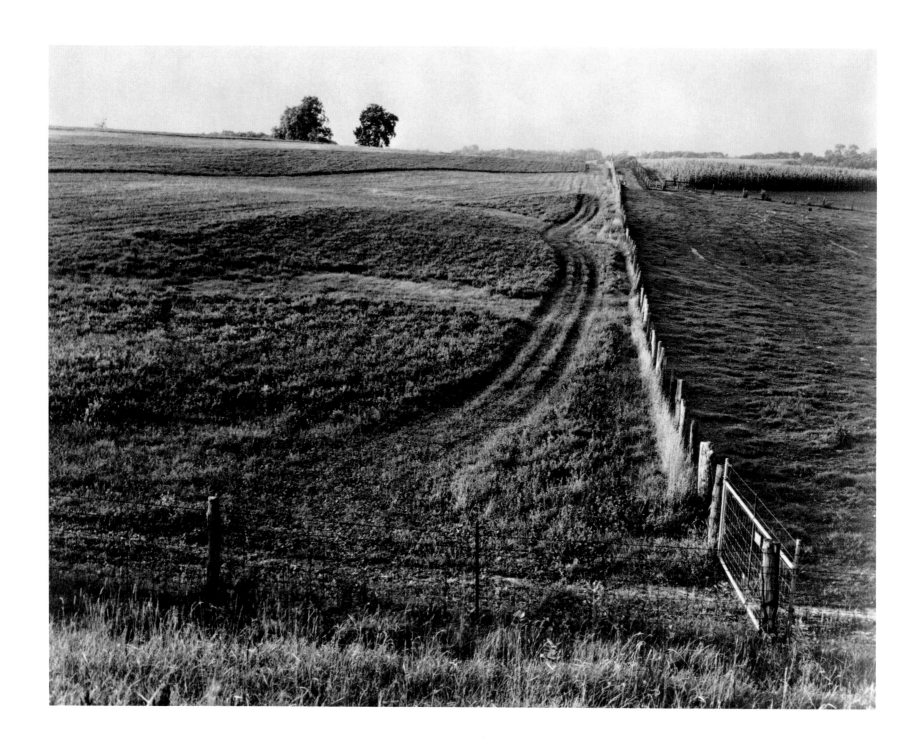

38. Paul Vanderbilt, [Fields with wagon tracks and dividing fence, Patch Grove, Wisconsin], 1961.

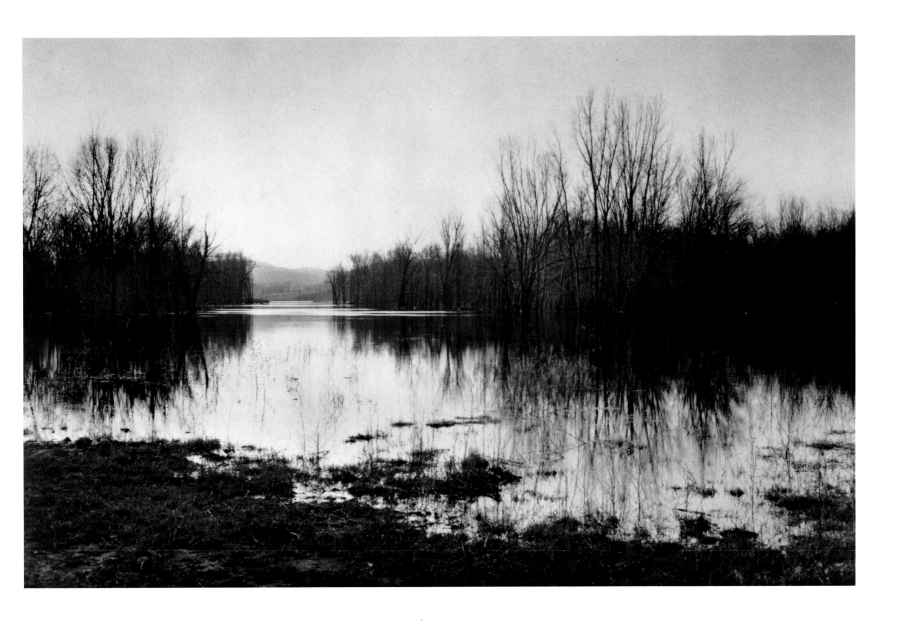

39. Paul Vanderbilt, *Wisconsin River Flood, Bridgeport-Woodman (vicinity), Wisconsin*, 1965.

of ocean spume or hoarfrost on window panes, White's distant landscapes of sky, water, and cloud often provide the same sense of an initiation into cosmic mysteries (plate 40).

Though Minor White's landscapes are symbolic, they never employ the allegorical mode. He does not personify ideas, but creates symbols for inner feelings, honoring the Chinese painting philosophies he deeply revered. In *The Way through Camera Work*—the title refers not to Stieglitz directly but rather to Tao achievable through photography—White quotes many Oriental poets and mystics, and also Laurence Binyon's observation that "the landscape in the long Chinese tradition ... merges the local in the cosmic, and mirrors rather a state of soul."[30] That is a classic statement of the goals of the Symbolists.

In the pictorialist version of symbolism, the object was to create "a mood of dreaminess and detachment."[31] In surrealist symbolism, the object was "the systematic derangement of the senses."[32] In Minor White's symbolism, the object was to create an experience similar to that of a Zen Buddhist *koan,* out of deep "poetic intuition." Jerry Uelsmann's collage effects shatter conventional realities. Wynn Bullock, Paul Caponigro, and Linda Connor venture into the fourth dimension, into another order of time and space. The essence of modern symbolism seems not to be the one-to-one interpretation of allegorical, heraldic, or mythological symbols, but rather the creation of the mood-evoking, ambiguous, timeless icon ritualistically experienced in a state of quasi-religious contemplation. Landscape, in that context, becomes neither "Nature" nor "Beauty," but a style of reverence. It becomes poetry because it shares the compressed format, the unified vision, and the evocative—rather than representational—language of lyricism.

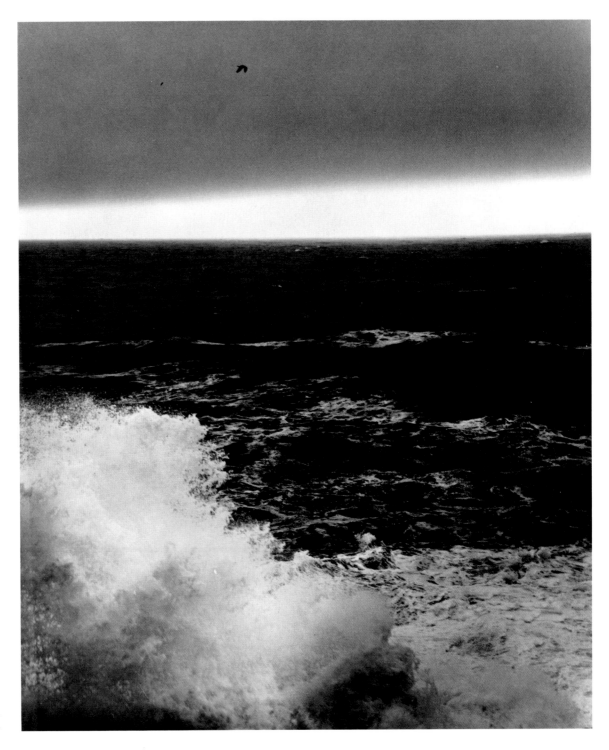

40. Minor White, *Gull over Pacific, Shore Acres, Oregon*, 1960.

41. Alfred Stieglitz, *Equivalent: Music No. 1, Lake George, New York,* 1922.

5 Landscape as Pure Form

1 MONOCHROME
LANDSCAPE
PHOTOGRAPHY

God geometrizes.—Plato

In 1922, Alfred Stieglitz began to produce a series of photographs which he variously labeled *Songs of the Sky, Equivalents,* and *Clouds.* One of these images he called, simply, *Music No. 1* (plate 41). Taken from a hill near Lake George, the picture is divided into three main areas: a dramatically dark cloud mass dominates a ragged, narrow band of light sky above a darkened valley; in the valley, a single white triangular shape, the pitched roof of an isolated house, points like an arrow toward the sky. The elements of the picture are organized in what is conventionally considered to be an abstract arrangement, with the forms seeming to hang parallel to the picture plane and strongly related to the four edges of the frame.

The fact that Stieglitz called this photograph *Music* suggests that he saw a relationship between music, abstraction, and pure form as these terms apply to landscape. These connections will be found to have a substantial history. (Part 2 of this chapter will be devoted to these issues as they relate to color.)

The pictorialists with whom Stieglitz was long associated, and whom he championed in the early years of *Camera Work,* are usually dismissed by photographic purists as soft-focus, would-be painters who were confused about the proper aims of photography. The fact was, however, that they were not so much confused about the aims of photography as they were dedicated to the *making of pictures*—hence the name Stieglitz gave to the movement. What this meant was that the mere recording of nature was not sufficient for the purposes of art. In the 1890s and the early years of the twentieth century, the purposes of art were no longer didactic, moralistic, and narrative, but decorative, symbolic, and poetic. Regarding the print as an edge-to-edge phenomenon in which

79

80 composition was of prime importance, the pictorialists were, curiously enough, among the first photographers to place formal considerations above all others. Whether they were influenced by Whistler, Arthur Wesley Dow, or Gauguin, the pictorialists were intent on incorporating the new lessons of art. For them, as for other moderns, nature had become, more and more, simply the excuse for the organization of interesting shapes and the creation of moods.

The soft-focus landscapes of Steichen, for example, used diffusion of detail not only to create mood but to suppress distracting minutiae in favor of large masses or evocative shapes. As a rule, the soft focus was favored as means of elevating the particular to the general. The pictorialist landscapes were "abstract statements about landscape that expressed more about a concept of tranquillity than a particular time and place."[1] A stand of poplar trees was thus generalized into representing nature itself, and nature was used to convey moods as various as tranquility, torment, despair, isolation, or pleasure.

If the pictorialist landscapes are considered as only poetic and symbolic of mood, it is perhaps because they have not been sufficiently related to the late nineteenth-century obsession with how form communicates meaning. The purist contempt for manipulation of the photographic print, for example in the use of gum bichromate, has obscured the fact that the pictorialist's "eagerness to experiment with diverse image-making processes . . . further reduced *the honor granted to the object in the world* [emphasis added]. These works asserted the superiority of the artist's conceptual ability."[2] The pictorialist landscape, therefore, was an attempt to coax the physical world into communicating messages that were more about an ideology of art than about optical phenomena, more about the expressing of emotion than about the impressionistic rendering of the transitory passage of light. Verisimilitude to

natural phenomena, to the Truth to Nature that Ruskin had extolled, had long ceased to astonish the photographic audience. What mattered was that ideas were being expressed.

The problem was, of course, that photography seemed eternally wedded to "nature." How, then, could ideas be expressed, particulars be generalized, truths be expounded, through a medium which, in one way or another, recorded the phenomenological world? If, as Minor White would decree, "The function of camera work, when treated as a treasure, is to invoke the invisible with the visible,"[3] how, exactly, was this to be done? The symbolists had resorted to metaphor, simile, mythic figures, and classical analogies, sometimes so arcane as to be unintelligible. Was there any other way except blurring reality by soft-focus techniques? If the object was no longer to be the guest of honor in the house of Art, what was to take its place? What *could* take its place?

According to the abstract painters in the first decades of this century, what would take the place of the object was the essence of all creation: the laws of number and relationship. Long ago, the Pythagoreans had determined that "Numbers are the whole Heavens."[4] They believed that natural laws—principles—governed the rhythmic movement of the stars and of all the universe, including "all that nature embraces."[5] These laws were based on mathematics. Mathematics, Pythagoras discovered, also governed the laws of music, and his followers believed in a cosmogony in which the rhythm and spacing of the planets and the stars as they circled the heavens created a literal music of the spheres. When William Blake wrote that the stars sang in the sky, he meant just that. In his *Ode to St. Cecilia*, Dryden spoke of the harmony of the heavens, not metaphorically, but as a description of what was considered by many, including the astronomer Kepler, to be scientific truth. The laws governing the stars and the mu-

sical octave, the fourth and fifth intervals, were "inherently consonant because they were spaced on the strings of the lyre and are arranged as the stars are arranged to each other in the heavens."[6]

These ideas of music's relationship to celestial orders and the secrets of number seem to have emanated from Eastern philosophies. Perennially, these Eastern influenes revive or reinforce archetypical ideologies already embedded in Western thought. In the nineteenth century, Madame Helen Blavatsky had traveled to India and returned to set forth cosmic principles in her Theosophy, a system of metaphysics of the most profound significance in the artistic development of abstractionists like Wassily Kandinsky and Piet Mondrian, as well as of photographers like Alvin Langdon Coburn. An extrapolation from Theosophy, nurtured by the Russian mystics Gurdjieff and Ouspensky under various rubrics, including "The Fourth Way" and "The Universal Order," offered correlations between a proposed hierarchy of the planets and galaxies and the seven-note musical scale, each note representing the mathematically determined set of vibrations which, taken together, constitute what Ouspensky called "The Ray of Creation."[7]

The idea that music depends on vibrations that can be mathematically described led to the corresponding theory that all of "nature" exists and demonstrates its essences through similar vibrations. In commenting on color and form in the visual arts, Theosophists like Annie Besant and Charles Leadbetter set forth a theory of *Thought Forms*[8] that suggested the way in which forms stimulate emotional responses. "The thought forms are not only shaped by vibrations, in their turn they also produce radiating vibrations which on striking the mental body of another person tend to produce thoughts of the same type in the recipient."[9] There is no magic, therefore, in the fact that art arouses emotion, since there is an isomorphic relationship between the

vibrations which stimulate the production of the work of art and the ensuing vibrations from the forms of art. Besant and Leadbetter also believed that their principles of what might be termed occult physics could be used as explanations "for the moral effect of music and the arts."[10]

Each shape, according to Besant and Leadbetter, generates characteristic vibrations, just as feelings and thoughts do. Like Kandinsky, who attempted the same kind of typology with respect to color, the Theosophists suggested that jagged lines represent rage, rings or vortices signify sudden emotions, fear manifests itself in zig-zags. The astral, or mental, planes of being are capable of producing forms which imitate the principles of matter. The correspondences over which Mallarmé had lyricized now became literal affinities: "The affinity of colour, sound and feeling reveals a unity of cosmic dimensions, since Nature also plays on the strings of our soul, setting them in vibration."[11]

Whether Alfred Stieglitz actually became a practicing Theosophist—as did Alvin Langdon Coburn, for example—does not matter as much, perhaps, as the fact that he was strongly influenced by Maurice Maeterlinck and by the metaphysical underpinnings of early-twentieth-century abstract art. Maeterlinck, whose aesthetic opinions Stieglitz published in *Camera Work*, had attempted in his plays and poetry to remove language from its function as signification in order to use words for the beauty of their musical values. Not only was the object dethroned, but the language that humanity had evolved to signify the object was also challenged. For a variety of reasons, music was now the paradigm for all artistic production, interpretation, and appreciation. The ideal of music as a model for the arts had been espoused by numerous nineteenth-century aesthetes, most prominent among them Walter Pater, whose pronounce-

ment that *"All art constantly aspires towards the condition of music"*[12] was received as gospel.

That photography, especially photography of Nature in the form of landscape, should be able to participate in this aspiration toward the condition of music seems at first glance to be ludicrous, if not impossible. There are, however, definite resemblances between Pater's dictum and the definition of the very nature of photography which John Szarkowski has offered. For Szarkowski describes photography as the only art in which form and content are synonymous. Pater described music in precisely the same way: "It is the art of music which most perfectly realizes this artistic ideal, this perfect identification of matter with form."[13]

Pater typifies the longings of the fin-de-siècle symbolists to dematerialize the world, to be relieved of the burden of nature. Art, he believed, was "always striving to be independent of the mere intelligence, to become a matter of pure perception, to get rid of its responsibilities to its subject or material."[14] In following this notion to its logical extreme, Pater offered, as the ideal examples of both poetry and painting, "those in which the constituent elements of the composition are so welded together that the material or subject no longer strikes the intellect only; nor the form, the eye or the ear only; but form and matter, in their union or identity, present one single effect to the 'imaginative reason,' that *complex faculty for which every thought and feeling is twin-born with its sensible analogue or symbol* (emphasis added)."[15] Szarkowski was probably not suggesting that photography always makes a direct appeal to "imaginative reason," but rather that a photograph is a transparent medium whereby what you see is what you get, at least in form. Pater, on the other hand, seems to have been oblivious to the possibility that music itself could follow a progression from the imitation of nature (for example, Beethoven's *Pastorale Sym-*

phony and other programmatic compositions) to the pursuit of pure forms, as for example, in the work of Stockhausen or Varèse. When the abstract painters spoke of music as an ideal, they did not seem to understand that there are *musics*, not simply *music*. They regarded all music as being essentially contentless, free from the necessity of imitating or copying Nature.

Paul Cezanne once observed, "Art is a harmony parallel to that of nature."[16] Picasso enlarged upon this statement, commenting on the presumed opposition of modern painting to naturalism. "I would like to know if anyone has ever seen a natural work of art. Nature and art, being two different things, cannot be the same things. Through art we express our conception of what nature is not."[17] Just as Maeterlinck had removed language from its utility as signification, so the visual artists wanted images to become self-reflexive, commenting only on the world of pure form. The task for the photographer was to seek only those forms which would resonate with emotion and significance without resort to narrative or descriptive elements.

A purist of the visual arts, Amadée Ozenfant, in exhorting painters to ignore the accidental or transitory aspects of Nature and urging them to pursue "the constants of the sensations and elements of form in nature and art,"[18] offered a comment about photography that could have emanated from Stieglitz himself: "All thanks to Daguerre; he revealed clearly that exact imitation, item for item, cannot reproduce nature, but that only EQUIVALENTS can."[19]

The Stieglitz *Equivalents*, which included his *Music*, were in some ways reminiscent of T. S. Eliot's search for "objective correlatives," or what Pater took for granted as thoughts and feelings "twin-born" with their perceivable analogues or symbols. Whether he subscribed to Annie Besant's Theosophical theories or not, Stieglitz— while recognizing the relativity to which human

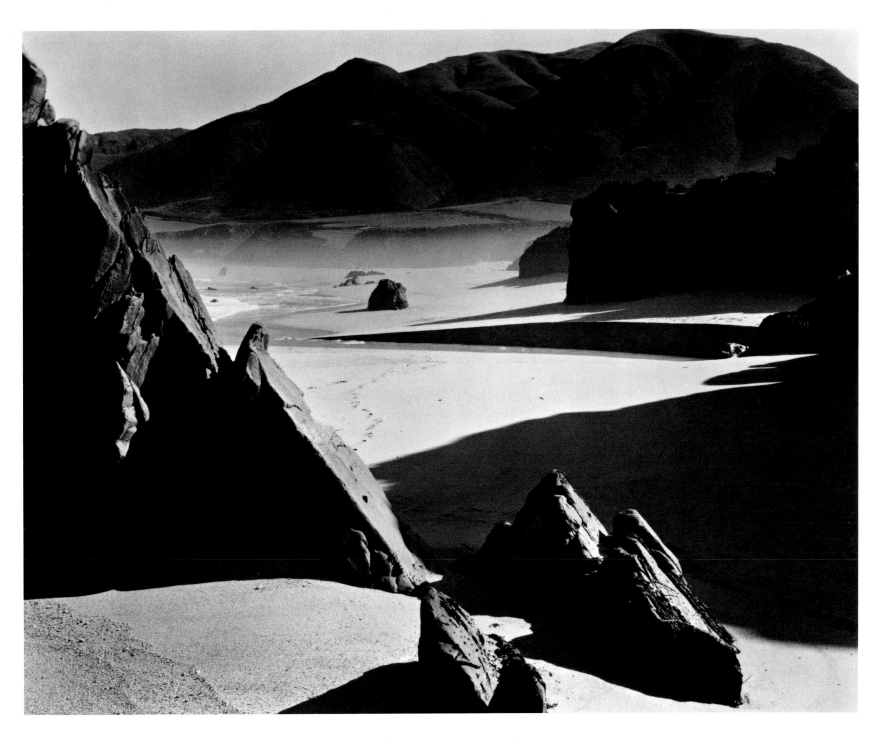

42. Brett Weston, *Garapata Beach*, 1954.

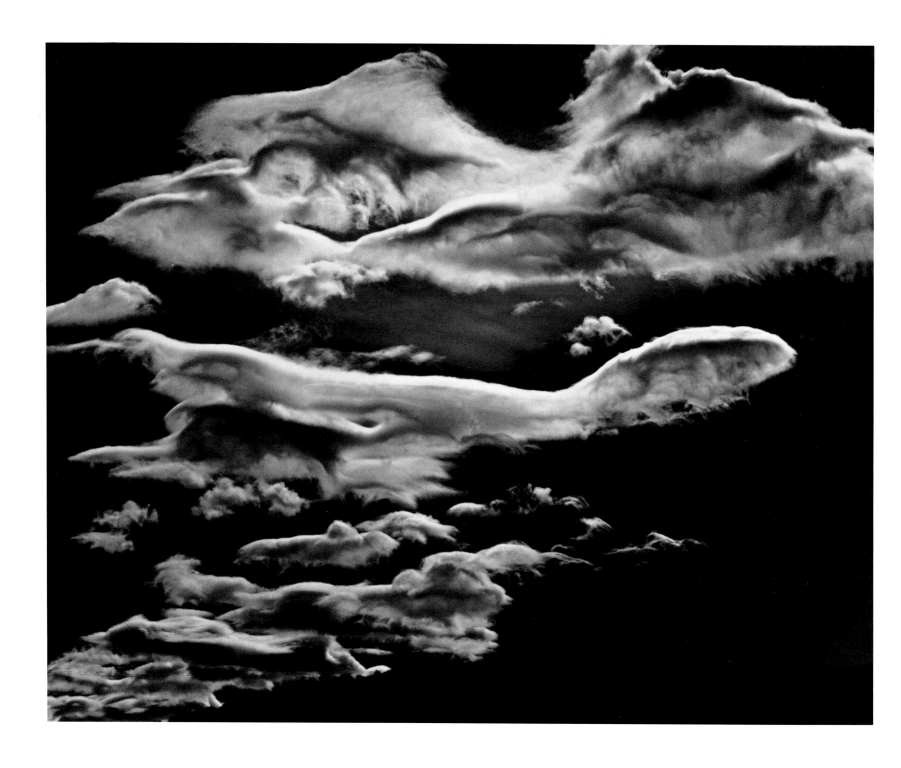

43. Brett Weston, *Clouds, Owens Valley,* 1968.

perception and apprehension are susceptible—was consciously pursuing forms, shapes, and contents expressive of thoughts rather than merely describing Nature. His *Songs of the Sky*, produced under the influence of powerful abstract and symbolic paintings by his wife, Georgia O'Keeffe, reveal a conviction that a musical analogy for photographs was by no means farfetched. If we read his *Music* landscape of 1922 correctly, we see that Stieglitz was offering proportion, rhythm, harmony of opposing forces (earth/sky), and coloration as a kind of algebra of emotion. Like music, his abstract forms are a notation on the vibrations of the universe. Music is the arithmetic of the cosmos, and Stieglitz's *Music* is photography's music for the eye.

It is by no means irrelevant to note that O'Keeffe's painting titled *Ladder to the Moon* (1958) contains a low silhouette of dark mountains and a stretch of sky in which a floating ladder forms seven intervals between eight steps as it reaches upward. (The O'Keeffe painting was appropriately selected as a poster design for the Santa Fe Music Festival of 1974.) Through music, we are literally "in tune" with the cosmos: the seven intervals represent the seven notes of the octave, the same octave which Minor White used for the title of his book, *Octave of Prayer.*

It was Minor White who said of the last photographs of Edward Weston taken at Point Lobos that they "may parallel in content the last quartets of Beethoven."[20] Weston, who was passionately addicted to music, would have been pleased by such a eulogy, even if he might have preferred to have his photographs likened to the soaring polyphony of Johann Sebastian Bach, his favorite composer and an admitted source of inspiration. But what could Minor White have meant by the word *content*? Beethoven's last quartets are among the most complex and sonorous outpourings of emotion in musical form ever composed. If their "content" is powerful emotion, and simultane-ously music is considered to be abstract—that is, free from representational connection with nature—then we have been brought full circle to the question: How does form stimulate the response of emotion? How can pure form express emotion or thought? In what ways does pure form act on us—by resemblance? by metaphor? by kinesthetic imitation? by mathematical vibrations akin to Nature's vibrations?

In describing Edward Weston as one of the few great creative artists of his day, Ansel Adams declared, "He has recreated the mother-forms and forces of nature; he has made these forms eloquent of the fundamental unity of the world"[21] These forms were thought to be essential to any art that presumed to offer an experience of beauty. According to Immanuel Kant, the aesthetic emotion—the experience of beauty—depends on certain fundamentals common to all the arts: repetition, variation, contrast, and balance. Amadée Ozenfant's constants of the sensations and elements of forms in nature and art were four fundamentals: verticality, horizontality, obliqueness, and the curve.

Like the nineteenth-century theorist Charles Henry and his disciple, the painter Seurat, who tried valiantly to determine the symbolism and the psychological effects of pure form, Ozenfant suggested that verticality reminds us of the force of gravity: we know this from standing erect on the ground with the horizon at right angles to us. Treated as a straight force unhindered by the curvings of mountains, the horizon not only emphasizes the potential dynamism of the vertical, but, because it is the opposite of the vertical, reminding us of our sleeping posture—lying more or less flat—it "emphasizes inert stability, repose."[22] Ozenfant is thus suggesting a geometry of the emotional effects of pure form, one that is predictable because it is axiomatic. He then adds one last element, that of time. "A form does not yield its full effect instantly. We have to

'follow' it. Time intervenes in acts of sight as in music, dance, literature."[23] The Cubist painters had demonstrated this intermix of space/time relationships on a flat surface, and certainly, when we look at photographs by Brett Weston, Edward's son, the temporal connections are as evident as are the spatial relationships (plate 42). In this strongly contoured image by Brett Weston, it is obvious that the forms are not geometrically squared off by the artist; *Garapata Beach* is the optical music of found triangles reverberating against each other and across space and time.

When we compare this with two images by Edward Weston (plates 44, 45), the formal elements in Edward's *Oceano* and his *Tomato Field* are clearly Kant's elements of repetition and variation. A sense of the patterns in which natural forms arrange themselves is dominant; but also, because the eye must traverse the endless rows of tomato plants and the repetitious but varying ridges of sand, Ozenfant's notion of time as an element of "acts of sight" is affirmed. In musical terms, these pictures are composed in regular rhythms that could probably be measured out in specific time notations. The tomato plants could be said to move in a marching rhythm, the sand dunes—because they dip and shift diagonally—may remind some viewers of the abrupt rhythmic shifts of the tango. Kinesiologists theorize that we respond to rhythmic visual forms by an imitative action, inadvertent and unconscious, consisting of repressed muscular responses.

If Ozenfant's and Kant's typologies are accepted as final, then all questions of form would be resolved according to geometric, and indeed metronomic, formulae. The difficulty is that there is more than one "pure form": two major varieties are the geometric, which we have been discussing, and the biomorphic. Kandinsky, who influenced both Stieglitz and Edward Weston not only through his paintings but through the theories expounded in *Concerning the Spiritual in Art*, was strongly opposed to predictably metronomic images. He was unsure of the extent to which visual artists can remove themselves from the matrices of nature. "If we begin at once to break the bonds which bind us to nature, and devote ourselves to combinations of pure colour and abstract form, we shall produce works which are mere decoration, which are suited to neckties or carpets."[24] Certainly, the painting by Kandinsky which Stieglitz purchased at the Armory Show in 1913 was an experimentation in pure biomorphic form, wherein very little of either cubism's sculptural reconstruction of nature or the square geometry of someone like Malevich could be discovered. Kandinsky's versions of "pure form" have the slithering, floating, nebulous, completely untethered dynamism of primordial matter; in fact, some of his abstractions resemble the magnificent chaos out of which the ultimate structures of nature would arise. In trying to let his art express the mutuality of vibration connecting nature and art forms, Kandinsky devoted himself to the practice of automatic writing and other avenues to the subconscious mind which antecede surrealism's adherence to the principles of automatism. His pictures have the complex vitality originating more with chance combinations and dream states than with dogmatic preselection. Even while assembling a taxonomy of color and form, Kandinsky stressed intuitive grasp of form, since he believed that Nature—God, the Creator—created form out of divine play, a free and autographic activity restricted only by the intrinsic possibilities of matter.

Chance and spontaneity became the watchwords of Minor White and his disciples. Edward Weston had pointed the way with his intense observation of the idiosyncracies of natural forms. He had said, "I am no longer trying to 'express myself,' to impose my own personality on nature, but without prejudice, without falsification, to become identified with nature, sublimating things

44. Edward Weston, *Oceano*, 1936.

45. Edward Weston, *Tomato Field*, 1937.

seen into things *known*—their very essence—so that what I record is not an interpretation, my idea of what nature *should* be, but a revelation—an absolute, impersonal recognition of the significance of facts."[25]

Chance may be equated with discovery of the forms of the natural world. In Paul Caponigro's close-up of a Revere beach, (plate 46), chance has deposited certain stains of seaweed and the glitter of salt water on sand. The eye of the photographer has noted these accidents of the interplay between the natural elements and has selected a specific frame of what is obviously a space/time interaction (the water will return, the seaweed will float away, the rock will be submerged), which he believes has connotative or descriptive force. In Chris Enos's *Saguaro* (plate 47), accidents of growth and environment have produced a cascading explosion of shapes that seem stilled but are part of the flux of nature (the cactus will deteriorate and rot, parts of it will grow, the birds will come to nest in its columns, and so on, depending on what the viewer knows about the desert). Brett Weston's *Clouds, Owens Valley* (plate 43) represents Nature at its most histrionically bizarre—for while clouds are often seen to be amorphous, they do not seem simultaneously to be totally out of control.

While Harry Callahan depends on chance to create the beaches that he loves to photograph, his photographs (plate 48) are absolutely controlled with respect to proportion and rhythm. Using the four edges of his frame to demarcate a field on which he will observe the play of natural forces, Callahan in his beach scenes seems almost to assemble the pieces of the picture. Resembling the floating horizontal counterpoint in Mark Rothko's abstract paintings, the beach pictures assert a strict vertical parallelism of shapes in order to deny three-dimensional perspective. The beach/water's edge/distant sea/sky combinations of more or less rectangular areas return

us to the geometry of "pure forms." They are, once again, music for the eye. We do not so much read the forms as feel them pushing against each other, in a controlled harmony like an acoustically enlarged chamber work.

The ascription of the term *formalistic* has caused bitter controversy in contemporary photographic criticism. This perennial issue ripened when Lee Friedlander's *Factory Valleys* was published in 1982. While the geometric push/pull of forms are almost impossible to deny in an image like plate 49, it is less easy to see how plate 50, with its irregularities hanging like a skein of unpredictable biomorphic textures across the townscape in the distance, could be described as formalistic. Since the natural world manifests itself in forms, what type of forms and what concentration of types of forms, what relationship between forms and what overall disposition of forms determine that a photograph shall be termed formalistic or documentary? The skein of tree and branch forms in plate 50 offers Kant's fundamentals of "repetition and variation, contrast and balance," previously cited. The picture is divided into vertical thirds and roughly in half horizontally. This is its composition, a term contemporary photographers seem to shudder at, presumably because it echoes the art of painting.

The Friedlander photograph (plate 50) partakes of a certain fascinating vitality, one that verges on melancholy and estrangement, however. Its complex of meanings includes the kinesthetic response that most people experience when they are confronted with the barrier of a dense forest or the bars of a cage: the instinct is to turn away, to seek an easier path or a window that does not remind us of having lost our freedom. Again, the kinesiologist and the sociobiologist could probably interpret this kind of picture best, not the Ozenfantian geometer or a botanist. Landscape frequently speaks to us through the projected sense of touch rather than sight. If the

46. Paul Caponigro, *Revere, Massachusetts,* 1958.

47. Chris Enos, *Saguaro*, 1977.

48. Harry Callahan, *Cape Cod*, 1974.

Friedlander photograph repels, that is the result of its imagery, not in terms of picture-making but the physical implications of the facts presented. Here photography functions as a window, documenting the disorder and alienation of the distant town from the presumed "beauty" of nature, as well as from connection with the larger world. Not for the first time in his career, Friedlander defies all conventions of frontal, precisionistic, beautiful picture-making. Nature can be a snare as well as an invitation.

Edward Weston would not have liked this particular Friedlander (plate 50) or even accepted it as part of the domain of photography; for his idea of significant fact had more to do with the metaphysical apprehension of the underlying geometry of nature. It is hard to say what Minor White would have made of it, unless we remember that he worshiped the accidental, the discovered, rather than the composed and assembled. In *The Way through Camera Work* he wrote: "What is more anonymous than the handwriting on walls and faces, rocks, clouds, and eyes? And who can interpret the message of chance without bowing?"[26] Here, however, Friedlander does not seem to be asking us to bow in homage to the messages of chance. We are being asked to reflect, perhaps even to revile, certainly not to rejoice. He seems to be asking us to respond to a gestalt he perceived rather than to admire, as Janet Kardon put it, "a parody of geometry [laid] across a defenceless subject,"[27] an act he could be more readily accused of performing in plate 49.

Rosalind Krauss has insisted that photography does best when it accepts the world as "a complex and disordered fact"[28] in which nature reveals not geometry but chaos, a chaos far too multiplicitous to be captured in the art of painting. If we look at photo-realist paintings, however, which copy that detailed disorder, and do so extraordinarily well in terms of minutiae, it is difficult to understand Krauss's insistence on an absolute separation between painting and photography. Photography once imitated painting's ability to subdue natural detail, for the sake of significant form; now painting imitates photography, specifically color photography, for its shimmer of detail, its inescapable specificity, and its reverberations of popular culture. Even Robert Adams, after listing the detritus of the modern landscape which he had discovered along the South Platte River and Interstate 70, remarked, "What I hope to document, though not at the expense of surface details, is the Form that underlies this apparent chaos."[29]

Rather than merely copying the random disorder which Krauss insists is the fundamental essence of nature, it may be that photographers seek to generate new approaches to the forms in nature. Stieglitz made music by analogy, through cosmic reverberations; Edward Weston articulated shapes as precisely as if a Creator were at work on primordial matter; Brett Weston orchestrates time and space, occasionally demonstrating that Nature unpredictably creates bizarre anomalies of form; Caponigro captures the mood of a moment by suggesting that eternity resides in the very heart of flux; Friedlander weaves clusters of repetitive shapes into a tactile aggregate; Robert Adams accepts the traces of human interference with pure landscape; each photographer of land/water/sky/flora seeks and discovers new relationships and new meanings. As Henri Focillon remarked concerning various concepts of space, "the life of forms is renewed over and over again, and . . . far from evolving according to fixed postulates, constantly and universally intelligible, it creates various new geometries even at the heart of geometry itself."[30]

49. Lee Friedlander, *Pittsburgh, Pa.* [*Factory Valleys*, p. 3], 1982.

50. Lee Friedlander, *Pittsburgh, Pa.* [*Factory Valleys*, p. 29], 1982.

2 COLOR LANDSCAPE PHOTOGRAPHY

. . . this succession of melodies whose variety ever issues from the infinite, this complex hymn is called color.
—Baudelaire

Nowhere in the world . . . is the autumn foliage as brilliant in color as in the United States
—Josef Albers

Color and nature seem inseparable, yet for nearly a hundred years after the invention of photography, and despite occasional attractive successes like the Lumière Autochrome transparencies, the color of nature proved to be the most difficult, elusive, and tantalizing of all the technical problems which confronted the camera. Not only did it seem impossible to duplicate the quickly shifting harmonies of nature, but when the first viable techniques were applied, color seemed "unnatural." It was raucous, inharmonious, or schmaltzy, more suited to commercial applications,

picture postcards, or calendars than to the serious business of "art."

For the greater part of photography's history, we have been looking at landscape photographs in monochrome. We tend to segregate photography into two camps: black-and-white and color, even though black-and-white may actually include a wide range of monotones from sepia to blue-gray. In any event, the large body of landscape photographs in "black-and-white" constitutes translations from nature. No one would argue that they are abstractions, no matter how illusionistic the perspective or how well we have accepted the convention of black-and-white standing for nature.

It has been assumed that the presence of color in a photograph automatically makes it more realistic. Yet even Andreas Feininger, who at first subscribed to this notion, admitted that "unless expertly executed, color photographs no longer

appear realistic, but are actually less so than similar pictures of the same subject which have been taken in black and white."[1] In considering, for example, whether Edward Weston's color pictures were as great as his black-and-white ones, Feininger favored the latter. "These pictures are an interpretation of nature. To me, they depict . . . *the basic character of a landscape* rather than its temporary experience. It is the very *absence of color* which makes these photographs so powerful. It is through abstraction, through the suggestion of feeling and mood, that the artist establishes contact with the viewer."[2]

Feininger ventured those opinions in 1954, when color photography was struggling to emerge from its commercial cocoon, and when the relative realism or abstraction of a photograph were prime criteria of its worth. Unintentionally or not, his arguments mimic the continuing battle between the presumably rational appeal of contour and the presumably sensual appeal of color, a fight in which painters had indulged for several centuries. Nearly two decades were to elapse before photography's most influential critic, John Szarkowski, would announce that color photography had been "invented." Its "inventor" was William Eggleston, who in 1976 received the ultimate recognition of an exhibition at the Museum of Modern Art. In his essay for the catalog, Szarkowski elaborated on the significance of Eggleston's achievement. Fundamentally, Eggleston had capitulated to neither of color photography's previous sins: formlessness and prettiness. In formless photographs, "the meanings of color have been ignored." In pretty photographs, the meanings of color were valued "at the expense of allusive meanings." Colors have meanings, Szarkowski argued, and Eggleston had somehow discovered how to combine the realism of the natural world with the numinous significance of thought and interpreted experience. It was, above all, Eggleston's achievements in form

through color that Szarkowski lauded, for "Form is perhaps the point of art."[3]

Not everyone agreed with Szarkowski. In 1978, the critic Gene Thornton wrote a diatribe on Eggleston's recent work. His argument was that Eggleston was merely carrying the ideals of Stieglitz and Strand to their logical conclusion—namely, the same formalism which characterized all modern painting. Accordingly, there was no content in any of Eggleston's photographs, including his landscapes. "In his photographs, form is all, and photographic form is as random, scattered, artless and accidental as nature itself." Calling him "photography's Matisse, Kandinsky, and Mondrian all rolled into one," Thornton decided that Eggleston was photography's "great liberator from order, purpose, meaning, nature, art and everything else that has conspired to keep photography from being itself."[4] Aside from the conspicuous facts that Matisse was a stupendous order-maker and a creator of sensually formal arrangements, and that Kandinsky and Mondrian were both advocates of an art of purpose and meaning, an examination of one of Eggleston's landscapes should demonstrate that color has created formal order where perhaps black-and-white would have been unintelligible.

The untitled Eggleston color photograph (colorplate 1) is, at first glance, a picture of two trees, one dark and one lighter. On closer examination, we find another tree between the others, at the bottom of the picture. All three trees are situated against a blank sky; only the foliage is emphasized. The left tree is a dark blue; the right tree manifests a range of greens, from dark to yellow-green; the middle, or bottom tree, is softened to a pale blue, the result of atmospheric perspective, exactly as one would find a distant tree depicted in a Renaissance painting. The subject of this photograph is light on foliage; the essence of it is light. Color cannot exist without light. Light and color are synonymous. The nat-

ural world and its colors are described, delineated, and designated by the action of light.

Feininger once noted, "Normally, color will be found to be stronger than form, and when it comes to a clash between the two, color destroys form."[5] In Eggleston's untitled photograph, color and form seem to be synonymous. Somehow, he found the way to coordinate the specific shapes of the trees with color. If this is liberation, as Thornton would have it, from "order, purpose, meaning, nature, art and everything else," it is difficult to imagine what could be substituted for it. The statement Eggleston makes here is not a traditional one in which classical composition is based on the fulcrum and lever, the balance and weights, or any other elements we are used to seeing in landscapes utilizing a horizon line as a fundamental design force. Neither mathematics nor geometry is involved here, but rather, optics. New irregular forms, sometimes centripetal, sometimes centrifugal, and a hundred varieties thereof, can create an entirely different sense of what seems to be most looked for: a sense of organic stasis, a harmony of relationships made possible only through color. As Feininger insisted, "Color photography is a completely new medium."[6]

Dean Brown's striking *Death Valley* (colorplate 2) is an interesting example of how color can organize a perceptually inchoate subject into sharply delineated shapes, in this case by playing with the geometry of triangles. Can any photographer go beyond either Edward or Brett Weston's extractions of form and rhythm from sand dunes? Only an exquisitely tuned apprehension of the possibilities of what could be a trite subject—Death Valley having its own peculiar aura in American history and ideology—could help Brown create coherence out of a proverbial wasteland. But this is no desert devoid of life; Brown has transformed it into elements of Nature, with God as the Eternal Geometer. Perhaps

for that reason it would seem like the ultimate desecration to set foot on these geometrized sands. No slovenly prospector, no John Ford epic, could mar these eternal rhythms. It should be no surprise that Dean Brown was a devoted musicologist who believed that the experience of listening to music could be translated into visual equivalents. For him, landscape was visual music.

Kandinsky, of course, would have agreed. He had offered specific equivalents for various colors, as had Goethe and other color theorists. But Kandinsky went further, equating color with form, and even anthropomorphized color as a force:

Generally speaking, color directly influences the soul. Color is the keyboard, the eyes are the hammers, the soul is the piano with many strings. The artist is the hand that plays, touching one key or another purposively, to cause vibrations in the soul. It is evident, therefore, that color harmony must rest ultimately on purposive playing upon the human soul.[7]

The *Ten Synthetic Landscapes* of Syl Labrot represent this purposive playing on the responses of the spectator. Greatly resembling the color field paintings of the 1960s and 1970s, the Labrot photographs were manipulated in both overall shape, parts of the picture not touching the frame, and in the vertical bands of color (colorplate 4). They crossed the arbitrary boundary erected by many critics to separate "straight" photography and the graphic arts categories established by museums and collectors. When you examine the work of a photographer like Gail Skoff (colorplate 6), who continues a long tradition of hand-coloring landscape photographs in a sophisticated and intricate manner, the question arises as to what degree of color manipulation removes a print from "photography" and places it in "graphic arts." This is, of course, not a problem peculiar to landscape photography, yet it has particular significance in discussions concerning the

relationship of photography to the phenomenological world. Like Syl Labrot in the *Ten Synthetic Landscapes*, the photographer who hand-colors or, more correctly, hand-*paints* a print, is calling attention not to nature but to the subjective vision of the artist. "More significantly, this process functions as a means with which to control, parody, parrot, dismantle, reconstruct and reinvent any given set of photographical facts. It allows the photographer to objectify subjective realities, personal visions and private fantasies, while maintaining a provocative surface tension between the photographic and the painterly."[8]

Dismantling photographical facts and reinventing them, restructuring them according to artistic vision, is certainly the unstated goal of Joel Meyerowitz's landscapes of Cape Cod, despite his protestations that he seeks only to record what nature bestows. The light is what is truly there, not a fantasy, not a darkroom extrapolation, according to this contemporary master of color. Yet his spectacularly abstract photograph, a seascape (colorplate 3), in which isolated forms hang as if magically reverberating in a force field of energy, conveys significantly less of "fact" than of sensibility. He was seeking to obliterate the horizon line, to make nature conform to an idea, an idea about the way large continuous tone color fields resound like musical chords. Unconfined by representational detail, a picture like this gives the lie to the notion that only black-and-white photographs can convey abstraction. Meyerowitz has succeeded in abstracting pure form from nature, and this photograph is about as close to the idea of musical notation as can be expected from the presumably "realistic" color print.

The abstraction inherent in the Meyerowitz seascape brings to fruition a yearning, shared by photographers and painters alike, to be liberated "from the sensory illusions of our ephemeral life."[9] The theorist of art nouveau, Henry van der Velde, insisted that "the role of nature had been played out"[10] so that only abstract forms could communicate. The color-filled impressionist paintings had not helped matters; for what visual artists sought were lines and colors "metaphysically more real than those feeble reflections of being that are adjusted to cerebral perceptions." Kandinsky in all his writings on color and form stressed this point: "One no longer adheres to the picture of nature, one annihilates it, in order to show the powerful laws that rule beneath a beautiful appearance."[11] Yet the suppression of natural detail in Meyerowitz's seascape is not necessarily following Kandinsky's dictum. What it reveals is not the powerful laws of Nature (as opposed to mere "nature") as a revelation of God, but rather a sensualist's yearning to be the supreme juggler of pure form, to abstract form from recalcitrant and ephemeral appearances to establish a counterpoint resembling musical polyphony.

In an interview Meyerowitz had with a New York critic in 1981, he remarked that the public had begun to see "that you can make a color picture as interesting as a black and white picture." Despite the long prejudice against color photographs, which has a complex history, he believes that color photography has advanced sufficiently to become an embodiment of ideas, questions, and imagery as challenging as any black-and-white photograph. The same critic also interviewed that master formalist, Harry Callahan. Acknowledging that he had been working in color for about forty years, Callahan admitted that his first impulse toward color had come from the abstractions of the painter Stuart Davis. "In those days, if you made a photograph of a regular natural scene in color, it looked kind of goofy. And I thought I could avoid that by doing abstractions."[12]

The color theorist Josef Albers noted that the colors of nature can, indeed, do seem bizarre in photography, but even more so in color repro-

1. William Eggleston, [Three trees], 1978.

2. Dean Brown, *Death Valley*, ca. 1972.

3. Joel Meyerowitz, *Bay/Sky/Jetty Series, Provincetown*, 1983.

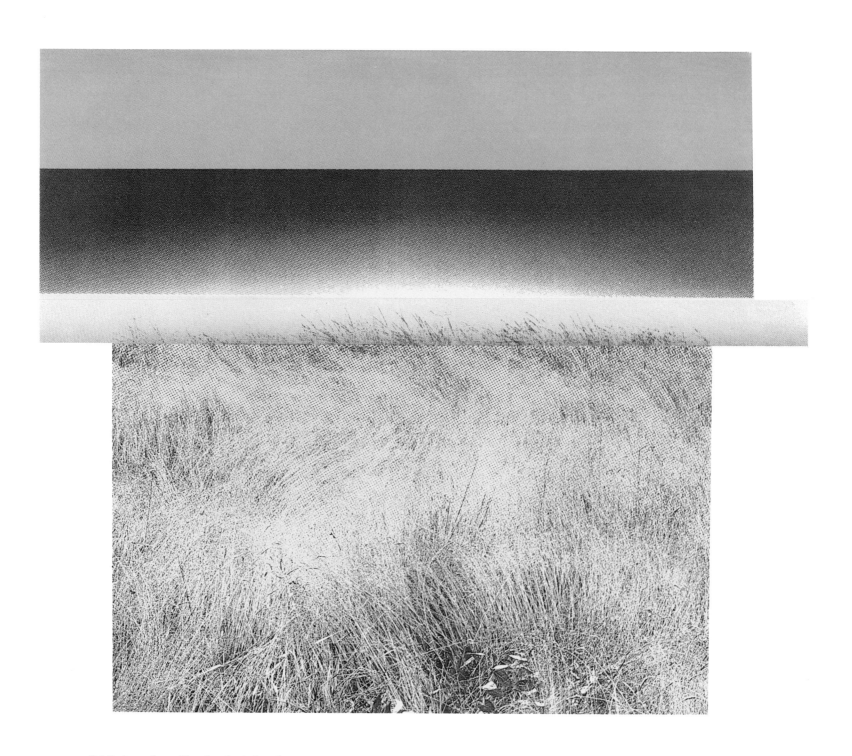

4. Syl Labrot, from *Ten Synthetic Landscapes*, 1973.

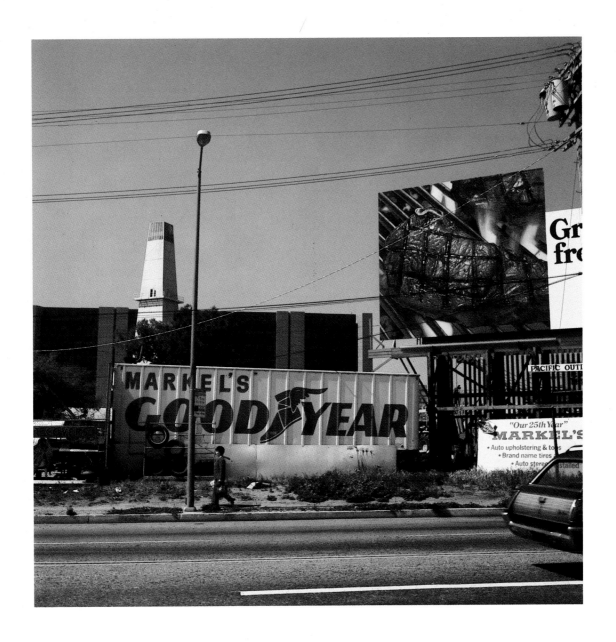

5. Kenneth McGowan, *Steak Billboard*, 1977.

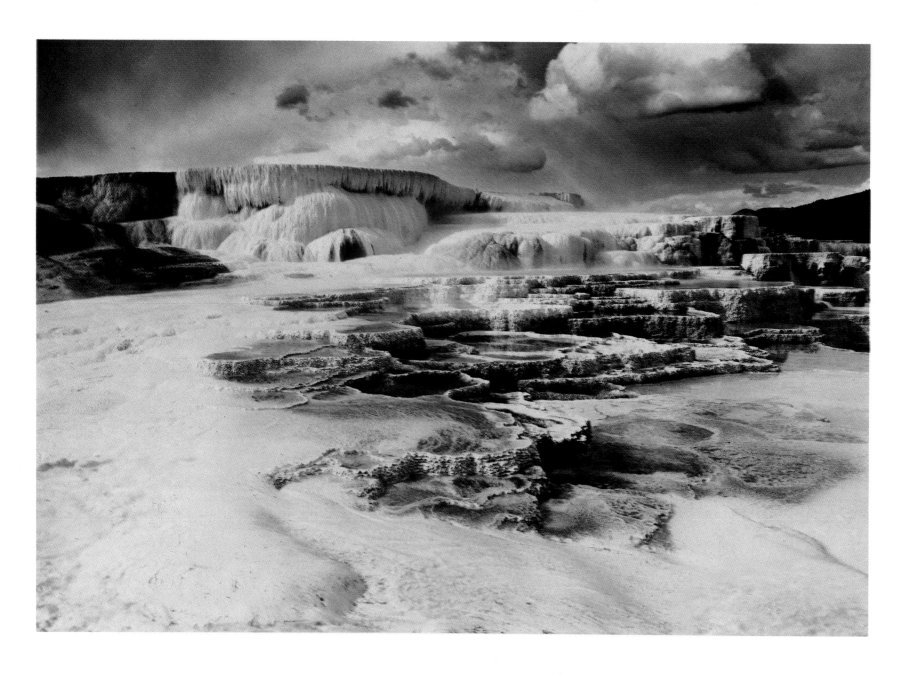

6. Gail Skoff, *Mammoth Hot Springs*, 1980.

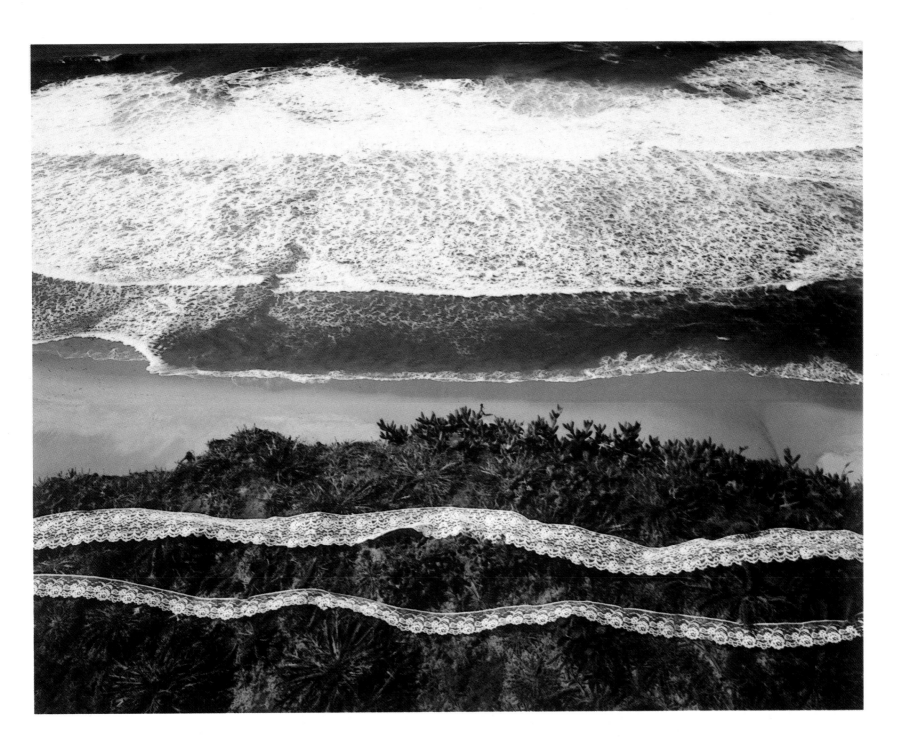

7. John Pfahl, *Wave, Lave, Lace*, 1978.

8. John Divola, *Zuma #25*, 1978.

duction. While Max Kozloff argues that color photography came into its own in the 1970s, it would be possible to suggest that it was not until the 1980s that highly accurate color reproduction technologies became widely accepted and used by publishers of photographic reproductions in books. There had always been economic barriers for the photographers themselves, given the excessive expense of dye transfer prints or the substantially greater expense of the permanent Fresson process. But there were ideological obstacles as well, as we have noted. The situation has somewhat resembled the tremendous artistic development enjoyed by the black-and-white silent motion pictures. The epics of directors like Sergei Eisenstein and D. W. Griffith more than compensated for the lack of "natural color" by two expedients: they hand-colored parts of their films and they dazzled viewers with expressive form created through ingenious montage and dramatic camera angles. When the sound film arrived, the theory of montage collapsed under the demands of a new medium in its technical infancy. When Eisenstein finally essayed color, in the second part of *Ivan the Terrible*, it proved shockingly disappointing, and when Michelangelo Antonioni color-coordinated parts of the city of Ravenna in his first color film, *Red Desert*, one critic remarked that as long as he had shot in black-and-white, Antonioni had seemed a genius; in color, he was forced. Still photographers must have feared a similar fate in color.

The shift into color for landscape images was, as Andreas Feininger indicated, a shift into a new medium where abstract form seemed the salvation from both nature's idiosyncrasies and ideational banality. Harry Callahan succeeded by pushing far beyond his previous work in black-and-white. For his first major publication in color, Callahan included an image of a Cape Cod beach scene that was startlingly different. Instead of relying on horizontal bands of beach/water's edge/waves/distant sea/sky to create a pulsing sarabande, Callahan waited patiently until the atmospheric conditions obliterated the clear demarcation of his customary tonal strips. Except for a graceful edge of wave caressing the bottom of the picture, the image rises in mist, fog, and haze *seamlessly* from color area to color area. It is a remarkable evocation of shimmering, ephemeral nature, in a mood of contemplative beauty, a distillation of pure form dissolved in color.

Whether in color or in black-and-white, landscape photography which pursues pure form has been subject to the criticism that it is in the thrall of the ideologies of modern painting. These ideologies presume certain psychological and metaphysical verities which can be disputed. In arguing with Kandinsky's theories, for example, E. H. Gombrich rejects the notion that "shapes have physiognomic or expressive content which communicates itself to us directly." Despite the Theosophist-based notions that there are universal "vibrations" in nature which can be transmitted through the visual arts, Gombrich finds that Kandinsky's forms, highly colored and expressively emotional, are "in fact very low in content, unless we attribute to these forms some system of conventional meanings not inherent in the forms themselves."[13] Form, like color, can only be interpreted within specific cultural contexts. Color, perhaps surprisingly, is culture-based in its connotations; we have only to think of China, where white is not the color for brides but of mourning, or where green does not signify "go" in traffic but rather "stop," because green in Chinese culture signifies inaction and caution. Any examination of color equivalencies from Goethe to Albers yields an extremely varied list of color connotation.

On another level, criticism addresses itself to the implications of abstraction. The movement from Cezanne's cube, cylinder, and cone to Ed-

ward Weston's meticulous rendering of precise form seems a development contingent on a search for the geometric, mathematical order which presumably underlies the disordered visual world. This impulse is allied with the desire to plunge through the superficial skin of "nature" to find "Nature"—God, the primal force, eternal Law—by whatever name, a Platonic ideal. The end product is a visual paradox: photography, once relied upon for its miraculous rendering of the irrepressibly accidental, has increasingly relinquished the human world and the rugosities of real people and their vitally chaotic environments. Since it establishes as its primary goal the creation of beauty and the discovery of ultimate truth (often synonymous), the photograph of pure form has been condemned as merely providing an aesthetic experience removed from the arena of ethical or political concerns. Douglas Davis claims that "the basic requirement of this ideology [formalism] is that no meaning of any kind can be allowed to pollute visual integrity."[14] This is the inevitable result of taking Maurice Denis too seriously when he said that a picture is essentially an organization of shapes on a two-dimensional surface; formalists forget that he began that statement with the observation "Before it is

a war-horse, a nude . . . etcetera," in other words, indicating that *content* is not banished from the scene, only organized in an interesting way. Critics like Davis are calling for renewed attention to content, insisting that formalism has run its course in all the visual arts.

To condemn all formal interests in landscape photography however, is to go to an extreme. It seems inescapable, nevertheless, that the act of imposing overwhelming design on nature increases the possibility that we shall expect too much perfection from imperfect reality. Marxist criticism, as propounded by Herbert Marcuse, suggests that attempts at pure abstraction represent a privileged and insular class phenomenon, a removal from reality that is, in fact, "the construction of an entirely different and opposed reality."[15] At the opposite end of the ideological spectrum is someone like Herbert Read, who steadfastly maintained the position that humanity is in as much need of beauty as it is of bread, and that the activity of playing with pure form has a long human history involving magic, metaphysics, and conceptual activities. Arguments along these lines grow even more irreconcilable when we consider landscape photography in the context of popular culture.

51. Roger Minick, [Southwest viewed from car], 1977.

6 Landscape as Popular Culture

I suppose I would still prefer to sit under a tree with a picnic basket rather than under a gas pump.
—Roy Lichtenstein

There is a wonderful story by Flannery O'Connor called "The View of the Woods," in which a septuagenarian and his nine-year-old granddaughter engage in a ferocious struggle over the old man's desires for "Progress." "He wanted to see a paved highway in front of his house with plenty of new model cars on it, he wanted to see a supermarket across the road from him, he wanted to see a gas station, a motel, a drive-in picture-show within easy distance. Progress had suddenly set all this in motion." These desires seem so reasonable and natural to the old man that he is absolutely amazed when his granddaughter complains that "We won't be able to see the woods across the road." Equally incomprehensible to him is the fact that she dignifies the woods across the road—perfectly ordinary scrub pines, commonplace and rather ugly—by calling them "the view."[1] The old man intends to sell the property in front of their house to an entrepreneur who plans to erect a bright, shiny new gas station right on the road. To do that, the child explains angrily, would be to prevent her family from seeing the woods from their front porch. The story ends in violent tragedy for them both, as it has in reality on occasion when small towns are caught between the virtues of saving a view and the virtues of more jobs and increased prosperity or, as in the case of this story, when human greed outweighs the enjoyment of nature.

The essential motifs of the O'Connor story are the highway and the gas station, whose symbiotic relationship produced what has been called "highway culture," a functional relation between the internal combustion engine, the automobile, and a widely dispersed population. In American popular culture, few images have exhibited such continuing virility as the road, with its various 105

metaphoric meanings: the search for self, identity, salvation for the metaphysically inclined, the appeal of adventure, freedom from responsibility or restrictions, new opportunities for the experientially minded. In Ed Ruscha's *Twenty-Six Gasoline Stations*, for example, a series of photographs purports to represent an autobiographical adventure of "a trip of 1500 miles and sixty hours of life."[2] To have sixty hours of your life demarcated by the way stations where your car is primed to continue on a long journey may seem a satiric commentary, but there is no reason why it cannot be taken as a straightforward one on the realities of contemporary car travel. If it is satiric, that is because the usual tourist method of documenting a trip is through the assiduous searching out and photographing of the picturesque views not too far from the highway. If it is not satiric, that is because every motel along the highway will sell you postcards of its exterior which are just as banal as Ruscha's gasoline stations. Postcards bearing the jarring colors of the plastic environment are sold right alongside the only slightly less jarring colors of the local "view": a mountain in the distance, an indiscriminately chaotic valley, an especially juicy bit of vernacular history, the center of town, the Old Mill, or the local college. Ed Ruscha might be considered as the perfect recorder of what John Brinckerhoff Jackson sees as the essential truth:

. . . whether we like it or not we cannot really see our country merely as a succession of views to be judged in esthetic terms. We have to see it in terms of a social and human process, an unending creation in which all of us are taking part. The American landscape becomes the composite image of millions of individual destinies, all interlocked not only with their neighbors but with us. We see a reflection of ourselves as Americans.[3]

Like Robert Venturi and Denise Scott Brown, Jackson finds there is much to enjoy in "aspects of the landscape we have been taught to despise—the strip, the wide stretches of mechanized farming, the subdivision, the cheap resort."[4]

Critics like Venturi, Brown, and Jackson contend that the despised instant Los Angeles strip—flashy, seemingly incoherent, screamingly verbal in neon and billboard—is not only uniquely suited to the inescapable highway culture but offers much more vitality, energy, and appropriateness of design to function than the orderly, disguised commerce and boredom of model towns, homogeneously structured malls, or other attempts to patinate essential functions with the glow of idealism. The heartiness of popular culture is applauded; the artificiality of upper-middle-class design ideals is dismissed as veneer. The preservation of the traditional ideals of landscape in the model towns—with their neatly segregated patches of trees—is seen as a reactionary attempt to return to a time, long gone, when the small community was viable. Because of the ever-increasing nationalizing of communities—the ubiquitous Coke machine, the juke box blaring tunes recognized both regionally and nationally, the gas pump dispensing national brands, and the homogeneity cultivated by broadcast television and the nearly simultaneous distribution of Hollywood films—individuals are served more and more by national industries and institutions. But not everyone, apparently, rues the day when "social boundaries break down, and individuals face the world in relative isolation," as part of a mass public described by one commentator as a "huge, inchoate, socio-cultural compost heap in which everything is mixed up together."[5]

Gary Metz has attempted to define the various responses photographers have been making to this "socio-cultural compost heap." He offers the following list of possible reactions: dismay, wit, neutral observation, tough-minded tourism, cynicism, humor, perceptual involvement (the last including a laconic statement of found patterns),

humanistic concerns for the inhabitants of the highway culture towns, and even lyrical formalism. It is a good list, but it does not specify the evident delight that someone like Jonathan Green takes simply in seeing the man-made environment in the intensity of its colors or indicate the fascination of the way sunlight slants through the artificial canyons of city streets. Green comments that the objects in his photographs "say something about the contemporary American decorative values, our tendency toward the ornate, the brazenly colorful, the plastic."[6]

Whereas the cool, distanced photographs of Walker Evans were acceptable and even aesthetically satisfying in black-and-white, it was the color of the brazen environment which gave some critics the worst indigestion. Max Kozloff laments, "The new palette in photography, with its bogus lushness, had become the captive of the most vulgar visual lusts of the mass audience."[7] One presumes that the vulgar visual lusts of the mass audience include such kitsch as the red heart-shaped bathtub in the honeymoon resort, the black-and-red pseudo-Renaissance wallpaper in the bedrooms of same, kidney-shaped blue-tiled swimming pools adorned with plaster cupids, and garish paintings, some on velvet, of "nature scenes," which hang over headboard, sideboard, and lounge chairs fetchingly upholstered in puce velveteen. Is there a landscape photography that matches this vision of a tawdry, brutal, tasteless subculture?

According to Andy Grundberg and Julia Scully, Kenneth McGowan's work "shows no sense of outrage at the environmental disorders he describes; instead, it offers a cool, deprecating irony."[8] In colorplate 5, we find a monumental steak on a billboard overpowering a Goodyear sign. A car is passing off to the right, while a woman in red sedately walks along a narrow sidewalk to the left. There are vestiges of what once was the landscape of this now cluttered environ-

ment: a tree peeks over the Goodyear sign, scrub grass grows along the sidewalk, the kind of grass you can find anywhere, pushing its ineluctable way through cement, surviving bulldozers and refuse tossed from cars. But the calm woman apparently feels no discomfort in this junky environment. McGowan does not show her shrinking in loathing. The scene is simply described in lively color. The viewer is more or less left to experience an unmanipulated response, depending on his or her already established attitudes toward scenes of this sort.

Like McGowan, Stephen Shore seems to be displaying "the exquisite nuances glancing off unaffecting places." A disciple of Walker Evans, and admittedly fascinated by picture postcards, Shore moves confidently through a landscape in which "highbrow tastes and lowbrow motifs exist very well." The socio-cultural compost heap has either obliterated the pretensions of intellectual aristocrats and visual snobs or it has seduced them into acquiescence in what previous decades might have considered visual rape. A democratization of tastes has occurred; pure form is reserved increasingly for the aesthetically intolerant minority. Yet Shore does not radiate happiness, for, as Kozloff observes, "if his art *illustrates* anything, it is the theme of being *alone* in color, a solitary in a lavishly rendered brick, grassroots, and plastic America."[9]

There has been an intimate connection between photography of the man-made landscape, in its essential pop art vulgarity, its vividly expressive flamboyance, even its technological formalities, and the expression of profound alienation. The landscape viewed from the automobile droning through a southwestern oasis wet with rain is staked out with the inevitable, and necessary, gasoline pylons and roadsigns. Roger Minick (plate 51) gazes out through the organizing boundaries of the interior of his car, safe from the rain but threatened by the dark-

ening clouds ahead. The miniscule palms, the isolated motel sign, the implications that human assistance might be available (but only if asked for), all lighten the emotional weight of the scene, even if the solitary structures imply a psychological as well as physical aloneness often experienced by travelers.

The dark mood of Minick's highway differs radically from the seemingly more optimistic 1930s hitchhikers of Walker Evans (plate 52). A single couple does not evoke the tragedies of the migrating Okies fleeing the Dust Bowl. These hitchhikers are on that typically American fantasy voyage: moving on to a better place, a better life. Not for them the forbiddingly endless empty roads depicted by Russell Lee, Dorothea Lange, or Robert Frank. A car will come along soon to take these hitchhikers over the next hill and down into the dismal industrial heartland where they will look for jobs. But in the 1970s, when Roger Minick was traveling the rainswept lonesome road, Americans were once again, as they had been in the Depression, not quite so sure of what the American Dream was, or where the American road might lead.

The more mordantly accurate view that confronted road people in the 1970s might be Tod Papageorge's "tough-minded tourism," as Gary Metz called it.[10] On a road marked, curiously, NORTH RELIEF 85, we encounter a slick billboard advertisement for an undertaking establishment, the French Mortuary (plate 53). A discreet male hand, emerging from an immaculately white, cuff-linked sleeve, rests reassuringly on a female hand clutching white gloves. The caption reads: "We know how to help." Below the billboard is a sign, "Boxcar Statuary," and two monument-shaped objects loom in the near distance. If ever there was a brief, succinct poem on the passing of life and the commercial exploitation thereof, this would seem to be it. Some few rag-tag evidences of an untended underbrush accompany this road that leads us inexorably toward death, which may or may not be a relief. But perhaps anything would be a relief from the constant manipulation of our emotions and ideals. One can only assume that the two hands meeting in the mortuary would also feel completely at home in the restaurant that Kenneth McGowan's steak is inviting us to visit. The photography which records the road is simultaneously recording the popular culture mores of a locale. The French Mortuary sign would not tolerate a washerwoman's hands clutching a tear-stained handkerchief. No. One of the tenets of popular culture is the desire to identify upward. If highbrow culture can enjoy the enthusiastic brashness of working-class culture, the latter is just as likely to aspire to Machiavellian gentility, as trashy and ever-popular serials like *Dynasty* and *Dallas* attest.

It was presumably to rebel against the human emptiness of much abstract expressionist painting that the photo-realist movement began in the 1960s. For painting to copy photography so literally was an astonishing and disturbing turn-about. Critics used to excluding photography from the sacred precincts of the fine arts suddenly were confronted with a fine art, painting, which elevated photography to equality with nature. Furthermore, it was not "art" photography—that is, formalistic photography—but snapshots, glossy magazine reproductions, and postcards that were being elevated. These were models for paintings that would avoid lapsing into "outdated formal languages."[11]

As Christine Lindey observed, what photography was offering painting was a universally accepted way of seeing:

The camera's manner of recording the world could be investigated: its cropping of the subject; its shallow spatial organization; its tonal—as opposed to linear—description of form; its inability to focus at will; all provided new ways of seeing

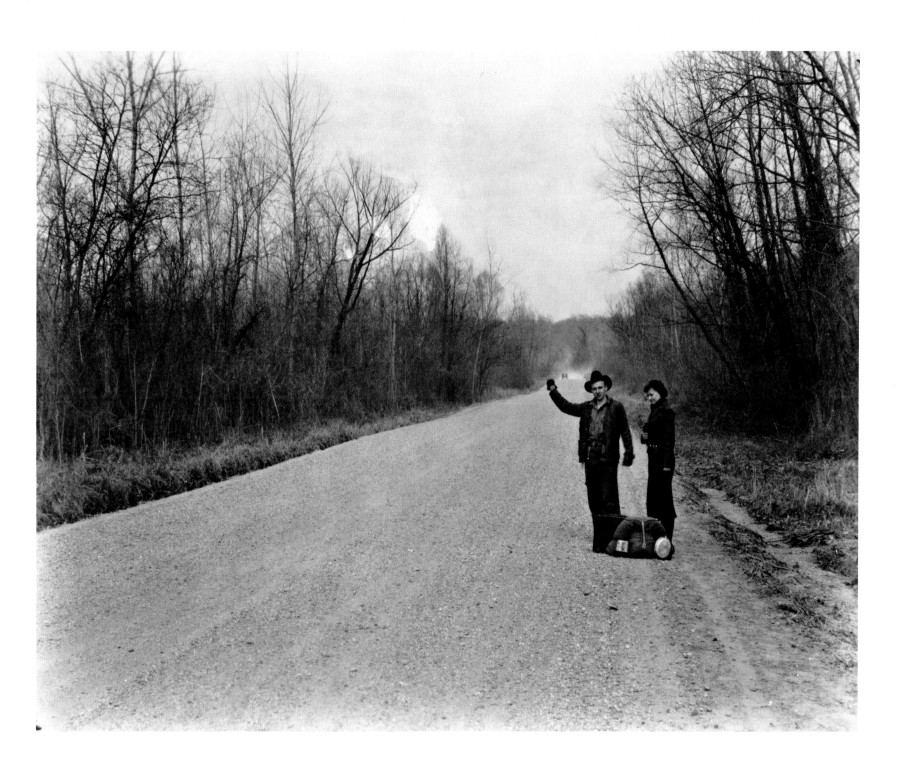

52. Walker Evans, *Hitchhikers (vicinity Vicksburg, Mississippi)*, 1936.

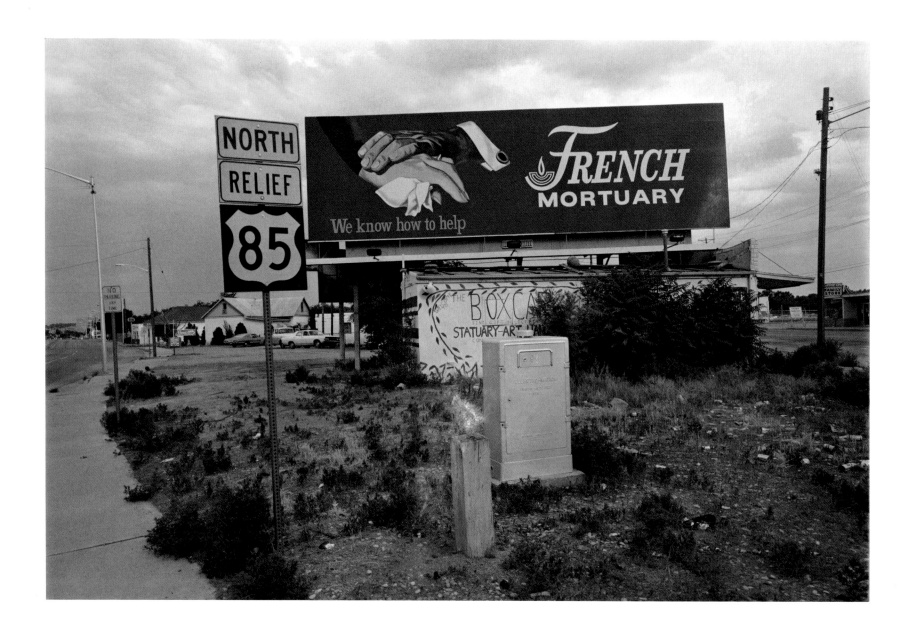

53. Tod Papageorge *Albuquerque, New Mexico*, [French Mortuary billboard], 1973.

which differ from human vision. It provided painters with a visual language relevant to their own times but fresh to realist art, so freeing them from the shadow of all previous forms of realism.[12]

Realism, not idealism, was now no longer simply meat for the untutored masses who presumably cannot understand formalist visual art in any medium; realism would return the world to imagery, but it would be a world transmuted by the camera. It would be, moreover, not the world of either Nature or nature, but of the man-made popular artifact, from diner cuisine to the automobile itself. Like Stephen Shore and McGowan, the photo-realists—for example, Robert Bechtle and Richard Estes—would be absolutely neutral, as the camera was supposed to be. Making no comment on their subject matter, merely presenting machines, plastics, glass, shining chrome, as facts of the twentieth century, the photo-realist painters offered few, if any, clues to the meaning of a particular image. Accordingly, "we are forced to come to terms with our own views on its inherent meanings. Bechtle's paintings underline the essentially modern concept that we each have our own reality."[13]

This cool version of artistic sensibility and goals was widely accepted in film as well as in painting and photography. Who can forget Alain Robbe-Grillet's *Nouvelle vague*, in which pure description was posited as the only way to confront the new, alienating, technological postwar explosion of commodities and consumption? *Things* are not human, and are therefore mysterious because they can be "neither comprehended in a natural alliance nor recovered by suffering."[14] Nature, having been replaced by things man-made, no longer mattered. The sublimities of the nineteenth century, the grand otherworldliness of turn-of-the-century visual artists, the tentative explorations of a possible compromise between the natural world and human artifacts—all of these were now discarded for a nonheroic, noncommittal, vacuously frenetic world of movement and things.

The automobile, in fact, was the perfect apotheosis of thing culture as well as highway culture. The car began to be photographed for its formal values, for its combination of curves, circles, and horizontals. The insides of engines, the sleek coils of motorcycle hoses, and the polished smoothness of waxed metals replaced the nature study, flowers in vases, and trees in the twilight of academic painting. Skill in handling paint and illusionism were now to be valued— all because photography had provided access to popular culture artifacts in a way that was both new and formally intriguing. The snapshot—casual formlessness epitomized—was suddenly the most cherished American photographic style. For the new realists, the information in photographs, especially the snapshot, supplied the randomness of nature.

Traditional concepts of "composition" were taboo. Yet even Henry Wessel's strongly geometric photographs were considered as realism. His seemingly casual and off-center compositions borrowed something from the snapshot aesthetic, but they were in essence concealing a powerful sense of structure. This structure, however, had nothing to do with "an underlying structure of the world or the prevalence of pattern in it." What Wessel and other photographers working in a similar vein are reporting is how the camera shapes the world into meaning "from a particular vantage point."[15] The natural world, in the shape of palm tree trunks, suburban heterogeneous plantings around houses, or isolated fragments of "nature," is subjected, consciously and inescapably, to the vantage point of the camera and the characteristics of various lenses.

Further vantage points embodying the snapshot aesthetic are epitomized in a shot taken by Joel Meyerowitz from a moving car (plate 54). In

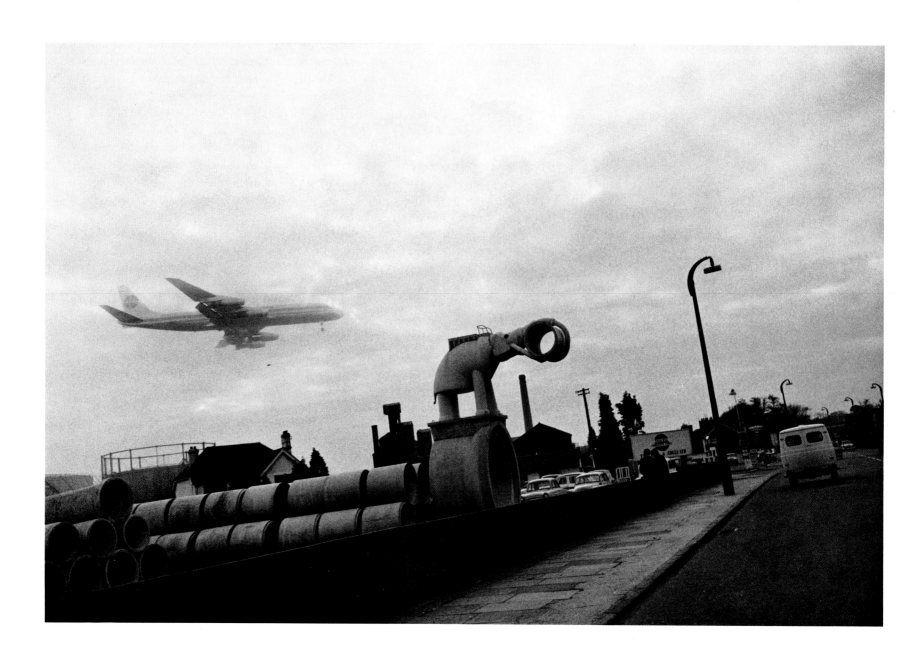

54. Joel Meyerowitz, *Jetliner*, 1966.

it, a huge jetliner ponderously rises toward a pipe-casting stockyard where a concrete elephant triumphantly and humorously holds aloft a single unit of concrete pipe. In the circumstance of movement and shooting from the vantage point of the open car window, Meyerowitz could hardly pay attention to straight horizon lines or other traditional niceties, even if he had wanted to. He seized on a moment of accidental visual juxtaposition of two weighty subjects; if anything of the natural world remains, it is the unseen force of gravity. The visual world as seen from a moving vehicle has been called "a sequence played to the eyes of a captive, somewhat fearful, but partially inattentive audience, whose vision is filtered and directed forward."[16] Wielding a Leica as if it were part of his arm, Meyerowitz is hardly inattentive; he had developed a sense of split-second timing suited to a subset of "street photography"—namely, "auto photography."

The road might be said to lead in two directions in today's America: to the suburbs, where strict zoning laws prohibit manifestations of the more flamboyant and baroque varieties of popular culture while strictly enforcing spaces, walkways, types of housing, even mailboxes; and, for those who cannot afford the pristine suburbs, to the affordable mobile home. Frank Gohlke (plate 55) gives us the perfect suburban street, where boisterous nature is severely trimmed into a neat lawn, where a newly planted tree gamely tries to survive a bulldozed quarter-acre of dryness, where the white car represents the best middle-class virtues of consumption, and where the pervading sterility marks the subordination of random nature to a conformist ideology. But although we often think of mobile-home camps as a shambles of makeshift technology and the instincts of kitsch, Robert Adams surprises us with a formalist view of a quintessential aspect of highway culture (plate 56). He has always announced his

desire to help us enjoy even the most mundane and banal of subjects, and here he succeeds quite well. That is, does quite well until you begin to look at the relationship between the distant hill—perhaps a mountain flattened by erosion?—and the white forms laid out as neatly as in a park. What are these forms doing in this empty landscape? Why are there no people about? And if there were people, how could they relate to such barrenness? City dwellers may assume that anything beyond the confines of cement and asphalt is magically "country," country meaning "the tamed wilderness reserved for picnicking, hiking and camping."[17] The idea of country includes the idea of a tree, at least one. Unfortunately, in the semi-arid deserts of the American West, trees such as one encounters in the lush summers of New England are almost entirely absent. They have to be imported, planted, and tended carefully. As J. B. Jackson observed, in the flat country of the Midwest and the Great Plains, "Texas and Kansas and Western Oklahoma—a stand of trees has a very precise meaning. It means the presence of man."[18]

The presence of man in a landscape is often revealed by his garbage as well as by his thoughtful planting of trees. In an ironic sequence, John Wood (plate 57) reveals a frequent finding of anyone walking along a road or through a well-worn forest trail: the throwaway beer can. In this case, Wood tells us that the Iroquois, once a great nation who revered Nature, have been thrown on the rubbish heap of civilization, along with the Nature that was sacred to them.

Like the Indian adorning the beer can, much of our popular-culture heritage is firmly embedded in the politics of an aggressively mobile nation. The photo realists, in observing and factually recording the social environment, are making political statements, whether they like it or not. At least that is what the Marxist critic George Lu-

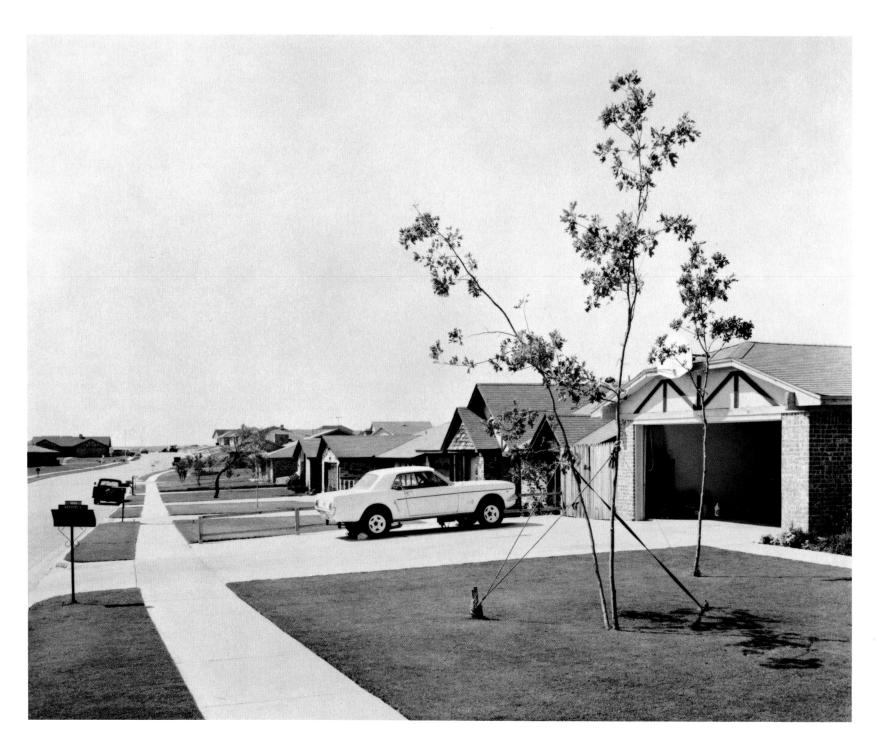

55. Frank Gohlke, *Housing Development South of Fort Worth, Texas*, 1978.

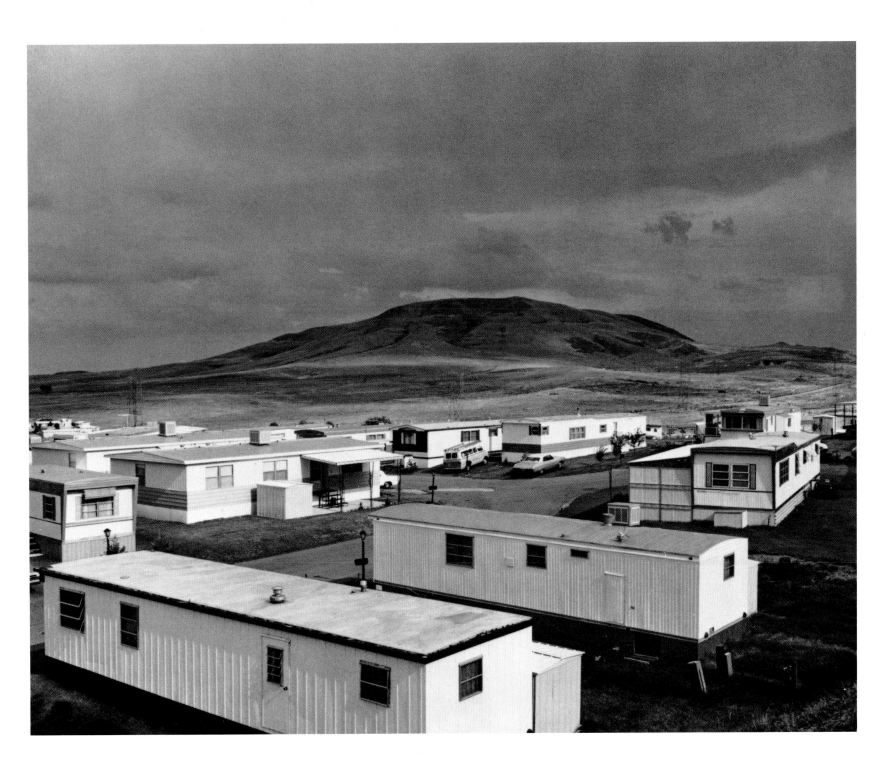

56. Robert Adams, *Mobile Camp*, 1974.

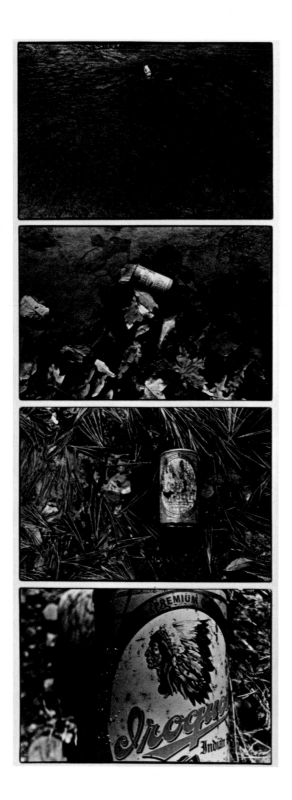

57. John Wood, *Iroquois Beer Cans #8*, 1975.

kács would have us understand. "Any accurate account of reality is a contribution—whatever the author's subjective intention—to the Marxist critique of capitalism, and is a blow in the cause of socialism."[19]

The arrangement of the physical landscape, as opposed to images photographed or painted from it, is subject to political analysis, and not merely in the simple way that Flannery O'Connor's characters experienced the implicit politics of "Progress." J. B. Jackson reminds us that the road, for example, has always been "a device whereby the city exerted its authority in other parts of the landscape." He cites the parallel rows of poplar trees planted by French authorities to separate the king's highway from farmland, simultaneously announcing to the populace that the power of the crown was omnipresent and swift to arrive. The road, or the king's highway, was a link between the public and the private realm.[20] America, too, has its state highways, its national thruways, and its local roads—all interdependent yet maintained by a hierarchy of agencies and funding arrangements which are political in nature. The town square, in New England and the South, boasting its courthouse, library, drugstore, historical society, and the tallest and oldest trees in the community, is a recognizable polity. It is a polity, however, that the superhighways bypass, leaving fragile communities hanging onto customs and technologies increasingly dysfunctional in a network of national scale. These isolated small towns inevitably become havens for disgruntled city dwellers who long for the country—meaning, access to nature—for community, and for a cohesiveness which seems to escape even this presumably homogenated mass society. Photographs of these small islands of urbanity in a rural countryside tend to be collected by historical agencies and more often record the hapless provinciality of inhabitants than the country–town relationship.

August Heckscher has suggested that the historical situation today can be viewed as "the movement from a view of life as essentially simple and orderly to a view of life as complex and ironic."[21] Conservative yearnings for stability, homogeneity, and demarcated divisions between rich and poor, black and white, are daily assaulted by a sprawling, uncontrollable population and its functional, unabashedly commercial artifacts. Those who seek a more "tasteful" popular culture rarely confront the political and economic pressures which militate for venality and self-serving greed. Landscape photography has been actively commenting on—or, at the very least, documenting—the internecine warfare between the aesthetically satisfying, the aesthetically sterile, and the ebullient chaos which signals to critics like Venturi and Jackson that the human race is surprisingly efficient.

If, as Heckscher has suggested, in a Hegelian mood, "equilibrium must be created out of opposites,"[22] photographs of the random disorder and the conflict between visual styles have certainly helped us to understand what is happening. They may also bring us to a more tolerant enjoyment of popular-culture ingenuity, its humor, and the irony of the paradoxes of highway culture. Jack Welpott's photograph of a painted truck (plate 58), for example, offers us a witty commentary, for the vehicle has been decorated with an illusion that it is a flatbed and a further illusion that a landscape can be viewed through it. It is almost like the apology to the natural world which glass-curtain buildings make by reflecting the sky and the clouds: we took away your sky and clouds, but now, magnanimously, we return them to you in a more shimmering form. The truck's painting apologizes for the truck, which has taken away the landscape by moving too quickly through it to its commercial destinations and now returns the landscape to the world in illusionistic form. But when the truck is

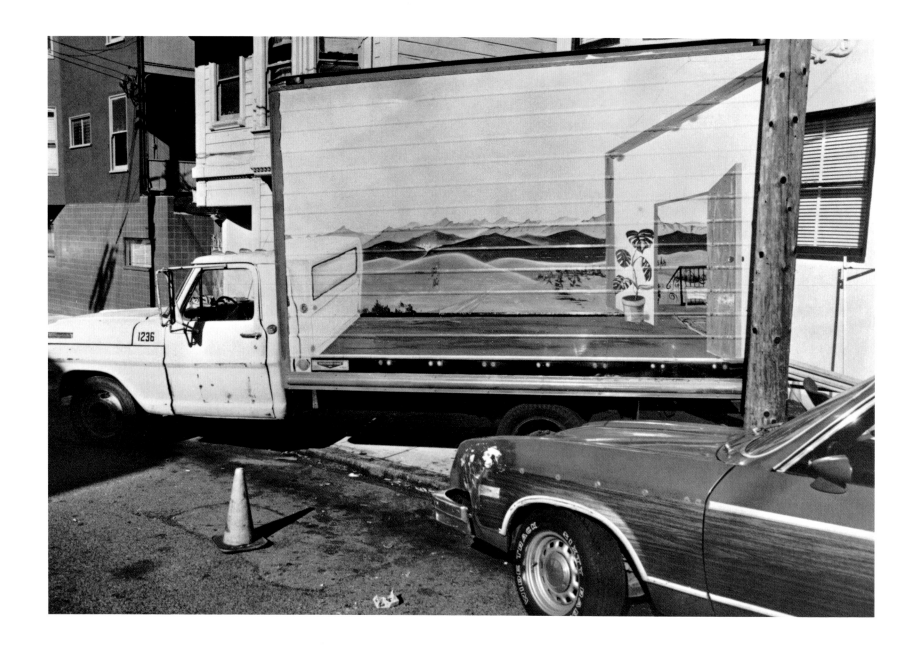

58. Jack Welpott, [Painted truck], 1979.

actually speeding along the highway, the real landscape is static while the truck landscape is moving, a nice perceptual paradox.

Unlike strict adherents to pure form in photography, the realist artists who devote themselves to the temporary excrudescences of mass culture remind us that we are the makers of our own world. That world, to use Venturi's rolling phrase, includes the "megatexture of the commercial landscape."[23] The coolness, the distancing of a Stephen Shore and others who pursue a Brechtian reportage, seems to indicate that these artists are neither celebrating mass culture nor reacting against it.

Instead, popular imagery is used as a kind of stalking horse, a means of creeping up on abstruse philosophical problems. The artists, when questioned, nearly always talk about the ways of looking at something, rather than what is actually seen. . . . The imagery is 'given,' is gratuitously there, so that there is no need to confuse the issue by creating it afresh.[24]

Not all photographers of the landscape as popular culture seem to be pursuing "abstruse philosophical problems." They are amused by the ubiquitous kitsch, the lawns sprinkled with painted gnomes and plaster ducks, the cheese shops in the shape of a slab of Swiss, the roadside carnivals in Maine featuring Wild West shows, or topiary fantasies of bushes lopped into the form of Mickey Mouse. This way of looking at landscape results in cheap irony which quickly palls. It is based on an ideology of a strict hierarchy of aesthetic objects, of "good taste" and historicity, scoffing rather than accepting, manipulating our responses rather than permitting us to arrive at conclusions freely. This is not to say that the satiric mode is inappropriate: the Tod Papageorge "French Mortuary" picture demonstrates how much more profound our reaction may be when the artist is functioning in a presentational mode rather than a dogmatic or moralizing one.

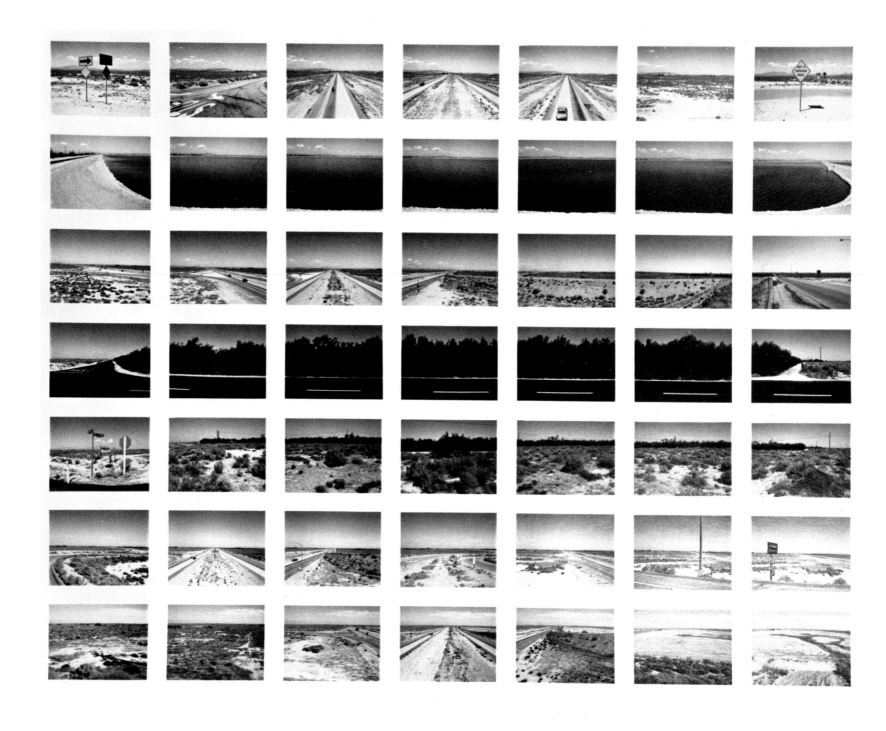

59. Robbert Flick, *East of Lancaster*, 1981.

7 Landscape as Concept

Visual perception is visual thinking.
—Rudolf Arnheim

One of the demigods of popular culture, Andy Warhol, began in the 1960s to incorporate photography into his paintings, not as subject matter to be copied realistically, or even superrealistically, but as the ultimate repeatable, the machine form which had superceded Gutenberg as the creator of precise duplication. As for the automobile, itself a product of the assembly line, Warhol transformed single images into multiple ones called *White Disaster*—five repeats of the same horrifying image of an overturned burning car and impaled victims—and *Green Disaster*—ten repeats of a mangled convertible. He employed this same multiplying technique for portraits of Rauschenberg and Liz Taylor, Elvis Presley and the Mona Lisa, and cows, electric chairs, race riots, in the same way that he had *painted* a rect-

angular canvas containing slight variations on two hundred and ten Coca-Cola bottles neatly arranged in seven rows.

There are several levels of commentary implied in Warhol's images. The mindless, mechanical, and never-ending replication of identical objects is no different from the merchandizing of popular idols. The commercial object and the persuasion engines of advertising dominated American life in the affluent 1960s. But there were deeper levels in the act of repetition: the car crashes, the white and green disasters, the agonized face of the abruptly widowed Jackie Kennedy transmuted into an overall pattern of thirty-five identical panels—these tormented and brutal images spoke of a society in which repeated acts of violence were becoming the norm. The repetitions enhanced the intrinsic fascination of the subjects; they were much more riveting than a single image passed by quickly in a gallery. Besides, they were too large in scale to be ig-

nored. In a decade when the repetitious but hypnotic pictures distributed by television were beginning to compete with the print medium of *Life, Look*, and other magazines dominated by still photography, the single photograph seemed too limited to convey complexities. It no longer seemed an adequate vehicle for communicating the tangled ambiguities of the civil rights struggle, the expanding war in Vietnam, or the political chaos of the late 1960s.

Warhol's multiples were, of course, only one aspect of the response by the visual arts to explosive events and the competition of new visual media. Painters refused to conform to the restrictions of the Renaissance picture-window format of the rectangular canvas. Sculptors crushed wrecked automobiles into blocks of colored metal, galleries exhibited ephemeral installations of "anti-art"—string, rocks, earth, fabrics, crushed glass, anything that would signify the artists' rebellion against tradition, commercial exploitation, and illusionistic representationalism. Not only were the single picture and the rectangle too limited, but the galleries were too small. The solution was to move art from the museums and galleries into the landscape itself. Earthworks, as these generally monumental creations were called, involved the removal or the emplacement of large sections of land or natural formations like boulders in the process of designing a significant artistic statement. Robert Smithson's *Spiral Jetty* curled out into Utah's Salt Lake like the head of a gigantic fiddle fern floating on water. Micheal Heizer's *Double Negative* required the excavation of 240,000 tons of rocky earth from a Nevada mesa, with the final declivities measuring fifteen hundred by fifty by thirty feet wide. He defined it as "a different basic conception of mass, time, size and space challenging 3,000 years of occidental art."[1]

What was paradoxical in many of these escapes out into the landscape was that they could be viewed by the average person only through the medium of photography, and photography mounted on the walls of galleries at that. The monuments of desert and lake were reported by photographic enlargements, just as Ed Ruscha's conceptual piece *Twenty-Six Gasoline Stations* had memorialized the diaristic activity of driving 1,500 miles. Landscape photography was no longer serving as aesthetic object, but as the display of conceptual works in other media or as the manifestations of thought and idea. In fact, photography, once believed to be the ultimate tool of materialism, was proving to be the ideal instrument of metaphysics. It was being used to document actions taken, to recount elaborate narratives, and to investigate the abstruse philosophical ideologies formerly attributed to pop art and the super-realists.

Inevitably, the new strategies of the avant-garde painters, combined with the complex pressures on the single image, forced photographers to invent new forms. Just as they had responded to abstract expressionism in the 1950s by pursuing overall blackness illuminated by mysterious biomorphic or hieroglyphic shapes, intensely subjective ambiguities, poetic double exposures, poetic allusiveness, and close-ups of natural forms that eliminated all context and therefore the possibility of identification, photographers now turned to multiple images à la Warhol repeats, collages, combinations of graphic media, and experimentation with large formats. All of these possibilities had been explored previously, but never with the forceful inventiveness demanded by competition with new media.

The creative ferment of these new explorations was brought to the public by Nathan Lyons in a crucial exhibition, *The Extended Frame* (1977). In his essay for the catalog of that show, Lyons identified several avenues of exploration which were effectively dislodging "photography's traditional descriptive role."[2] That role of de-

scription had been tied to several ideologies, primarily that the camera could not do better than record nature precisely and that, therefore, photography's possibilities for creativity lay within the realm of formal manipulation of the objects already found in nature. But as long ago as the mid-1930s, Francis Bruguière had questioned whether anyone had ever agreed on what nature actually looks like. It was therefore legitimate to question "whether a photograph looks anything like nature." Henry Holmes Smith in the 1960s rejected mimicry and resemblance as "the lowest common denominators of the classical photograph." "To single out the obvious and most easily identified function of the image as more 'real' than some others is folly; to regard the same function as the entire image is inexcusably simpleminded."[3] If nature itself could be challenged as a universal, then the notion of only one kind of photography could be challenged as well. The arbitrary and tenacious hold of the single image as a window on reality could now be broken.

Among the new modalities Nathan Lyons described for *The Extended Frame* were series and sequences of images that could offer "an extended experiential display." In addition to new configurations of images, or the combinations of new complex elements within single images, photography was now being combined with other visual media, as well as printed words, as part of an image. Photographs-within-photographs and other self-referential combinations were frequently observed as a method of destroying the viewer's habitual response to photographs as referring to nature. Thomas Barrow's *Cancellation* series is a typical example, wherein the formerly sacrosanct print surface was scratched with a corner-to-corner *X*, reminding the viewer that the object under scrutiny is nothing but chemicals on paper—in other words, a picture. Barrow's bleak construction environments in the landscape around Albuquerque, New Mexico, were

thus transformed into four irregular triangles in which chunks of the outer world collide with the surface of the paper. As Lyons would describe it, "rational description is relinquished, is held in tension or is even over-stated."[4]

Lyons himself had been engaged in sequential work since 1955, and continues to explore the concept of sequence. Though Minor White had been similarly committed, they disagreed on what might be intrinsically or appropriately sequential. Acccording to Lyons, Minor White had a tendency to *illustrate* a philosophy, while he himself was interested in *discovering* a philosophy. Intent upon broadening the concept of the instantaneity of photography and relating to the flow of time rather than arresting time, Lyons walks through a landscape recording "the present and the past while metaphorically configuring the future."[5] In his *Strata Series*, part of an intended sequence of over three hundred images, Lyons patiently records the changing relationship of the foreground shadow to the enclosed vein of rock. He alludes to time and the changes it brings, both in the moment-by-moment passages of the present and in the long ago, when the upheavals of mountain generation squeezed and convoluted molten strata of rock. Similarly, his humorous *Dinosaur Sat Down*, another sequence, employs distant past and its evidence in the present.

Lyons recently offered a useful definition: "Series generally are thematically related or connected while sequences are based on causal relationships."[6] The subtleties of sequence are often best revealed by reproducing the photographs in book form, and he, like Minor White, advocates the book as the most accessible format for reengaging the visual experience.

Lyons had studied with the graphic artist John Wood in the 1950s. With Keith Smith, John Wood saw in photographs "a means of incorporating fragments of reality into their work while

retaining the freedom to use nondescript color and the power of pure drawn marks."[7] Wood was by no means hesitant to incorporate the reproduction processes developed by various photographic technologies into his printmaking activities. His influence extended not only to Lyons but to Barrow and Betty Hahn, who began to create landscapes and garden scenes by using gum bichromate emulsions and direct stitching in colors through the print. A major goal of these associated photographers was to introduce direct human intervention into the final print, in an effort "to evoke more directly the primal roots of art. For them to make marks on photographs was a means of returning to the idea that art is a form of incantation."[8]

Some critics relegated the notion of "markings" on photographs to a hangover of the gestural influence of the abstract expressionists. It seems more likely that various artists found the single image too confining, while even sequences or series offered insufficient autographic or gestural latitude. In the face of strong and still unrelenting opposition from purists of photography, these artists accepted photography's place in the total spectrum of visual media, including drawings and all reproductive print media, which had already been incorporated into the works of pop artists like Roy Lichtenstein. His enlargements of cartoons, replete with the halftone process dots by which they were tinted, along with Rauschenberg's canvases using photolithography of popular images, verified that a non-natural environment was now dominating human consciousness. Picture-making could not ignore the omnipresent print/verbal environment.

Traditionalists, not unexpectedly, flatly reject manipulated prints and multiple-media prints, whether by pictorialists or markers. Just as painters had once refused to acknowledge that photography could produce works of art, now purists refused to accept anything but the straight print as "photography." This revived some of the old issues, including the hoariest chestnut of them all: that photography is *not* art, but something else, something different and unique. This, in turn, stimulated controversy about what *was* art.

In his brilliant article "Art after Philosophy," Joseph Kosuth scathingly denounced traditionalists. Explaining that the purest definition of conceptual art would be "that it is inquiry into the foundations of the concept 'art,' as it has come to mean," he ridiculed critics who did not understand that all art is conceptual in character. "Formalist critics always bypass the conceptual element in works of art. Exactly why they don't comment on the conceptual element in works of art is precisely because Formalist art is only art by virtue of its resemblance to earlier works of art. It's a mindless art."[9]

Kosuth reminded his readers that the life of Marcel Duchamp had been devoted to returning *mind* to art by rejecting the appearance of nature and all visual tricks devoted to rendering nature illusionistically. The fundamental essence of art is *conception*. But, of course, it was precisely the influence of Duchamp, the dadaists, and the surrealists which threatened the purist stance most forcefully. Nor did mediocre photographers relish the notion that it was not their exquisite camera technique, but the profundity of their concepts which exalted the work of the Westons, Minor White, Strand, Meyerowitz, and others entranced by visual beauty. Even beauty turns out to be an idea in someone's head. Each culture, each generation—indeed, each decade—has demonstrated a capacity for inventing new forms of the beautiful. Concept, then, does not rule out aesthetics.

It was undoubtedly the increasing influence of semiotics and structural analysis, promoted by French critics and philosophers, that was demolishing prior conceptions of some kind of ideal and universal beauty. Not only anthropology, but

psychology, sociology, and media theory were directing the criticism of the arts to new considerations of meaning, process, and the "grammar" of each medium. One critic noted, "The unpopularity of Conceptualism is to no small extent due to its blatant exploitation of the inherent linguistical and ritualistic nature of art."[10] Artists who substituted typewritten words for paint on canvas, dispensing with the physical artifact, were using their brief declarative statements as directions for mental activities on the part of the viewer. Art—under the specific title of "Conceptual Art"—had become pure idea, dematerialized into the abstractions which constitute our languages. One can only wonder what Theosophists like Annie Besant and her taxonomy of "thought forms" would have made of this extraordinary development.

Having relied upon the relationship between the camera and the external world for over a century, photographers were probably loath to substitute words for pictures, to dematerialize not only nature but even the image of nature. Nevertheless, they were confronted with a prevailing ideology, and Benedetto Croce, after all, had suggested that landscape is a state of mind. "Art both culturalizes the natural and naturalizes the cultural."[11] How could photography express this complexity? It was obviously true that the landscape had been "culturalized," not merely cultivated. Even cultivation, or farming, was a human intervention in nature and, until the scientific age, had prompted mankind to coerce nature. Of all human activities, perhaps none was as dependent in primitive societies on ritual and ritualistic objects as agriculture. Much of what was known as culture had been invented to account for the miracle of the seed and the plant which renders up food. "Nature" itself had been the idea of a generative force, in some cultures shared among various beneficent spirits, in others, the sole purview of an omnipotent creator. In everything human

there is both nature and culture, interacting. Essentially, this imposition of human ideas on nature is forgotten. Yet, as the conceptual artist Bruce Nauman remarked, "Between the world and our mind there is a whole system that we take for granted."[12] In Western societies, for example, the system stipulates a sharp demarcation between persons and nature; Oriental philosophies, on the other hand, accept humanity as part of nature. Each ideology, however, is just that: an idea about the phenomenological world, including the human beings inhabiting it.

Though photography could not become pure idea, the conventions of photography could be challenged. To convey aspects of the system we impose on the world, to illuminate the system's operations within artistic behavior, photographs could be embroidered, drawn on, pasted on, cut up into collages, made to repeat themselves, and generally defy the stifling sensory domination of nature. Even the nineteenth-century experience could be relived, transmogrified, in order to develop new attitudes toward image-making as well as meaning. Rick Dingus could pursue Timothy O'Sullivan's routes into the Far West, rephotograph the same sites, and then, almost as if he wanted to enter into the chemistry of the picture, vigorously slash graphite over the smooth paper print. He was redoing O'Sullivan with gestures (plate 60). Joseph Jachna and Ken Josephson could thrust their arms into the landscape and either amalgamate an outstretched arm into a metaphoric extension of the road (plate 61, Jachna's *Door County*, 1970) or offer the landscape a picture of itself.

The roads, travel routes, vistas, views, everything seen in passing, could be serially recorded by Robbert Flick (plate 59) and printed as one unit of information. Barbara Crane could make trees repeat themselves (plate 62) or she could decorate walls with huge collage murals created from repeats. Meridel Rubenstein could

60. Rick Dingus, *Earth in Motion*, 1979–81.

61. Joseph Jachna, *Door County, Wisconsin,* 1970.

mount a picture of stacked stag horns on her moody photograph of the New Mexican landscape to remind us of life cycles, the hunted, and the ritualistic aspects of hunting, in her *Penitente* (plate 63). Marcia Resnick could mock the tourist snapshot taken at national parks in her *See* series or photograph clouds, take the print to an easel, and reproduce their shapes in white cotton fluff for the sake of contrasting art and nature. This is almost a joke on the order of Robert Pincus-Witten's remark, "Until post-Minimalism, 'Art' was indoors and 'Nature' outdoors."[13]

Some artists have decided to abandon nature altogether in their search for ideational modalities. Few pictures are more conceptually "landscapes" than Carl Chiarenza's triptych called *Menotomy 293*, of which only the right-hand portion is reproduced here (plate 64). A snowy mountain develops through three striking panels that are fabrications of paper and light, total unrealities manufactured in the studio. John Pfahl, too, has turned to the unreal image—nothing more than light dots projected toward the human eye—of the television screen for some remarkable photographs of the idea of landscape transformed by electronics.

Pfahl is perhaps one of the most characteristically "conceptual" of recent photographers of nature. In his *Altered Landscapes*, he reveals both wit and ingenuity. Rigidly enforcing one-point perspective, his well-known *Bermuda Triangle* (not reproduced) uses a pointed boulder a little way from shore as the apex of a triangle he created with the use of string attached to stakes on the sand and in the water. His beach/lace fantasy (colorplate 7) uses both metaphor and simile, fooling us just for a moment into thinking that the spumey edge of a wave is lace and vice versa. He has described what he does as "the possession of the space and then its return to a pure state following my own personal ritual."[14] Obviously, many more artists are venturing into conceptual formats. Among these is Gillian Brown, who produced a sequence of three pictures, seen vertically, as follows: a desert plant stands against distant mountains; a hand appears with a spray can, spraying a reddish-brown paint on the top brush of the plant; finally, the painted plant stands alone against the distant mountains. This kind of sequence closely approximates the typewritten placard of instructions that we have already mentioned as the semiotic branch of conceptualism. John Divola, in his *Zuma* series, presents the interior of a vandalized seaside cottage which has been decorated with gestural slashes of spray-can paint (colorplate 8). Through open windows he lets us see magnificent Pacific seas and skies of extraordinary color. There is a powerful decorative tension between the unmarked sea/sky and the destroyed but rhythmically painted interior of the house.

The nineteenth-century landscape photographers like Eadweard Muybridge, having discovered that it was impossible to capture both sky and clouds at the same time when the exposure was correct for the foliage and mountains, had no scruples about printing in a suitable cloud vista from a second negative. In Lawrence McFarland's *Yucca*, the shock of low-sweeping clouds theatrically dominating an empty landscape is obviously the result of Muybridge's technique modernized and much more sophisticated. Here the concept, not the reality, dominates. But just as totally "conceptual" are landscapes like Frederic Sommer's flattened saguaro-covered desert, Joe Deal's *Fault Zone* series or his inventory of topographic details, and John Gossage's ruthlessly impenetrable mishmash of limp vegetation (plate 65). To paraphrase Arnheim, visual selection is visual thinking.

Despite these and many more examples, however, anyone who contends that *all* photography is conceptual in essence is bound to arouse violent opposition. That is precisely what we sug-

62. Barbara Crane, *Morton Arboretum, Lisle, Illinois,* 1974.

63. Meridel Rubenstein, *Penitente*, 1981.

64. Carl Chiarenza, *Menotomy 293* (right portion of triptych), 1982.

gest is the truth. Even so simple an act as the selection of the framing of a picture through the lens is a conceptualization which governs the picture-making behavior. The most advanced landscape photographers, from Stieglitz to Ansel Adams, insist that a picture is "previsualized" in its entirety in the mind long before the shutter is opened on the scene. Nor does previsualization merely suggest a thoughtful transposition of natural color into zones of gray, black, and white, or into the characteristics of specific color films. It includes paper, toning, and contrast, and most importantly, the exact transmission of the original elements of form which stirred the imaginative response.

Even the family snapshooter and the tourist amateur are conceptualizing: "Aunt Milly's flowered dress next to Uncle Jack's blue suit would make a nice picture"; "That lake against the dark mountains is so pretty"; or "This gasoline station is so unusual and funny with all those crazy signs on it." It can be argued that these concepts are simple-minded; the point is that they are *minded.* Admittedly, they are probably preverbal, or even nonverbal. The accomplished amateur will reach for his or her camera out of habit whenever a predetermined stimulus is discovered, something within a range of interests and ideas about what makes an interesting—though not necessarily beautiful—picture. Garry Winogrand, for example, was accused of being simple-minded when he tried to discover what the camera's various lenses would do to streets and people. Rather, he should be considered *single*-minded; for despite the fact that ultimately he selected for publication only a very few pictures from the thousands he took, he clearly had definite ideas about picture-making. This is obvious from the pictures he let us see and from the fact that his style is recognizable.

Whether Garry Winogrand editing a series on Texas stockyards or Nathan Lyons construct-

ing elaborate sequences on time/space relationships, the activity involved is mental as well as physical and technical. Even Andy Warhol's stupefying films, for example, the eight-hour epic of the Empire State Building qua building, are not so much reality as they are concept. Concepts can be boring, exciting, beautiful, ugly, fragmentary, unresolved, simple-minded, amateurish, complex, aggressive, passive, memorable, faddish. They are all, necessarily, products of the mind and are associated with underlying philosophies—ideologies, if you prefer—about the nature of the world, the nature of Nature, human nature, the nature of art, photography, communication, money-making, fame, success, the pleasures of creative activity, technology, politics—the list is endless.

"Thinking is radically metaphoric,"[15] according to the great logician I. A. Richards. He believed that the mind takes hold of phenomenological reality by "the analogy, the parallel, the metaphoric grapple or ground or grasp or draw by which alone the mind takes hold. It takes no hold if there is nothing for it to haul from, for its thinking is the haul, the attraction of likes."[16] We haul in images with cultural nets; we unconsciously carry with us a stream of associations for such abstractions as liberty, progress, strength, time, omnipotence, sorrow, and we either construct visual symbols for these ideas or we find analogies in nature's happenstance. The pathetic fallacy, the anthropomorphizing of natural forms—a proud stand of oaks or a sorrowing willow, a majestic mountain or a joyful brook—occurs as readily in visual images as in poetry, even if visual images are more ambiguous.

For photographers to deny that their work is conceptual would be the equivalent of admitting that their work is utterly mindless. For landscape photographers, particularly, to deny their conceptual operations would be to suggest that they simply wander the face of the earth without pur-

65. John Gossage, *Nature III*, 1975.

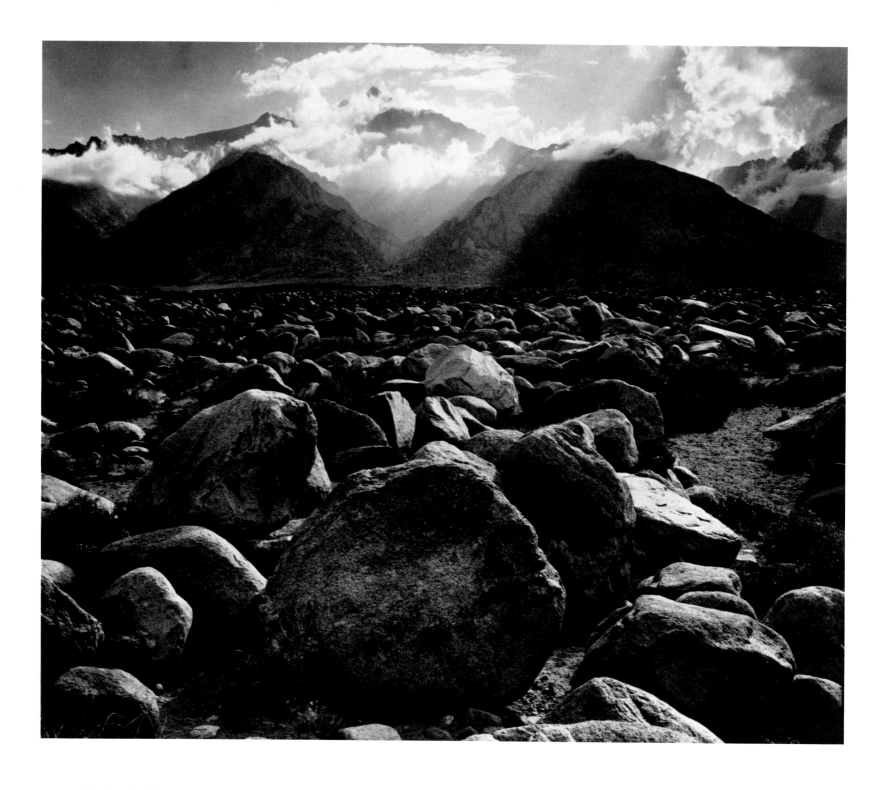

66. Ansel Adams, *Mount Williamson, the Sierra Nevada, from Manzanor, California*, 1944.

8 Landscape as Politics and Propaganda

There is an often repeated legend to the effect that it was the photographs taken by William Henry Jackson which caused Congress to legislate a national park to preserve the fantastic Yellowstone region. While it is true that his large descriptive plates did corroborate previous rumors of Yellowstone's wonders, recent research indicates that it was primarily the impressive written and oral reports delivered by the leader of the expedition, F. V. Hayden, which actually accomplished the miracle of persuasion.[1] A better example of the persuasive powers of landscape photographs would be Ansel Adams's *Sierra Nevada: The John Muir Trail*, which so impressed Secretary of the Interior Harold Ickes that he brought the book to the attention of President Roosevelt. The result was Congress's establishment of the half-million acres of the Kings Canyon region as a national park in 1939.

This idea of a simple and direct cause-and-effect between photographs and action is, unfortunately, the way many people think communication works: one or more outstanding pictures presented at the right time to the right people will alter opinion, marshal appropriate action, and deliver the desired decision without much further ado. It would be exceedingly strange if, for example, the same Ansel Adams book were to be shown to former Secretary of the Interior James Watt in the expectation that both he and President Reagan would enthuse over the prospect of establishing yet another national park. On the contrary, pictures of glorious forests would undoubtedly arouse in these politicians thoughts of their allies in the timber industries, while pictures of craggy mountains might elicit a lust for copper, coal, and natural gas exploration. Photographs in and of themselves may prove to be like Scripture, which the Devil has been known to quote to his own advantage.

Modern propagandists—by whatever name and of whatever political persuasion—recognize 137

that propaganda for a cause can succeed only if a number of conditions are present in the decision-making context. To begin with, there is more than one kind of propaganda: Jacques Ellul calls these prepropaganda and active propaganda, the former obviously being indispensable to the latter. Prepropaganda has the task of mobilizing our psychological responses, loosening the old reflexes, and instilling images and words in repetitive formulas. According to Ellul, prepropaganda, perhaps surprisingly, "does not have a precise ideological objective; it has nothing to do with an opinion, an idea, a doctrine. It proceeds by psychological manipulations, by character modifications, by the creation of feelings or stereotypes useful when the time comes."[2] But even months of repetitive conditioning will not precipitate the desired action when action is finally called for—like voting for a national park or going to war—unless there is a profound consonance between people's "deep social beliefs"[3] and the ideologies being promulgated. Tony Schwartz, a master at political propaganda (it was he who created the television ads for Lyndon Johnson in the Johnson–Goldwater campaign of 1964), calls this consonance "the responsive chord."[4]

Playing on the already present assumptions and unconscious motivations of individuals and groups is the art of the propagandist. In order to be successful as propaganda, photography has to create images that not only resonate with what people will accept, but also has to contribute to the creation of the fundamental myths by which we all live. If you are on the side of the angels, this might be the "myth" (or ideology) of democracy, liberty, productivity, authority, the dignity of labor, or the sanctity of life. But there are other myths, like racial superiority, religious "truth," the beliefs that life is dog-eat-dog in the best tradition of social Darwinism or that people are no good and that women deserve to be raped, for those who feel too threatened to be civilized.

Ellul finds that propaganda must relate to these myths to be effective. By "myth" he means "an all-encompassing, activating image: a sort of vision of desirable objectives that have lost their material, practical character and have become strongly colored, over-whelming, all-encompassing, and which displace from the consciousness all that is not related to it. Such an image pushes man to action precisely because it includes all that he feels is good, just, and true."[5]

An informed opinion is indispensable to the working of propaganda. In other words, you cannot create something out of nothing. Information with reference to political or economic realities is an absolute prerequisite for the successful manipulation of opinion-into-action. Of course, as Ellul acknowledged, "information" is not neutral, and information viewed as part of the communication process is always biased in the sense that it pretends to represent a totality which may, in fact, have no basis in reality. It is a truism of communication that its aim is to alter behavior, even on the most minimal level. Lying through statistics, for example, is not merely the norm in propaganda activities; it is unfortunately a normal consequence of human perception, simply because the mind tends to operate in habitual stereotypes, according to the principle of minimum effort.

Suppose, then, that photographs have as their aims alteration of opinion and mobilization to action. It seems fairly easy to perceive this intent in, say, the *Minimata* series by W. Eugene Smith or the war photographs of David Douglas Duncan. Pictures of people grimacing in pain or deformed by ecological poisoning seem more accessible in terms of potential meaning and interpretation than, say, a picture of a rock. We tend to think of propaganda photographs as concentrating on images of people in disasters of one kind or another. Susan Sontag spoke of the indelible effect of the photographs of Auschwitz.

Perhaps we may conjure up the Farm Security Administration's long-lived efforts to inform the American public, not to mention its politicians, of the reality of hunger, the geographic displacement, and the destruction of the small farm during the Dust Bowl catastrophe and the migrations of the Great Depression. Certainly the documentary films of the 1930s dealt with economic conditions and their impact on human destinies. But how can a photograph of, say, the Canyon de Chelly function as propaganda? Do landscape photographs operate as propaganda only when they have as their content the horrors of ecological disasters and the inescapable trashy detritus of the automobile culture?

In a recent issue of *Life* magazine, an article on the increasing destruction of Montana's Glacier National Park featured a large color photograph of a meadow, a river, and a distant, gloriously snow-covered peak. The meadow was strewn with abandoned automobile carcasses, rusting vehicles in considerable numbers and of no explained origin. The otherwise impassioned text commented on this eyesore as being a "merely aesthetic" problem.[6] The more conspicuous dangers were the strip-mining operations and energy resource explorations on the boundaries of the park, the atomic dump sites nearby, and the unwitting destruction of the delicate balance of nature by admiring hordes of tramping tourists. In other national parks and preserves similar destruction continues unabated. As the *Life* reporter noted, for more than a hundred days a year, smog drifting in from Los Angeles prevents tourists from seeing across to the opposite rim of the Grand Canyon. Acid rain pours down relentlessly on the forests of New England and Canada, and a film informing the public of the effects of this chemical precipitation is labeled "propaganda" by a government agency. The list of elements and activities destructive of nature—not to mention human health—is unbearably long. Yet it is typical

that the commentary about the trashing of our wilderness areas by the automobile culture is relegated to the "merely aesthetic." We suggest that this scanting of the aesthetic issue represents a much deeper aspect of American behavior toward nature and the fundamental ideologies which inform that behavior.

We might begin by blaming Abraham Maslow for listing the aesthetic need last in his famous hierarchy of human needs. Not only does he place it last, but he insists that only for *some* people is the desire for the beautiful a genuine need. Not everybody has this need. Maslow does not say who does, but the implication is that they are probably aristocrats or the "artistic" minority. While it is obvious that food, water, clean air, adequate housing, and the satisfaction of domestic and affectional needs precede any absolute requirement for the "beautiful," it is not so obvious that this relegation of the need for an aesthetically satisfying environment to a most uncertain place in Maslow's hierarchy has had the effect of propagandizing against the respect for nature which the preservationists advocate. By denying the need for aesthetic experience—one of the fundamental benefits which the early national park advocates recognized as being inextricably connected with fresh air and recreation—or by minimizing it, the environmentalists play into the hands of their enemies. For it is the attention to a beautiful environment in nature that ensures the fresh air and the recreation; trashing nature destroys the very purpose of a national park. In the case of national parks and preserves, not to mention inner cities or beltways or suburbia or the small town, neglect of the aesthetic leads inevitably to neglect of the pragmatically beneficial aspects of nature. When the photographer Paul Caponigro compares visiting certain grand wilderness scenes with the experience of entering a cathedral, we should recognize that the overburdened word *beautiful* stands for all

that is exhilarating, liberating, and evocative of a sense of identification with the cosmos; we are talking about perhaps the last trace of the religious experience left in materialistic America, the need for the sublime, the grand, something beyond the power of mere mortals.

Yet there are many curious problems associated with *photographs* of the sublime and the beautiful, just as there are conflicts about the utility of the "beautiful." When the increasing urbanization of Americans, for example, began to separate the natural landscape from the cities, "nature" was transformed into "country," something reserved for weekends and often painfully difficult to reach from the heart of congested inner cities. *Country* often means little more than overcrowded areas like Bear Mountain Park near New York City, several hundred acres granted by a land-wealthy individual for the healthful enjoyment of the lower classes. Picnic grounds, sometimes set aside in dusty pine forests bordering major highways (and equipped with a public restroom), are also cherished, but are hardly the encounters with wild nature that philosophers and psychologists insist are necessary for the refreshment of the soul as well as the body. For inner-city minorities, trapped by poverty, the segregation of spectacular scenery into national parks beloved by landscape photographers is a gesture unrelated to their desperation. To live in the South Bronx or in Harlem is to experience "nature" in the form of an occasional sumac tree—what New Yorkers called "railroad trees" because they grew along the tracks into the city— and mammoth legions of roaches, rats, pigeons, sparrows, and the tough grass which even cement pavements cannot entirely squelch.

How does seeing a stunning color photograph by, say, Eliot Porter, assist these slum dwellers in their daily lives? For some, if they can afford the Sierra Club calendars, pictures of golden aspens and snowy pines may refresh the

spirit, reminding them of the nature of which we are all a part. On the other hand, for others, such pictures only widen the gulf between their status as social outcasts and economic pariahs and that of the very rich, who can afford to travel to spas, national parks, and their own more private nature enclaves whenever they like. The national parks were conceived in the spirit of democratic sharing, rich and poor alike—that was a significant part of the ideology and political pragmatics of nineteenth-century congressional actions. And although photographs can distribute images of these wonderful places, they can never alleviate the bitterness of those who can hardly afford the busfare to Bear Mountain.

To ghetto dwellers, then, a beautiful photograph of nature may provide either refreshment or increased resentment. An image that a landscape photographer hoped would arouse some manifestation of an aesthetic response, on whatever level, may be viewed as an expansion of consumerist propaganda: if you are wealthy, or at least a member of the middle class with a steady job, then you may "consume" nature; if not, you may go hungry in spirit as well as in body.

During the Great Depression of the 1930s, when Nazi Germany was perfecting its own style of propaganda and Hitler was preaching conquest, genocide, and totalitarianism, there was violent dissent among photographers as to what their ethical and artistic stance should be. The situation can be summed up by a statement attributed to Henri Cartier-Bresson; indeed, it is much more than a statement, it is a shocked expostulation: "The world is going to pieces and people like Adams and Weston are photographing rocks!"[7] Because he believed that humanity needs the purely aesthetic as much as anything material, Adams defended himself: "I still believe there is a real social significance in a rock—a more important significance therein than in a line of unemployed."[8] Unfortunately, Adams did not

explain what that social significance might be, and he was accused of being politically and humanly insensitive.

The story is reminiscent of an exchange that took place between Berthold Brecht and André Gide. The latter, writing at the time of the appalling expansion of nazism, happened to speak about a tree he greatly admired. Brecht wrote, sorrowfully,

What kind of times are they, when
A talk about trees is almost a crime
Because it implies silence about so many horrors?[9]

To talk about trees, to photograph trees, to think about nature, were all insupportable in the midst of barbarism. One critic, writing about the Gide-Brecht episode, elaborated on the political nuances of the love of nature in an era of genocide:

At least since the Romantic movement, contemplation of nature has served to console, divert, to offer a realm apart from human struggle, something holy and untouchable except through poetic rapport. In itself, this is genuine and good; but from a political point of view, poetry grounded in imagery of nature is misleading because it convinces us, especially through images of the sublime—sea, space, night, mountains—that human strife and pain are not important; that the cosmos is a timeless whole transcending hope and fear, and thus an awful conflict arises. In dark times even nature is suspect.[10]

Like poetry, photography, with its compression and metaphor, can be considered a seductive anodyne, not a remedy; it could even be condemned as a hypnotic substitute for direct experience leading to action for socially beneficial causes.

When Roy Stryker was exhorting his Farm Security Administration photographers during the Second World War, he fully recognized that what was needed was a gigantic propaganda effort. For landscape, the Great Depression and its Dust Bowl

documents were to be forgotten. "Emphasize the idea of abundance—the 'horn of plenty'—and pour maple syrup over it. . . . I know your damned photographer's soul writhes, but. . . . Do you think I give a damn about a photographer's soul with Hitler at our doorstep?"[11] Thus, instead of Dorothea Lange's tractored-out farm (plate 67), Americans were treated to images of this land as a vast granary, with wheat and corn sheaves stacked in never-ending rows.

As propaganda for improving farm conditions during the Dust Bowl epic, Dorothea Lange's photograph makes a useful comparison with several other images of the same subject: the tractor and the land. In Walker Evans's scene in Jackson, Mississippi, the plowed field leads gently back to a farmhouse and a barn edged with trees. There is little inherent melodrama, if any, in this cool vision of a simple one-family farm (plate 68). At the opposite end of the spectrum is the famous aerial view which Margaret Bourke-White (plate 69) took of a gigantic spiral, the tracks of a single large tractor producing a huge symbol of power: the little farm, of course, was to be no more; it was to be combined with many other little farms to form an agribusiness. That is perhaps one of the messages implicit in the Lange photograph. William Stott described it in this way: "Lange's noble pictures of the Dust Bowl—an abandoned tenant shack floating in a sea of tractor furrows that rise even to the porch—explain completely why no humans are to be seen and what pushed them out."[12] Stott implies that the viewer of this particular Lange photograph (plate 67) will know *without being told* why this shack was abandoned. He is an optimist. If Lange thought she was committing propaganda—that is, supplying information which would arouse emotions leading to a change in political behavior—she must also have realized that her pictures could only be understood in context: the context of other pictures, the context of a verbal explanation of how

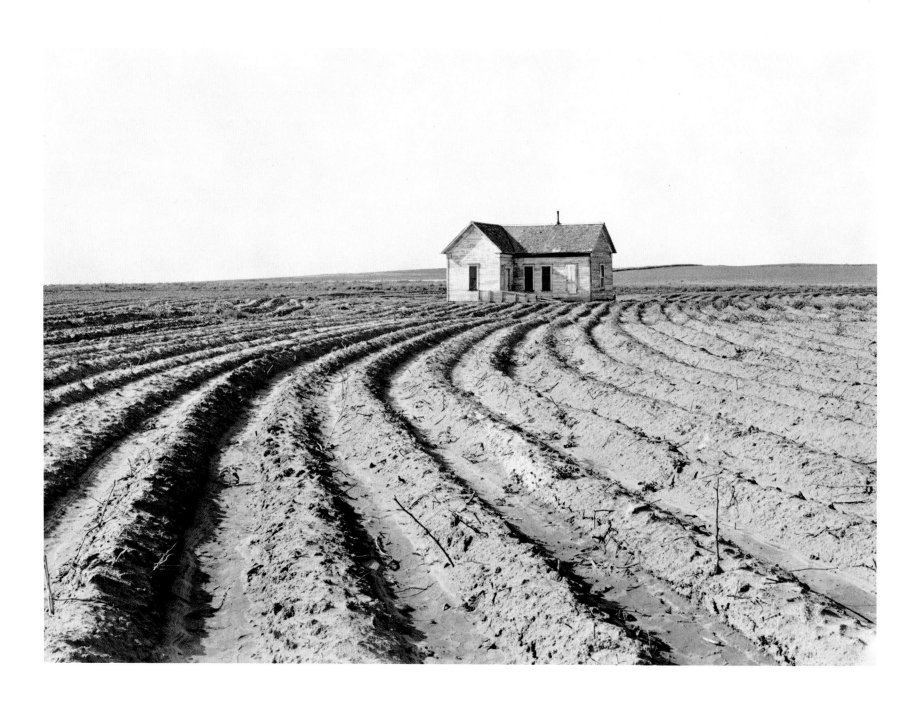

67. Dorothea Lange, *Tractored Out (Childress County, Texas)*, 1938.

68. Walker Evans, *Farm Scene, Jackson, Mississippi,* 1936.

69. Margaret Bourke-White, *Protective Pattern, Walsh, Colorado*, 1954.

big agribusinesses were taking advantage of the Depression to acquire larger and larger tracts of land, the context of vastly changed agricultural technology—in other words, the context of the times. Though her photograph is more dramatic than the Walker Evans's farm scene—her plowed furrows hurtle toward the shack in menacing whip-snake diagonals—it is as uncertain of interpretation. Lange understood propaganda; she insisted on verbal captions for many of her photographs, including this one. Instead of leaving the viewer to wonder if the shack was abandoned because there had been a death in the family, or because the owners were poor managers, or even because of some climatic catastrophe, she entitled it, simply, *Tractored Out*. Yet even that title does not tell the whole story of the depletion of the soil and the aggrandizement of big farm businesses.

As for the Margaret Bourke-White, no one has yet accused her of aestheticizing totalitarianism, as Susan Sontag once accused the filmmaker/photographer Leni Riefenstahl of aestheticizing fascism; but her monumentalizing of the furrowed land and its tiny human participants certainly shares many of the visual qualities of the paeans to labor and the soil of the German nazism/Soviet realism modalities of the 1930s. Bourke-White's image is operatic: its grandiloquent form sings of productivity and awesome power. Next to her picture, the Walker Evans sounds the modest note of a folk ballad.

In *Land of the Free*, Archibald MacLeish assembled sequences of pictures from the Farm Security era and constructed a balladic poem to accompany images of confused and bewildered farming families, ruined and pushed out on the road. He raised several poignant issues with the refrain "We wonder if the liberty was land." Here are some sample verses:

Now that the land's behind us we get wondering
We wonder if the liberty was land and the

Land's gone: the liberty's back of us . . .

[verse 29]

All we know for sure—the land's going out from us:
Blown out by the dry wind in the wheat:
Blown clean to the arrow-heads under the centuries:
Blown to the stony clay . . .
 and we get wondering:
We wonder if the liberty was land.

[verse 49]

Once off the land which represented to the farmers freedom of action, the coveted liberty which their grandparents had emigrated to this country to enjoy, they find:

We've got the road to go by where it takes us
We've got the narrow acre of the road
To go by where it gets to
We can go there[13]

[verse 63]

Combined with the pictures, which include Lange's *Tractored Out*, MacLeish's poem leaves little doubt that he saw the destruction of the small family farm as the extinction of a uniquely American liberty, doomed by the closing of the frontier to end with the migrant slavery of the West Coast so eloquently described by John Steinbeck in *The Grapes of Wrath*. In the context of the Dust Bowl migrations, photographs of tractored-out farms meant more than the loss of property; they could be read as symbols of lost human dignity, the atrophy of the American Dream of personal independence and self-reliance.

Shortly afterward, during the Second World War, America had to be portrayed as both the arsenal of democracy and the breadbasket of the free world. As we mentioned earlier, Roy Stryker then shifted the emphasis of his photographic group to displays of abundance, like the harvest scenes of Marion Post Wolcott or Jack Delano's

Thanksgiving dinners lavish with produce from the American land. Land, productive land, great farms, the cornucopia of abundance, all were equated with the liberty that Archibald MacLeish feared had been lost. To be a great nation meant to be a great *land*. The peasant fought for his land, literally. The Nazis had been particularly insistent on paintings and photographs of farms and other land-based institutions to represent the German *land*. Heroic epics exalted the Soviet soil and the American land, and in both countries the notion of Mother Earth was as important as one's mother tongue. There was a time during the 1940s and 1950s when Irving Berlin's *God Bless America*, as sung by Kate Smith, was suggested as a replacement for *The Star-Spangled Banner*. Smith sang mellifluously of the land she loved, from the oceans to the mountains, from the plains to the sky. Americans were expected to love the land, the physical materiality of their geography, and to identify that land—majestic mountains, magnificent skies, glorious seas, rolling prairies of grain—with nationhood and with their own identity.

Americans have a different attitude toward land in the 1980s: it is a war zone, an arena where preservationists and "land-developers" battle over the last remaining unpopulated areas. There are few more searing indictments of the "land-developer" than Lewis Baltz' *Park City*, and yet we can only wonder about its efficacy as propaganda. A series of 102 photographs documenting the construction of a bedroom community near Salt Lake City, Utah, *Park City* shows us—relentlessly, one might add—the earth scourged, scarred, unrecognizable as part of nature (plate 9). A barbaric invasion of a land area for buildings intended to seduce Los Angeles skiers, Park City is only ninety minutes away from it by air, with another forty minutes on a six-lane highway.

These views of Park City, while surely not submerged, do have a feeling that the place from which we look at them is under the earth, over the lip of a pit or trench. There is about them a subterranean feeling in which the surprise and revelation is in the shock of realizing that the infernal regions have been disinterred and strewn about the surface—the repression of the depths are now the sublimation of the earth.[14]

The mud-filled trenches of the First World War and the bomb-devastated fields at Verdun, where the earth was pulverized, trees were shattered into bits, and humans contributed their blood and parts of their own bodies to the nauseating mess, are the closest analogies to the images Lewis Baltz presents. The heedlessness, the wastefulness, the unbelievable disorder, the irremediably wounded earth: "The condition of photography forces us to think out what it is that we have allowed to be done to us."[15] But let us pretend that *Park City*, with its excruciatingly exact images of destruction and chaos, falls into the hands of the land-developers. What will they think? That the chaos represents a bit of inefficiency? That the earth can be restored by bulldozing it once again into flatness and covering it over with grass carpets? That they wish they had bought into the deal because it looks like Park City will be a popular ski resort? In the context of financial transactions, of fast profit-making, these pictures may elicit no horror, only a bit of contempt for poor workmanship, if that. So to whom is *Park City* addressed? Baltz obviously wanted to chase the moneylenders out of the temple of the land, but unfortunately it is more likely that those of us already persuaded of the respect owed to nature will be studying Baltz's pictures and reading Guy Blaisdell's accompanying text.

Here is another truism of communications theory: people tend to read and to look at what confirms them in their already held opinions. Moreover, most people refuse to look at pictures which upset them. One of the most conspicuous examples of this fact was the discovery that pictures of sorrowful Cambodian orphans used in

advertisements for Christian charity made viewers feel so guilty that they flipped the page before having a chance to read the written message. The situation has become so desperate for charities that one recent ad pleaded: "Don't turn the page!" But in Lewis Baltz's *Park City*, no action is requested. There are no Sierra Club or Audubon Society membership blanks. The book arouses outrage, grief, amazement, despair; but even the Blaisdell text, which is deeply philosophical, does not point to a particular remedy. *Park City* is a not-so-quiet scream of horror from which we discover that "America itself has come unhinged."[16] What action can remedy the situation? What action does Baltz or Blaisdell require or suggest? Nothing less than a complete alteration of aesthetic attitudes toward nature. This, then, is pre-propaganda, aimed at undermining the old reflexes (development, *all* development is good), reconditioning the psyche ("merely aesthetic" becomes "nature" is what we are and all we have; when we treat it with disrespect we commit indecencies upon ourselves"). If Baltz's photographs and Blaisdell's text were widely circulated at town meetings in which new land-use proposals were being discussed, they might have some effect; but only if their readers were already kindly disposed toward the preservation of some kind of sanity in the matter of construction processes. To people for whom the superordinate ideology has become that development is good—and which of us can deny that jobs are of paramount importance in a lagging economy?—it would hardly matter that *Park City* shows us an unforgettable spectacle in which "nature—our own as well as the natural—looms before us as unreasonably afflicted."[17]

Sometimes the use of landscape photographs as propaganda merely astounds or amuses, and a particularly amateurish example appears in what Edward Steichen modestly touted as "the greatest photographic exhibition of all time,"[18] *The Family of Man*, the catalog of the exhibition.

The inside cover of the catalog is a nebula, apparently representing the cosmos from which the Earth originated. Then a moonlit ocean and beach by Wynn Bullock is captioned "And God said, let there be light: Genesis 1:3"[19] The very next picture (plate 70) is the evocative Bullock photograph of a naked child lying face down in the splendidly dense ground cover of a handsome wood; one presumes this picture is intended to introduce the theme of childhood. Now, the peculiar aspect of this poetic picture—which precedes a prologue by the poet Carl Sandburg—is that it would be as easy to interpret the child as being dead as it would to realize that lying naked in underbrush is a typically childish thing to do. Like many beautiful photographs, especially those which radiate an aura of the poetic, the lyrical, and the mysterious, the Bullock picture is ambiguous and out of place in the ensuing welter of gemütlichkeit and schmaltz which purports to convince us that all mankind is one big family. This is not the place to pursue all the propagandistic aspects of *The Family of Man*, as it essentially comprises pictures of people. But there is, curiously enough, another landscape in *The Family of Man* that comes as a total surprise and shock. It is by Ansel Adams and is the well-known image of a boulder-strewn foreground leading to handsome, cloud-strewn peaks (plate 66). The picture, unidentified except for the note "Mt. Williamson," seems almost like an afterthought, as if Steichen were saying to himself, "Gosh, we'd better put in some pictures of nature." Without the information that this was the view from the internment camps into which the United States had placed its Japanese-American citizens, the picture can only communicate how hard life is, or perhaps that nature is obdurate and aloof from our human needs. From the point of view of propaganda, it was a strange inclusion.

Steichen touted *The Family of Man*, of course, as being truthful. He did not elaborate upon how he had cropped various pictures to make his own

70. Wynn Bullock, *Child in Woods*, 1951.

propagandistic points. For him, it was enough to present straight—that is, unmanipulated—photographs to induce the desired emotional responses. Nathan Lyons, commenting on an exhibition he prepared of conceptualist photography in which manipulation, superimposed imagery, collages, and hand working were included, remarked, "The truth of the matter is that the exhibition, The Family of Man, is, in effect, as illusionistic as the work of [these] photographers."[20] Metaphor could now be used openly, not implicitly, to communicate in photography. We no longer had to judge the efficacy of photographs by their relationship to nature; and, according to Lyons, this meant that artists using the photographic media could now create more powerful statements.

Statements in themselves do not constitute propaganda; nor do pictures in themselves. It seems amazingly naïve of Roy Stryker, for example, to have stated categorically in the caption for a photograph in his book *In This Proud Land*

There are pictures that say labor
And pictures that say capital
And pictures that say Depression.[21]

At the same time, Stryker insisted that photographs cannot stand alone, that a photograph always depends upon the caption for its meaning. John Berger goes further than that. He suggests, first, that "In every act of looking there is an expectation of meaning."[22] Since photographs are ambiguous, extracting as they do a small segment from the context and continuity of life, Berger asserts that only words can provide reliable meaning. Though photographs can operate on the level of prepropaganda, it requires words—directions for action, as it were—to produce action.

What actions are required of us in an age when, as John Szarkowski noted, we have no wilderness left? Szarkowski considers this recent discovery to be useful. He reminds us that "in our hearts we still believe that the only truly beautiful landscape is an unpeopled one."[23] Recognizing and accepting the fact that the wilderness is gone, he believes, will predispose us toward rethinking our negligent attitudes.

As this recognition takes a firmer hold on our consciousness, it may become clear that a generous and accepting attitude toward nature requires that we share the earth not only with ice, dust, mosquitoes, starlings, coyotes, and chicken hawks, but even with other people.[24]

Szarkowski's cautious optimism would seem to indicate that the time of prepropaganda's use of landscape photography is over, and that now propaganda itself—that is, persuasion directed toward precipitating decision and action, not merely a shift in attitude—must begin to promote the protection of our natural environment as a politically acceptable and pragmatically operable reality.

Some Afterthoughts

Various chapters of this book have attempted to demonstrate that ideologies concerning an array of human preoccupations, from the aesthetics and art of picture-making to the politics of environmental concerns, reveal themselves in landscape photographs as well as in the critical discourse about them. In landscape photography, implicit or explicit ideas about nature, art, and the practice of photography inextricably combine. The choice of scenes, the treatment of aspects of the phenomenological world as the source for images, the inclusion or exclusion of persons, the suppression of detail or the stress on pure form, the conscious or unconscious imitation of music or painting, the hard-edged fact or the diffuse visual poem—all are the outcomes of ideologies. These ideologies are so pervasive that individuals are not often aware of them, either as producers of landscape images or as viewers of pictures. What individuals think about nature they bring both to the making of and to the appreciation of landscape photographs. What individuals claim

as the "true" purpose of photography they bring to both the production and the viewing of landscape photographs.[1]

Robert Adams has appeared in this volume as an optimist, asking that audiences forego the presumably elitist attitude of wanting landscape to be pure, free from the intrusion of people. Recently, however, in his foreword to a book called *American Spaces: Meaning in Nineteenth-Century Landscape Photography*, Adams revealed a darkly pessimistic response to what has happened to the American West. He sees landscape photography as documenting the destruction of silence, space, and clarity as evidenced in nineteenth-century images. Taking a stand on Timothy O'Sullivan— as everyone must, it seems—Adams refuses to accept interpretations of that photographer's career as having been influenced either by aesthetics or by Clarence King's philosophy of catastrophism concerning the origins of geological formations. While acknowledging that O'Sullivan took pictures at Clarence King's de-

mand, Adams insists on the photographer's independence. He sees O'Sullivan as someone who was seeking the silence of the western landscape after the horrors of the Civil War. And then Adams remarks:

. . . a truism from the experience of many landscape photographers: one does not for long wrestle a view camera in the wind and heat and cold just to illustrate a philosophy. The thing that keeps you scrambling over the rocks, risking snakes and swatting at the flies is the *view*. It is only your enjoyment of and commitment to what you see, not to what you rationally understand, that balances the otherwise absurd investment of labor.[2]

With all respect to Robert Adams, whose work is influential and significant, what we find here is a typical confusion about the unconscious and irrational elements in human activity. No doubt photographers do enjoy the view, but what they *select* of the view to enjoy—without thinking rationally about it—is the result of everything they have learned and adopted for use. It may be that only beginners in an art or practice are conscious of what they choose to imitate or rebel against. The mature artist (operator, photographer, whatever you choose to call this person who makes pictures) acts according to the ideologies, the philosophies, and the praxes he or she has incorporated, whether consciously or unconsciously. These ideologies need not be consistent; they rarely are, yet they govern our activities.

The deconstructivist philosophers have stressed the point that language precedes us into the world; that is, we are born into an already mature language that establishes the terms by which we will function in the world. The language is not static, nor is it a universal language that establishes the terms by which we will *all* function, African Bushman and Boston Brahmin alike. Even the most creative individuals, those who succeed in changing some of the terms or adding new ones, begin by viewing the world through the practices of their times as well as in

their individual contexts. William Henry Fox Talbot sought out what his era had decided was the picturesque in landscape; if his education had been totally in abstract design, it is quite possible that negative–positive photography would not have been invented, at least not by Talbot. The last vestiges of that attraction to the picturesque is the phrase, still in common currency, that some aspect of nature is "pretty as a picture." Considering that the nineteenth century also demanded that a picture have a moral, or that the nature displayed should supply "moral uplift" to the viewer, a good example of the change in ideologies is the fact that we no longer say (if we ever did) "moral as a picture."

Another example is the use of truly unreasonable terms like "the nineteenth century" or "the twentieth century," as if such arbitrary periods truly existed. For many art historians (and we include photographic historians in that category), the twentieth century began in 1890 and may have ended with Hiroshima or the man walking on the moon. The romanticism generally attributed to the nineteenth century began in the last quarter of the eighteenth. We have used the terms involving centuries primarily for convenience, not because we believe that they represent anything tangible. Thus, nineteenth-century photographic ideals survive well into the twentieth, and some of the preoccupations of the late twentieth century can be found to have had many precedents.

Our culture places a premium on individuality, at least in its stated ideals. It may be difficult to reconcile such an ideology with the increasingly apparent reality of our participation in a communal mind epitomized by our dependence on language and encouraged by the mass media. *Landscape as Photograph* has attempted to clarify some of the concepts that govern photographic behavior as an activity involved not only in image-making but in revealing the interconnections between nature, art, and ideology.

Notes

Introduction

1 D. W. Meinig, ed., *The Interpretation of Ordinary Landscapes* (New York: Oxford University Press, 1979), Introduction, p. 2.
2 Ibid., p. 3.
3 Rosalind Krauss, "Photography's Discursive Spaces: Landscape/View," *Art Journal* (Winter 1982), p. 311.
4 D. W. Meinig, "The Beholding Eye: Ten Versions of the Same Scene," in D. W. Meinig, ed., *Interpretation of Ordinary Landscapes.*

Chapter 1. Landscape as Artistic Genre

1 Linda Nochlin, *Realism*, "Style and Civilization" series (Middlesex, England: Penguin Books, 1971), p. 23.
2 Ibid., p. 36.
3 Kenneth Clark, *Landscape into Art* (Boston: Beacon Press, 1961), p. xvii.
4 John Szarkowski, *The Photographer and the American Landscape* (New York: Museum of Modern Art, 1963), p. 3.

5 John Szarkowski, *American Landscapes* (New York: Museum of Modern Art, 1981), p. 9.
6 Ibid.
7 Ibid., p. 7.
8 Roland Barthes, *Camera Lucida* (New York: Hill & Wang, 1981), p. 6.
9 Ibid.
10 Quoted in Lawrence Gilman, *Nature in Music, and Other Studies in the Tone Poetry of Today* (Freeport, N.Y.: Books for Libraries Press, 1914), p. 11.
11 Lucy Larcom, *Landscape in American Poetry* (New York: Appleton, 1879), p. 14.
12 Ibid.
13 Leo Marx, *The Machine in the Garden* (New York: Oxford University Press, 1964), p. 233.
14 Ibid., pp. 236–37.
15 Roger B. Stein, *John Ruskin and Aesthetic Thought in America, 1840–1900* (Cambridge, Mass.: Harvard University Press, 1967), p. 16.
16 Ralph Waldo Emerson, "Nature," in *Miscellanies Embracing Nature: Addresses and Lectures* (Boston: Phillips, Samson, 1856), p. 8. The first edition was published in 1836; reissued in 1847.

17 John R. Stilgoe, *Common Landscape of America, 1580 to 1845* (New Haven: Yale University Press, 1982), p. 170.

18 Robert Adams, "Inhabited Nature," *Aperture*, no. 81 (1978), p. 29.

19 Ibid.

20 Ibid., p. 31.

21 George S. Evans, quoted in Roderick Nash, *Wilderness and the American Mind*, rev. ed. (New Haven: Yale University Press, 1979), p. 141.

22 Roderick Nash, *Wilderness*, p. 145.

23 Emily Dickinson, quoted in John Conron, *The American Landscape* (New York: Oxford University Press, 1974), p. 299.

24 Ralph Waldo Emerson, "Nature," quoted in Conron, ibid., p. 226.

Chapter 2. Landscape as God

1 Roderick Nash, *Wilderness and the American Mind*, p. 91.

2 Walt Whitman, "Starting from Paumanok," quoted in Ansel Adams, *The Portfolios of Ansel Adams*, p. 18.

3 John Szarkowski, introduction to Ansel Adams, *Portfolios*, p. vii.

4 Ibid.

5 Thomas Burnet, quoted in Marjorie Hope Nicholson, *Mountain Gloom and Mountain Glory: The Development of the Aesthetics of the Infinite*, p. 207.

6 Ibid., p. 198.

7 James Hutton, quoted in Edward Battersby Bailey, *James Hutton: Founder of Modern Geology*, p. 28.

8 Ibid., p. 33.

9 Ibid., p. 50.

10 Ibid., pp. 118–19.

11 Weston Naef, in collaboration with James N. Wood, *Era of Exploration: The Rise of Landscape Photography in the American West, 1860–1885*, p. 57.

12 Edmund Burke, *A Philosophical Enquiry into the Origin of Our Ideas of the Sublime and Beautiful*, 1:vii.

13 Ibid., p. 42.

14 Ibid., p. 46.

15 Thomas Paine, quoted in John Conron, *The American Landscape*, p. 145.

16 Paul Caponigro, *Landscape*, p. 32.

17 George Wharton James, *The Grand Canyon, How to See It*, p. 10.

18 Walter John Hipple, Jr., *The Beautiful, the Sublime, and the Picturesque in 18th-Century British Aesthetic Theory*, p. 194.

19 William Gilpin, *Three Essays: On Picturesque Beauty; On Picturesque Travel; and On Sketching Landscape; to Which Is Added a Poem on Landscape Painting*, p. 52.

20 John Ruskin, *Modern Painters*, vol. 3, pt. 4, p. 259.

21 Ibid., vol. 5, pt. 9, chap. 1, p. 195.

22 Ibid.

23 Bradford Washburn, conversation with Estelle Jussim, April 1982.

24 Ralph Waldo Emerson, "Nature," p. 8.

25 Walt Whitman, quoted in Conron, *American Landscape*, p. 363.

26 Clarence King, *Mountaineering in the Sierra Nevada*, p. 80.

27 Roger B. Stein, *John Ruskin and Aesthetic Thought in America, 1840–1900*, p. 79.

28 Ibid., pp. 108–09.

29 Ibid., p. 119.

30 Thurman Wilkins, *Clarence King*, p. 45.

31 Elizabeth Lindquist-Cock, *The Influence of Photography on American Landscape Painting, 1839–1880*, p. 97.

32 Ibid., p. 93.

33 Ibid.

34 Wilkins, *Clarence King*, p. 85.

35 Joel Synder, *American Frontiers: the Photographs of Timothy O'Sullivan, 1867–1874*, pp. 42–44.

36 Naef, *Era of Exploration*, p. 135.

37 Ibid.

38 Nash, *Wilderness and the American Mind*, p. 16.

39 Ibid.

40 Ibid., p. 51.

41 Ibid., p. 151.

Chapter 3. Landscape as Fact

1 Robert Rosenblum, *Modern Painting and the Northern Romantic Tradition*, p. 23.

2 Ralph Waldo Emerson, quoted in Leo Marx, *The Machine in the Garden*, p. 17.

3 Michael Fried, *Absorption and Theatricality: Painting and Beholder in the Age of Diderot*, p. 130.

4 Andreas Feininger, *The Creative Photographer*, p. 180.

5 Keith F. Davis, "History in Words and Photographs," p. 25.

6 Alexander von Humboldt, *Cosmos*, 1:5.

7 *Niagara Falls*, in the series *America: Her Grandeur and Her Beauty*, introduction.

8 Ibid.

9 Shelley Armitage, "Robert Adams, Post Modernism and Meaning," p. 50.

10 James Huginin, "Joe Deal's Optical Democracy," p. 6.

11 Alan Sekula, "The Traffic in Photographs," p. 17.

12 Nancy Newhall, *P. H. Emerson: The Fight for Photography as a Fine Art*, p. 35.

13 Ibid., p. 98.

14 Ibid., p. 63.

15 Simply stated, Heisenberg's principle of uncertainty indicates that you cannot simultaneously measure the velocity and the mass of an atomic particle.

16 Thomas Southall, "White Mountain Stereographs and the Development of a Collective Vision," in Edward W. Earle, ed., *Points of View, The Stereograph in America*, p. 101.

17 Ibid.

18 Ibid., p. 106.

19 Susan Sontag, "Photography in Search of Itself," quoted in Peninah R. Petruck, ed., *The Camera Viewed*, 2:223.

20 Dorothea Lange, quoted in Milton Metzer and Bernard Cole, *The Eye of Conscience: Photographers and Social Change*, p. 80.

Chapter 4. Landscape as Symbol

1 Peter Bermingham, *America in the Barbizon Mood*, p. 71.

2 Ibid.

3 A. B. Walkley, introduction to Maurice Maeterlinck, *Treaure of the Humble*, p. xii.

4 Ibid.

5 Samuel Taylor Coleridge, quoted in E. F. Carritt, *The Theory of Beauty*, p. 298.

6 Edward Lucie-Smith, *Symbolist Art*, p. 57.

7 Charles Baudelaire, quoted in Philippe Jullian, *The Symbolists*, p. 15.

8 Baudelaire, quoted in Philippe Jullian, *Dreamers of Decadence: Symbolist Painters of the 1890s*, p. 256.

9 Abraham A. Davidson, *The Eccentrics and Other American Visionary Painters*, p. 119.

10 Charles Caffin, quoted in Wanda M. Corn, *The Color of Mood: American Tonalism 1880–1910*, p. 3.

11 Davidson, *Eccentrics*, p. 88.

12 Edward Steichen, quoted in Corn, *The Color of Mood*, p. 2.

13 Sadakichi Hartmann, *The Valiant Knights of Daguerre*, p. 204.

14 Albert Aurier, quoted in Lucie-Smith, *Symbolist Art*, p. 59.

15 Albert Mockel, quoted in Jullian, *The Symbolists*, p. 228.

16 Carritt, *Theory of Beauty*, p. 271.

17 Wynn Bullock, quoted in Nathan Lyons, ed., *Photographers on Photography*, p. 37.

18 Ibid.

19 Franklin Rosemont, ed., *Andre Bréton: What Is Surrealism; Selected Writings*, bk. 1, p. 131.

20 Ibid., p. 60.

21 Ibid.

22 Ibid., p. 7.

23 Jerry Uelsmann, quoted in James L. Enyeart, *Jerry N. Uelsmann: Twenty-Five Years: A Retrospective*, p. 37.

24 Susan Dodge Peters, "The Inclusion of Medieval and Victorian Art in Jerry Uelsmann's Photographs: A Reading of Associations," p. 8.

25 Caponigro, *Paul Caponigro* (Millerton, N.J.: Aperture, 1972), p. 42.

26 Peter Bunnell, quoted in James Huginin, "Tarnished Meditations: Some Thoughts on Jerry Uelsmann's Photographs," p. 8.

27 Ibid.

28 Jacques Maritain, quoted in Minor White, *The Way through Camera Work*, p. 68.

29 Minor White, *Mirrors Messages Manifestations*, p. 67.

30 White, *The Way through Camera Work*, p. 66.

31 Davidson, *Eccentrics*, p. 88.

32 Rosemont, *What Is Surrealism*, bk. 1, p. 131.

Chapter 5. Landscape as Pure Form

PART 1 *MONOCHROME LANDSCAPE PHOTOGRAPHY*

1 Anthony Bannon, *The Photo-Pictorialists of Buffalo*, p. 15.

2 Ibid., p. 29.

3 Minor White, *The Way through Camera Work*, p. 73.

4 Julius Portnoy, *Music in the Life of Man*, p. 155.

5 Ibid.

6 Ibid.

7 P. D. Ouspensky, *The Fourth Way*, p. 211.

8 Annie Besant and C. W. Leadbetter, *Thought-Forms* (Wheaton, Ill.: Theosophical Publishing, 1925).

9 Sixten Ringbom, "Art in the 'Epoch of the Great Spiritual'; Occult Elements in the Early Theory of Abstract Painting," p. 400.

10 Ibid.

11 Mallarmé, quoted in Ringbom, "Occult Elements," p. 402.

12 Walter Pater, *The Renaissance; Studies in Art and Poetry*, p. 133. First published in 1873.

13 Ibid., p. 138.

14 Ibid.

15 Ibid.

16 Paul Cézanne, quoted in Amadée Ozenfant, *Foundations of Modern Art*, p. 323.

17 Picasso, quoted in Paul Waldo Schwartz, *Cubism* (New York: Praeger, 1971), p. 23.

18 Ozenfant, *Foundations*, p. 259.

19 Ibid., p. 57.

20 Minor White, quoted in Nancy Newhall, *Edward Weston, The Flame of Recognition*, p. 100.

21 Ansel Adams, quoted in Newhall, *Edward Weston*, p. 100.

22 Ozenfant, *Foundations*, p. 259.

23 Ibid., p. 263.

24 Wassily Kandinsky, *Concerning the Spiritual in Art*, p. 47.

25 Edward Weston, quoted in Minor White, *The Way through Camera Work*, p. 73.

26 White, *The Way through Camera Work*, p. 73.

27 Janet Kardon, *Photography: A Sense of Order*, p. 7.

28 Ibid.

29 Robert Adams, quoted in William Jenkins, *New Topographics: Photographs of a Man-Altered Landscape*, p. 7.

30 Henri Focillon, *The Life of Forms in Art*, p. 30.

PART 2. *COLOR LANDSCAPE PHOTOGRAPHY*

1 Andreas Feininger, *Successful Color Photography*, p. 10.

2 Ibid., p. 16.

3 John Szarkowski, *William Eggleston's Guide*, p. 9.

4 Gene Thornton, "The New Photography: Turning Traditional Standards Upside Down," *Art News*, April 1978, p. 78.

5 Feininger, *Successful Color Photography*, p. 4.

6 Ibid.

7 José A. Argüelles, *Transformative Vision; Reflections on the Nature and History of Human Expression*, p. 188.

8 Paula Marincola, *The Hand-Colored Photograph*, Philadelphia College of Art Exhibition Catalog, 1980, p. 8.

9 Paul Vogt, *The Blue Rider*, p. 83.

10 S. Tschudi Madsen, *Art Nouveau*, p. 55.

11 Vogt, p. 83; 81.

12 Barbaralee Diamondstein, *Visions and Images*, p. 110.

13 E. H. Gombrich, quoted in Robert Venturi, Denise Scott Brown, and Steven Izenour, *Learning from Las Vegas*, p. 132.

14 Douglas Davis, *Art Culture: Essays on the Post Modern*, p. 140.

15 Herbert Marcuse, quoted in Douglas Davis, *Art Culture*, p. 24.

Chapter 6. Landscape as Popular Culture

1 Flannery O'Connor, *Everything That Rises Must Converge*, pp. 56–57.

2 Eleanor Antin, "Reading Ruscha," *Art in America*, p. 67.

3 John Brinckerhoff Jackson, "Various Aspects of Landscape Analysis," in *Texas Conference on Our Environment* (School of Architecture, University of Texas, 1966), p. 151.

4 Ibid.

5 Paul DiMaggio, "Market Structure, the Creative Process, and Popular Culture," p. 436.

6 Jonathan Green, quoted in Renato Danese, ed., *American Images: New Work by Twenty Contemporary Photographers*, p. 130.

7 Max Kozloff, "Photography: The Coming of Age of Color," p. 32.

8 Andy Grundberg and Julia Scully, "Currents—American Photography Today," p. 168.

9 Kozloff, "Photography," p. 35.

10 Gary Metz, "The Land Inhabited," in Sandy Hume and Ellen Manchester, eds., *The Great West: Real/Ideal*, p. 48.

11 Christine Lindey, *Superrealist Painting and Sculpture*, p. 13.

12 Ibid.

13 Ibid., p. 56.

14 Linda Chase, "Existential vs. Humanist Realism," in Gregory Battcock, ed., *Super Realism*, p. 82.

15 Ben Lifson, introduction to *Henry Wessel, Jr.*, exhibition organized by Grossmont College Art Gallery, Nov. 21–Dec. 17, 1976.

16 Robert Venturi, Denise Scott Brown, and Steven Izenour, *Learning from Las Vegas*, p. 74.

17 Metz, "The Land Inhabited," p. 46.

18 Jackson, "Various Aspects of Landscape Analysis," p. 152.

19 George Lukács, quoted in Joseph Masheck, "Verist Sculpture: Hanson and De Andrea," p. 96.

20 John Brinckerhoff Jackson, *Discovering the Vernacular Landscape*, p. 36.

21 August Heckscher, quoted in Robert Venturi, *Complexity and Contradiction in Architecture*, p. 24.

22 Ibid.

23 Venturi, *Learning from Las Vegas*, p. 13.

24 Edward Lucie-Smith, *Late Modern: The Visual Arts since 1945*, pp. 162–63.

Chapter 7. Landscape as Concept

1 Grégoire Müller, *The New Avant-Garde*, p. 162.

2 "Profile: Nathan Lyons," *Video Data Bank* (School of the Art Institute of Chicago) 2, no. 5 (September 1982): 21.

3 Patricia D. Leighten, "Critical Attitudes toward Overtly Manipulated Photography in the 20th Century," p. 316–17.

4 "Lyons," *Video Data Bank*, p. 21.

5 Nathan Lyons, conversation with Estelle Jussim, July 1, 1983.

6 Ibid.

7 Van Deren Coke, *The Markers*, p. 4.

8 Ibid., p. 5.

9 Joseph Kosuth, "Art after Philosophy," in Gregory Battcock, ed., *Idea Art*, pp. 70, 79.

10 Jack Burnham, "Problems of Criticism," in Battcock, *Idea Art*, p. 59.

11 Ibid., p. 65.

12 Müller, *The New Avant-Garde*, p. 119.

13 Robert Pincus-Witten, *Postminimalism*, p. 195.

14 Peter C. Bunnell, introduction to *Altered Landscapes: The Photographs of John Pfahl*, p. 12.

15 I. A. Richards, quoted in Kosuth, "Art after Philosophy," p. 75.

16 Ibid.

17 Carl Chiarenza, *Aaron Siskind: Pleasures and Terrors*, p. 199.

Chapter 8. Landscape as Politics and Propaganda

1 Howard Bossen, "A Tall Tale Retold: The Influence of the Photographs of William Henry Jackson on the Passage of the Yellowstone Park Act of 1872," p. 99.

2 Jacques Ellul, *Propaganda: The Formation of Men's Attitudes*, p. 31.

3 Ibid., p. 43.

4 Tony Schwartz, *The Responsive Chord* (New York: Doubleday, 1974).

5 Ellul, *Propaganda*, p. 33.

6 Anne Fadiman, "Nature under Siege," *Life*, July 1983, p. 106.

7 Henri Cartier-Bresson, quoted in Robert Cahn and Robert Glenn Ketchum, *American Photographers and the National Parks*, p. 133.

8 Ansel Adams, quoted in ibid., p. 133.

9 Berthold Brecht, quoted in Terrence Des Pres, "Poetry in Dark Times," in Bill Henderson, ed., *The Pushcart Prize VII: Best of the Small Presses* (New York: Avon, 1983), p. 363.

10 Ibid., p. 363.

11 Roy Stryker and Nancy Wood, *In This Proud Land: America 1935–1943 as Seen in the FSA Photographs*, p. 180.

12 William Stott, *Documentary Expression and Thirties America*, p. 62.

13 Archibald MacLeish, *Land of the Free*, ed. A. D. Coleman (New York: Da Capo, 1977).

14 Guy Blaisdell, text for Lewis Baltz and Guy Blaisdell, *Park City*, p. 239.

15 Ibid., p. 231.

16 Ibid., p. 234.

17 Ibid., p. 222.

18 Edward Steichen, *The Family of Man*, subtitle.

19 Quoted on the first page of *The Family of Man*.

20 Nathan Lyons, *The Persistence of Vision* (New York: Horizon Press and the International Museum of Photography, 1967).

21 Stryker, *In This Proud Land*, p. 62.

22 John Berger and Jean Mohr, *Another Way of Telling*, p. 117.

23 John Szarkowski, foreword to Robert Adams, *The New West: Landscapes along the Colorado Front Range*, p. 4.

24 Ibid.

Some Afterthoughts

1 There are market considerations which have not been touched upon to any great extent in this book. Obviously, the ideology of what sells, and to whom, is influential in encouraging types of images to be produced.

2 Robert Adams, introduction to Daniel Wolf, ed., *American Spaces: Meaning in Nineteenth-Century Landscape Photography*, p. 10.

Bibliography

BOOKS

Adams, Ansel. *The Portfolios of Ansel Adams.* Introduction by John Szarkowski. Boston: New York Graphic Society, 1977.

Adams, Robert. *The New West: Landscapes along the Colorado Front Range.* Foreword by John Szarkowski. Boulder, Colo.: Colorado Associated University Press, 1974.

Albers, Josef. *Interaction of Color.* New Haven: Yale University Press, 1971.

Argüelles, José A. *Transformative Vision: Reflections on the Nature and History of Human Expression.* Boulder, Colo.: Shambala, 1975.

Bailey, Edward Battersby. *James Hutton: the Founder of Modern Geology.* Amsterdam: Elsevier, 1967.

Baltz, Lewis, and Blaisdell, Guy. *Park City.* Albuquerque, N.Mex.: Artspace Press, in association with Millerton, N.Y.: Aperture, 1980.

Bannon, Anthony. *The Photo-Pictorialists of Buffalo.* Buffalo, N.Y.: Media Study, 1981.

Barthes, Roland. *Camera Lucida.* New York: Hill and Wang, 1981.

Battcock, Gregory, ed. *Idea Art.* New York: Dutton, 1973.

————, ed. *Super Realism.* New York: E. P. Dutton, 1975.

Berger, John, and Mohr, Jean. *Another Way of Telling.* New York: Pantheon, 1982.

Bermingham, Peter. *America in the Barbizon Mood.* Washington, D.C.: Published for the National Collection of Fine Arts by the Smithsonian Institution Press, 1975.

Besant, Annie, and Leadbeater, C. W. *Thought-Forms.* Wheaton, Ill.: Theosophical Publishing House, 1925.

Bunnell, Peter C. *Altered Landscapes: The Photographs of John Pfahl.* Carmel, Calif.: Friends of Photography, 1981.

159

Burke, Edmund. *A Philosophical Enquiry into the Origin of Our Ideas of the Sublime and Beautiful.* London: R. & J. Dodsley, 1757.

Burnham, Jack. "Problems of Criticism." In *Idea Art,* edited by Gregory Battcock, pp. 46–69.

Cahn, Robert, and Ketchum, Robert Glenn. *American Photographers and the National Parks.* New York: National Park Foundation and Viking Penguin, 1981.

Caponigro, Paul. *Landscape.* New York: McGraw-Hill, 1975.

———. *Paul Caponigro.* Millerton, N.Y.: Aperture, 1972.

Carritt, E. F. *The Theory of Beauty.* London: Methuen, 1914.

Chase, Linda. "Existential vs. Humanist Realism." In *Super Realism,* edited by Gregory Battcock. New York: Dutton, 1975.

Chiarenza, Carl. *Aaron Siskind: Pleasures and Terrors.* Boston: New York Graphic Society, 1983.

Cikovsky, Nicolai, Jr. *George Inness.* New York: Praeger, 1971.

Clark, Kenneth. *Landscape into Art.* Boston: Beacon Press, 1961. Rev. ed. New York: Harper & Row, 1979.

Coke, Van Deren. *The Markers.* San Francisco Museum of Art, 1981.

Conron, John. *The American Landscape.* New York: Oxford University Press, 1974.

Corn, Wanda M. *The Color of Mood: American Tonalism 1880–1910.* San Francisco: M. H. De Young Memorial Museum, 1972.

Danese, Renato, ed. *American Images: New Work by Twenty Contemporary Photographers.* New York: McGraw-Hill, 1979.

Davidson, Abraham A. *The Eccentrics and Other American Visionary Painters.* New York: Dutton, 1978.

Davis, Douglas. *Art Culture: Essays on the Post Modern.* New York: Harper & Row, 1977.

Des Pres, Terrence. "Poetry in Dark Times." In *Pushcart Prize VII: Best of the Small Presses,* edited by Bill Henderson. New York: Avon, 1983.

Diamondstein, Barbaralee. *Visions and Images.* New York: Rizzoli, 1981.

Earle, Edward W., ed. *Points of View: The Stereograph in America.* Rochester, N.Y.: Visual Studies Workshop Press, 1979.

Eauclaire, Sally. *The New Color Photography.* New York: Abbeville Press, 1981.

Ellul, Jacques. *Propaganda: the Formation of Men's Attitudes.* New York: Vintage Books, 1965.

Emerson, Ralph Waldo. "Nature," in *Miscellanies Embracing Nature; Addresses and Lectures.* Boston: Phillips Sampson, 1856.

Enyeart, James L. *Jerry N. Uelsmann: Twenty-Five Years, A Retrospective.* Boston: New York Graphic Society, 1982.

Feininger, Andreas. *The Creative Photographer.* Englewood Cliffs, N.J.: Prentice-Hall, 1955.

———. *Successful Color Photography.* 4th ed. Englewood Cliffs, N.J.: Prentice-Hall, 1967.

Focillon, Henri. *Life of Forms in Art.* New York: Wittenborn, Schultz, 1948.

Fried, Michael. *Absorption and Theatricality: Painting and Beholder in the Age of Diderot.* Berkeley: University of California Press, 1980.

Fryxell, Fritiof. *The Tetons: Interpretations of a Mountain Landscape.* Berkeley: University of California Press, 1938.

Gerdts, William H. *American Impressionism.* Seattle: Henry Art Gallery, University of Washington, 1980.

Gilman, Lawrence. *Nature and Music, and Other Studies in the Tone Poetry of Today.* Freeport, N.Y.: Books for Libraries Press, 1914.

Gilpin, William. *Three Essays: On Picturesque Beauty; On Picturesque Travel; and On Sketching Landscape; to Which Is Added a*

Poem on Landscape Painting. 2d ed. London: R. Blamire, 1794.

Goldwater, Robert. *Symbolism.* New York: Harper & Row, 1979.

Grossmont College Art Gallery. *Henry Wessel, Jr.* Exhibition catalog, Nov. 21–Dec. 17, 1976.

Hall-Duncan, Nancy. *Photographic Surrealism.* Exhibition organized by New Gallery of Contemporary Art, Cleveland, Ohio, 1980.

Hartmann, Sadakichi. *The Valiant Knights of Daguerre.* Berkeley: University of California Press, 1978.

Hipple, Walter John, Jr. *The Beautiful, the Sublime, and the Picturesque in 18th-Century British Aesthetic Theory.* Carbondale, Ill.: Southern Illinois University Press, 1957.

Humboldt, Alexander von. *Cosmos.* 2 vols. London: Henry C. Bohn, 1848.

Hume, Sandy, and Manchester, Ellen, eds. *The Great West: Real/Ideal.* Boulder, Colo.: University of Colorado, 1977.

Jackson, John Brinckerhoff. *Discovering the Vernacular Landscape.* New Haven: Yale University Press, 1984.

———. "Various Aspects of Landscape Analysis," in *Texas Conference on Our Environment*, School of Architecture, University of Texas, 1966.

James, George Wharton. *Grand Canyon: How to See It.* Boston: Little, Brown, 1910.

Jenkins, William. *The Extended Document: An Investigation of Information and Evidence in Photographs.* Rochester, N.Y.: International Museum of Photography, 1975.

———. *New Topographics: Photographs of a Man-Altered Landscape.* Rochester: International Museum of Photography, 1975.

Jullian, Philippe. *Dreamers of Decadence: Symbolist Painters of the 1890's.* New York: Praeger, 1975.

———. *The Symbolists.* Oxford: Phaidon Press, 1975.

Jussim, Estelle. *Slave to Beauty: The Eccentric Life and Controversial Career of F. Holland Day.* Boston: David R. Godine, 1981.

Kandinsky, Wassily. *Concerning the Spiritual in Art.* New York: Dover, 1977.

Kardon, Janet. *Photography: A Sense of Order.* Philadelphia: Institute of Contemporary Art, University of Pennsylvania, 1981.

King, Clarence. *Mountaineering in the Sierra Nevada.* 9th ed. Boston: Ticknor, 1871.

Klingender, F. D. *Art and the Industrial Revolution.* Edited and revised by Arthur Elton. New York: Schocken Books, 1970.

Kosuth, Joseph. "Art after Philosophy." In *Idea Art*, edited by Gregory Battcock, pp. 70–101.

Leitch, Vincent. *Deconstructive Criticism.* New York: Columbia University Press, 1983.

Lindey, Christine. *Superrealist Painting and Sculpture.* New York: William Morrow, 1980.

Lindquist-Cock, Elizabeth. *The Influence of Photography on American Landscape Painting, 1839–1880.* New York: Garland, 1977.

Lucie-Smith, Edward. *Late Modern: The Visual Arts since 1945.* New York: Praeger, 1969.

———. *Symbolist Art.* New York: Praeger, 1972.

Lyons, Nathan. *Notations in Passing.* National Gallery of Canada, 1971–72.

———. *The Persistence of Vision.* New York: Horizon Press and the International Museum of Photography, 1967.

———, ed. *Photographers on Photography.* Englewood Cliffs, N.J.: Prentice-Hall, 1966. See also under "Profile: Nathan Lyons."

MacLeish, Archibald. *Land of the Free.* Edited by A. D. Coleman. New York: Da Capo Press, 1977.

Madsen, S. Tschudi. *Art Nouveau.* New York: McGraw-Hill, 1967.

Maeterlinck, Maurice. *Treasure of the Humble.* Translated by Alfred Sutro. New York: Dodd Mead, 1912.

162 Marincola, Paula. *The Hand-Colored Photograph.* Exhibition catalog. Philadelphia College of Art, 1980.

Marx, Leo. *The Machine in the Garden.* New York: Oxford University Press, 1964.

Meinig, D. W., ed. *The Interpretation of Ordinary Landscapes.* New York: Oxford University Press, 1979.

Meltzer, Milton, and Cole, Bernard. *The Eye of Conscience: Photographers and Social Change.* Chicago: Follett Publishing Co., 1974.

Metz, Gary. "The Land Inhabited." In *The Great West: Real/Ideal,* edited by Sandy Hume and Ellen Manchester. Boulder, Colo.: University of Colorado, 1977.

Müller, Grégoire. *The New Avant Garde.* New York: Praeger, 1972.

Naef, Weston, in collaboration with James N. Wood. *Era of Exploration: The Rise of Landscape Photography in the American West, 1860–1885.* Boston: New York Graphic Society, 1975.

Nash, Roderick. *Wilderness and the American Mind.* rev. ed. New Haven: Yale University Press, 1979.

Newhall, Nancy. *Edward Weston: The Flame of Recognition.* Millerton, N.Y.: Aperture, 1971.

————. *P. H. Emerson, The Fight for Photography as a Fine Art.* Millerton, N.Y.: Aperture, 1975.

Niagara Falls. In the series *America: Her Grandeur and Her Beauty; A Gallery of Picturesque Reproductions with Descriptive Text, of America's Rivers and Lakes, Prairies and Savannahs, Valleys and Mountains, Fastnesses and Forests, Cascades and Waterfalls, Gorges and Canyons* (Union Book & Publishing, 1900).

Nicolson, Marjorie Hope. *Mountain Gloom and Mountain Glory: The Development of the Aesthetics of the Infinite.* Ithaca, N.Y.: Cornell University Press, 1959.

Nochlin, Linda. *Realism.* Middlesex, Eng.: Penguin Books, 1971.

Norris, Christopher. *Deconstruction: Theory and Practice.* London: Methuen, 1982.

Novak, Barbara. *Nature and Culture: American Landscape and Painting, 1825–1875.* New York: Oxford University Press, 1980.

O'Connor, Flannery. *Everything That Rises Must Converge.* New York: Farrar Straus and Giroux, 1956.

Ouspensky, P. D. *The Fourth Way.* New York: Knopf, 1968.

Ozenfant, Amadée. *Foundations of Modern Art.* Translated by John Rodker. New York: Dover, 1952.

Pater, Walter. *The Renaissance; Studies in Art and Poetry.* London: MacMillan, 1925. Originally published 1873.

Pincus-Witten, Robert. *Postminimalism: American Art of the Decade.* New York: Out of London Press, 1981.

Portnoy, Julius. *Music in the Life of Man.* New York: Holt, Rinehart and Winston, 1963.

Rosemont, Franklin, ed. *André Breton: What Is Surrealism: Selected Writings.* New York: Monad Press, 1978.

Rosenblum, Robert. *Modern Painting and the Northern Romantic Tradition.* New York: Harper & Row, 1975.

Ruskin, John. *Modern Painters.* 2 vols. New York: John Wiley, 1884.

Schwartz, Paul Waldo. *Cubism.* New York: Praeger, 1971.

Schwartz, Tony. *The Responsive Chord.* Garden City, N.Y.: Doubleday, 1974.

Snyder, Joel. *American Frontiers: The Photographs of Timothy O'Sullivan, 1867–1874.* Millerton, N.Y.: Aperture, 1981.

Sontag, Susan. "Photography in Search of Itself." In *The Camera Viewed,* edited by Peninah R. Petruck. 2 vols. New York: Dutton, 1979.

Southall, Thomas. "White Mountain Stereographs and the Development of a Collective Vision." In *Points of View: the Stereograph in America*, edited by Edward W. Earle. Rochester, N.Y.: Visual Studies Workshop Press, 1979.

Steichen, Edward. *The Family of Man*. New York: Museum of Modern Art, 1955.

Stein, Roger B. *John Ruskin and Aesthetic Thought in America, 1840–1900*. Cambridge, Mass.: Harvard University Press, 1967.

Stilgoe, John R. *Common Landscape of America, 1580 to 1845*. New Haven: Yale University Press, 1982.

Stott, William. *Documentary Expression and Thirties America*. New York: Oxford, 1973.

Stryker, Roy, and Wood, Nancy. *In This Proud Land: America 1935–1943 as Seen in the FSA Photographs*. Boston: New York Graphic Society, 1975.

Szarkowski, John. *American Landscapes*. New York: Museum of Modern Art, 1981.

———. *The Photographer and the American Landscape*. New York: Museum of Modern Art, 1963.

———. *William Eggleston's Guide*. New York: Museum of Modern Art, 1976.

Tate Gallery. *Towards a New Art: Essays on the Background of Abstract Art 1910–20*. London, 1980.

Venturi, Robert. *Complexity and Contradiction in Architecture*. New York: Museum of Modern Art and Graham Foundation, 1966.

———; Brown, Denise Scott; and Izenour, Steven. *Learning from Las Vegas: The Forgotten Symbolism of Architectural Form*. Rev. ed. Cambridge, Mass.: MIT Press, 1977.

Vogt, Paul. *The Blue Rider*. Translated by Joachim Neugroschel. Woodbury, N.Y. and London: Barron's, 1980.

White, Minor. *Mirrors Messages Manifestations*. Millerton, N.Y.: Aperture, 1982.

———. *The Way through Camera Work*. Millerton, N.Y.: Aperture, 1959.

Wilkins, Thurman. *Clarence King*. New York: Macmillan, 1958.

Wilmerding, John. *American Light: The Luminist Movement, 1850–1875*. Washington, D.C.: National Gallery of Art, 1980.

Wolf, Daniel, ed. *American Spaces: Meaning in Nineteenth-Century Landscape Photography*. Middletown, Conn.: Wesleyan University Press, 1983.

ARTICLES

Adams, Robert. "Inhabited Nature." *Aperture*, no. 81 (1978), pp. 28–31.

Antin, Eleanor. "Reading Ruscha." *Art in America*, November–December 1973, pp. 64–71.

Armitage, Shelley. "Robert Adams, Post Modernism and Meaning." *Exposure* 18, no. 2 (1981): 49–58.

Asbury, Dana. "Linda Connor: Solos and Landscapes." *Afterimage*, December 1979, pp. 5–7.

Bossen, Howard. "A Tall Tale Retold: The Influence of the Photographs of William Henry Jackson on the Passage of the Yellowstone Park Act of 1872." *Studies in Visual Communication* 8, no. 1 (Winter 1982): 98–109.

Crocker, Richard L. "Pythagorean Mathematics and Music." *Journal of Aesthetics and Art Criticism* 22 (Spring 1964): 325–35.

Davis, Keith F. "History in Words and Photographs." *Image* 22, no. 3 (September 1979): 19–26.

DiMaggio, Paul. "Market Structure, the Creative Process and Popular Culture." *Journal of Popular Culture* (Fall 1977), pp. 436 hr ff.

Fadiman, Anne. "Nature under Siege." *Life*, July 1983, pp. 106–12.

Foote, Nancy. "The Anti-Photographers." *Art Forum*, Sept. 1976, pp. 46–54.

Green, Jonathan. "Aperture in the 50's: The Word and the Way." *Afterimage*, March 1979, pp. 8–13.

Grundberg, Andy, and Scully, Julia. "Currents—American Photography Today." *Modern Photography*, October 1980, p. 168.

Huginin, James. "Joe Deal's Optical Democracy." *Afterimage*, February 1979, pp. 4–6.

———. "Tarnished Meditations: Some Thoughts on Jerry Uelsmann's Photographs." *Afterimage*, May 1979, pp. 8–11.

Karmel, Pepe. "Photography Raising a Hue: The New Color." *Art in America*, January 1982, pp. 27–31.

Kozloff, Max. "Photography: The Coming of Age of Color." *Art Forum*, January 1975, pp. 30–35.

Krauss, Rosalind. "Photography's Discursive Spaces: Landscape/View." *College Art Journal*, Winter 1982, pp. 311–19.

Leighton, Patricia D. "Critical Attitudes toward Overtly Manipulated Photography in the 20th Century." *College Art Journal*, Summer 1978, pp. 313–21.

Masheck, Joseph. "Verist Sculpture: Hanson and De Andrea." *Art in America*, November–December 1972, pp. 90–97.

Peters, Susan Dodge. "The Inclusion of Medieval and Victorian Art in Jerry Uelsmann's Photographs: A Reading of Associations." *Image* 22, no. 1 (March 1979): 8–15.

"Profile: Nathan Lyons." *Video Data Bank*, School of the Art Institute of Chicago, vol. 2, no. 5 (September 1982).

Ratcliff, Carter. "Route 66 Revisited: the New Landscape Photography." *Art in America*, Jan.–Feb. 1976, pp. 86–91.

Ringbom, Sixten. "Art in the 'Epoch of the Great Spiritual,' Occult Elements in the Early Theory of Abstract Painting." *Journal of the Warburg and Courtauld Institute* 29 (1966): 386–418.

Sekula, Alan. "The Traffic in Photographs." *College Art Journal* 41, no. 1 (Spring 1981): 15–25.

Thornton, Gene. "The New Photography: Turning Traditional Standards Upside Down." *Art News*, April 1978, pp. 74–78.

Westerbeck, Colin L., Jr. "Strangers in a Strange Land." *Art Forum*, March 1982, pp. 43–45.

Index